Hidden Landmarks
of New York

Hidden
Landmarks
of New York

A TOUR OF THE CITY'S
MOST OVERLOOKED BUILDINGS

Tommy Silk

BLACK DOG
& LEVENTHAL
PUBLISHERS
NEW YORK

Black Dog & Leventhal Publishers
Hachette Book Group
1290 Avenue of the Americas, New York, NY 10104
www.blackdogandleventhal.com
 BlackDogandLeventhal @BDLev

First Edition: October 2024

Published by Black Dog & Leventhal Publishers, an imprint of Hachette Book Group, Inc. The Black Dog & Leventhal Publishers name and logo are trademarks of Hachette Book Group, Inc.

Black Dog & Leventhal books may be purchased in bulk for business, educational, or promotional use. For more information, please contact your local bookseller or the Hachette Book Group Special Markets Department at Special.Markets@hbgusa.com.

The publisher is not responsible for websites (or their content) that are not owned by the publisher.

Print book cover and interior design by Katie Benezra

Library of Congress Cataloging-in-Publication Data

Names: Silk, Tommy, author.
Title: Hidden landmarks of New York : a tour of the city's most overlooked buildings / Tommy Silk.
Description: First edition. | New York, NY : Black Dog and Leventhal Publishers, 2024. | Includes
 bibliographical references and index. |
Summary: "For the past 4 years, Tommy Silk has walked around New York City photographing
 hundreds of landmarked buildings, many hiding in plain sight, and uncovering their history for his
 Landmarks of New York Instagram account. In his first book, he selects dozens of underappreciated
 landmarks and tells their stories in this unique hidden history of New York City" —Provided by
 publisher.
Identifiers: LCCN 2023042592 (print) | LCCN 2023042593 (ebook) | ISBN 9780762486762
 (hardcover) | ISBN 9780762486779 (ebook)
Subjects: LCSH: Historic buildings—New York (State)—New York—Guidebooks. | New York
 (N.Y.)—Buildings, structures, etc.—Guidebooks.
Classification: LCC F128.7 .S55 2024 (print) | LCC F128.7 (ebook) | DDC 917.47/104—dc23/
 eng/20240117
LC record available at https://lccn.loc.gov/2023042592
LC ebook record available at https://lccn.loc.gov/2023042593

ISBNs: 978-0-7624-8676-2 (hardcover); 978-0-7624-8677-9 (e-book)

Printed in China

APS

10 9 8 7 6 5 4 3 2 1

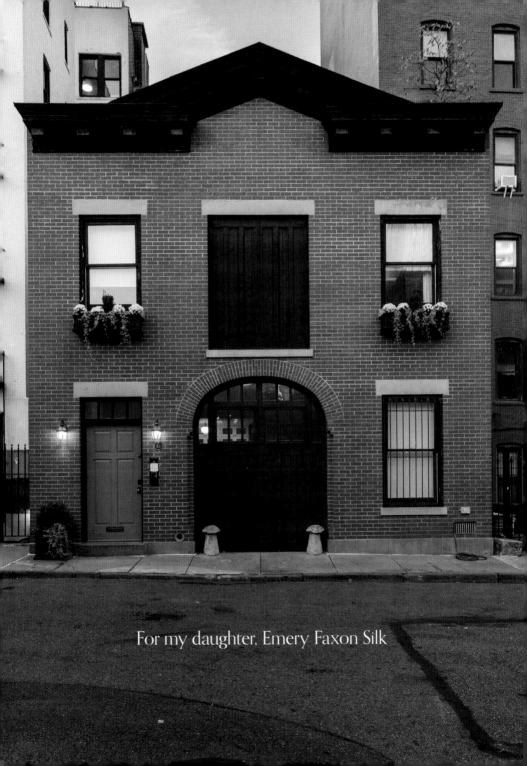

For my daughter, Emery Faxon Silk

CONTENTS

‹ Albemarle-Kenmore Terraces, Flatbush, Brooklyn

INTRODUCTION

In the early spring of 2019, I was walking home to my apartment on the Upper East Side from my office in midtown Manhattan. I had made a point once the weather became warmer to walk home whenever I could, using a different route each time. This was partly due to my desire to see as much of New York City as possible, and also because I needed time to decompress from what was objectively the worst job I ever had. On this March night, I found myself on Sixty-Fifth Street, where I saw a stately old town house with a plaque on it. I must have walked past this building dozens of times. Something compelled me to stop and investigate this time. To my surprise I found that it was the first home that Franklin and Eleanor Roosevelt shared after they were married in 1905. As I continued walking home, I thought about how much history I must be passing by on a daily basis without knowing it. I figured there had to be a place where I could find a list of all of these buildings. Luckily for me, the Landmarks Preservation Commission had created a virtual map of all of the landmarks throughout the five boroughs of New York. There are more than thirty-seven thousand of them.

I've always been interested in history. My grandfather, a native of Washington Heights, was a history teacher and historian, and when I was a child, we talked about history every time we saw each other. He had a particular affinity for local history and loved discovering more about the everyday people who made a place the way it was. At Fordham University, I followed in his footsteps and majored in history, just in time for the financial crisis. Which is exactly how I ended up with a career in financial software. Seven years after graduating, I still couldn't shake the itch of history.

I grew up in Fairfield, Connecticut, an old New England town complete with a common green and white clapboard town hall across from a Congregational church. Despite being founded in 1639, modern Fairfield has very few buildings from before the American Revolution on account of its having been burned down during the conflict. I was always jealous of the neighboring towns that had their old saltbox houses preserved. Like many people, when I moved to New York, I never really thought too much about its history. Boston and Philadelphia were the historical centers of the Northeast, while New York was the financial and cultural. I was shocked to find out that New York City was actually older than both of them. After reading Russell Shorto's amazing book *The Island at the Center of the World*, I realized how much history I was missing out on. Like Fairfield, New York was teeming with a rich story, if you knew where to look.

I took the New York City sightseeing guide exam in 2018 on a whim. (Yes, you need to be

‹ Brownstones on 2nd Street, Park Slope, Brooklyn

IX

licensed to give tours here.) I wasn't even sure if I wanted to be a tour guide; I just wanted to see if I could do it. Being the procrastinator I am, I didn't end up giving any tours. I kept telling myself I would create one tomorrow. But then a couple of things transpired that encouraged me to begin profiling the buildings around New York. The first major catalyst was a dinner with my wife's cousin, who lived outside of Washington, DC, at the time. After a few pints of Guinness, Matt said to me, "New York has no history. You want to see history? Come down to Washington." That set me off. "No history, are you kidding me? Washington, DC, wasn't even a gleam in the eyes of the founders by the time New York was over a hundred and fifty years old!" I responded. I decided that, somehow, I would show him how much better New York was than DC. The second catalyst was the aforementioned terrible job. It was a hostile work environment, the kind of place where the stress from the office would follow you home. I am a terrible compartmentalizer, and I couldn't figure out a way to block out that work stress. On St. Patrick's Day, I decided to do something about it.

I am not a professional historian, nor did I know anything about photography. But I decided to see what I could do. Armed with the map I had found from the Landmarks Preservation Commission and my sister's DSLR camera that I had watched multiple YouTube videos about, I decided to try to document as many of these landmarks as I could. If I was curious about the stories behind the buildings, then surely some other people would be too. I logged on to Instagram and found that the handle @LandmarksofNY wasn't taken, and grabbed it as fast as I could. I decided then and there I was going to try to post the story of one building, every day, as long as I could. Little did I know that there was a massive appetite for these stories.

Buildings are designated as landmarks in New York City by the Landmarks Preservation Commission (LPC), a government entity that was formed in the 1960s to preserve buildings in the city. This was in response to the rapid destruction of older buildings at the time, including the original Pennsylvania Station. Being landmarked by the city prevents a building from being torn down, or dramatically changed. The earliest buildings that were landmarked are what I like to refer to as Upper-Case Landmarks. They are the ones that you would be familiar with: the Empire State Building, Grand Central Terminal, and the New York Public Library main branch. But many more are relatively unknown. For example, did you know that the street system of Lower Manhattan is a landmark? Those streets have been there since the colony of New Amsterdam and have remained virtually unchanged in almost four hundred years.

This book seeks to go into more detail about the "hidden" landmarks of New York. *Hidden* is obviously a subjective term, and long-time residents of this city might see a building in here and say, "Hidden? Are you kidding me?" To them, I respond that this is my best attempt

at reducing the city to about 120 buildings that may be more off the beaten path, or have a more influential history than you might think. Buildings that can range from hidden to a tourist or to a local. I tried to choose a selection of buildings that present a cross section of a neighborhood's history.

Exploring the history of New York through its landmarked buildings does present some challenges, though. First and foremost, the buildings that are still here were likely built by white men. The original commissioners in charge of landmarking buildings were, you guessed it, mostly white men. I have sought to find landmarks throughout the five boroughs that tell a diverse story, but that story is probably going to be a bit more vanilla than the true history of New York. It also limits the stories as you go further back in time. Unfortunately, despite the length of human habitation of this area, the further you go back, the fewer buildings there are. The other downside with using buildings to tell these stories is that it doesn't tell the story of the people here before the Europeans. What became the city of New York has been inhabited for thousands of years by Indigenous peoples. It took until 2021 for the first Indigenous landmark to be built (see page 243).

This book draws from a variety of sources, but much of the history of the buildings can be found in the designation reports created by the researchers and writers at the Landmarks Preservation Commission. I would encourage you to bring the book with you as you wander around this city. You never know when you might be close to one of a dozen buildings in Manhattan from before the year 1800, or how close you might be to the home of the man who helped perfect the lightbulb. You might even find yourself in a clothing store with an eight-foot-tall well in the basement that is probably haunted. That said, if you'd like for this to look pretty on your coffee table, that's totally fine with me.

MANHATTAN

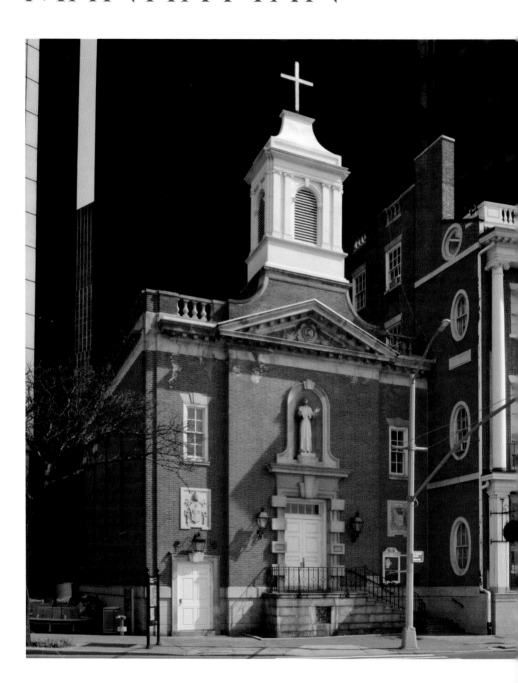

James Watson House

BUILT: 1793, 1806
LANDMARKED: 1965
7 STATE STREET
FINANCIAL DISTRICT

I t's hard to imagine, but most of Lower Manhattan at the turn of the eighteenth century looked like the James Watson House on State Street. Built in two sections, the center building in 1793 and the far right in 1806, it was turned into a shrine to the first American-born saint, Elizabeth Ann Seton, who lived here between 1801 and 1803. The church attached to the house wasn't actually built until 1965. The design of the original 1793 home is attributed to John McComb Jr., the co-architect of New York City Hall. When the east and west Buildings were unified, the columns were said to be taken from the masts of retired sailing ships. The shrine is currently holding its own, wedged between the massive skyscrapers of the Financial District. It was landmarked on November 23, 1965.

Fraunces Tavern

BUILT: 1719
LANDMARKED: 1965
54 PEARL STREET
FINANCIAL DISTRICT

Fraunces Tavern is both a functioning bar and restaurant and a museum dedicated to early America. The lot was landfill that was purchased by the Van Cortlandt family, specifically the patriarch, Stephanus Van Cortlandt. Stephanus gifted the property to his son-in-law, Stephen "Etienne" Delancey, of Delancey Street fame. Delancey built this house in 1719. It was purchased by Samuel Fraunces in late 1762 and converted into the Queens Head Tavern. Fraunces was a staunch revolutionary and a rumored American spy during the war for independence. The tavern is one of the most important historical buildings in New York and is the location where George Washington said farewell to his troops after the British evacuation of the city in 1783. After disbanding his army, he rode off into the sunset to enjoy his retirement before being shortly called back to be president. Like many older buildings in New York, the tavern was neglected and was at risk of being torn down in the early 1900s.

Fraunces Tavern would be the oldest building in Manhattan; however, that title comes with a lot of asterisks. The Daughters of the American Revolution purchased the building in 1900 and sold it to Sons of the Revolution in the State of New York, who hired architect William H. Mersereau to renovate it in 1907. The problem is we don't know what the original building looked like, and this is mostly a best-guess re-creation by Mersereau. There are some original parts of the building, for example the bricks between windows horizontally are mostly original, but those vertically between stories are from the restoration in the twentieth century. At a certain point, you have to ask yourself when a building is still the same building. However, its place in American history is firmly cemented. It was landmarked on November 23, 1965.

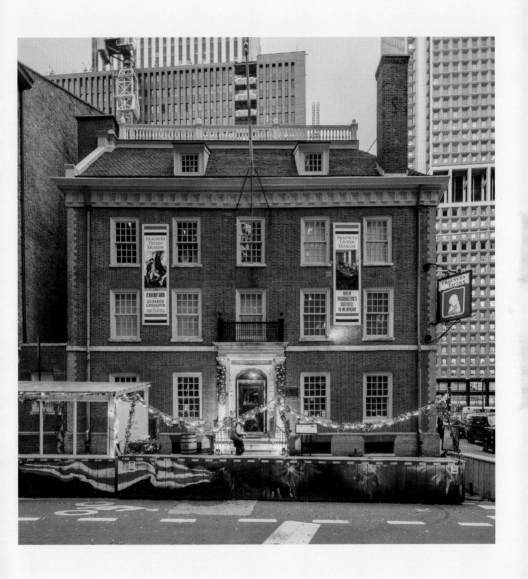

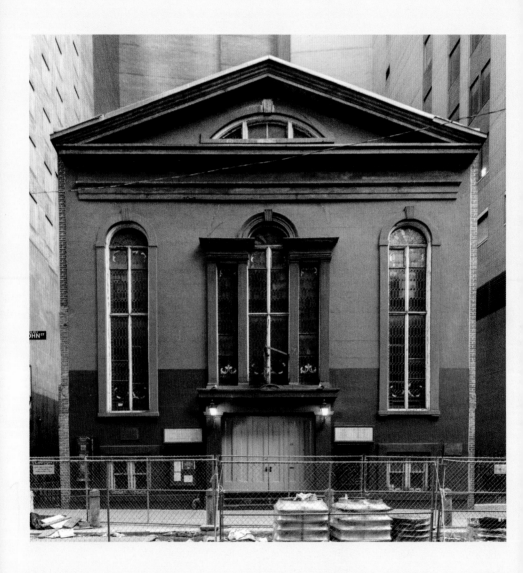

John Street Methodist Church

BUILT: 1841
LANDMARKED: 1965
44 JOHN STREET
FINANCIAL DISTRICT

The John Street Methodist Church is the oldest Methodist congregation in the United States. While it was founded in 1766, the current building on this site is actually the third iteration of the church and was built in 1841. The church has a long and interesting history. The original Communion rail is located in the basement, as is a clock given to the church by John Wesley, the founder of Methodism. During the revolution, the Continental Army used the sanctuary as a field hospital.

But perhaps more interesting is that this church led to the creation of one of New York City's first Black churches. While Methodist leadership was vocally antislavery, some congregants were still asking themselves whether they could be good Christians while still owning other human beings. There is only one right answer to that, but a few people still needed time to think about it. This would come to a slight head during the revolution, when one of its congregants, James Aymar, decided to move back to England and was ready to put a man he enslaved, Peter Williams, on the auction block. Williams was a sexton at the church even while he was enslaved, and was a devout Christian. Rather than seeing a member of the congregation auctioned off, the church paid the sum of forty pounds for him, which he paid back, gaining his freedom.

Williams would partner with some other Black parishioners and future bishop James Varick to help form the Mother Zion Church, which would eventually join the African Methodist Episcopal Church, based in Philadelphia. Originally just designed to be a chapel where Black congregants didn't have to deal with the discrimination of sitting in the back of the church and waiting for white congregants to get Communion before them, it would eventually break off in 1801. Ironically, Williams would remain with the John Street Methodist Church while assisting the separation. Both the John Street church and Mother Zion AME Church still exist today. John Street Methodist Church was landmarked on December 21, 1965.

The African Burial Ground

CREATED: LATE SEVENTEENTH CENTURY
REDISCOVERED: 1989
MEMORIAL BUILT: 2007
LANDMARKED: 1993
290 BROADWAY
FINANCIAL DISTRICT

At the corner of Duane and Elk Streets sits one of New York's more hidden landmarks. This is the African Burial Ground, a National Historic Landmark that marks the site of a six-acre burial ground used by New York's earliest freed and enslaved Africans. The practice of enslavement has a long history in New York. The first enslaved Africans were brought to the colony of New Amsterdam in 1626, less than two years after the first European settlement was established in Manhattan. Enslaved Africans were used to build houses and other civic buildings in the colony. They also helped build the wall that gave Wall Street its name. Under Dutch colonial rule, enslaved Africans had more opportunities to be emancipated than under the British, but were forced to live separately from white colonists. Many of them lived north of what was known as the Commons, the current site of City Hall.

The burial ground was established as a way for New York's African population to practice their funeral traditions with some degree of privacy. Churches forbade the burial of free or enslaved Africans in their churchyards, which forced them to establish this site north of the city. The burial ground was likely formed after the English takeover in 1664, as there is not much evidence that it was used during the Dutch period. The site remained an active burial ground until the end of the eighteenth century, when land was taken to build

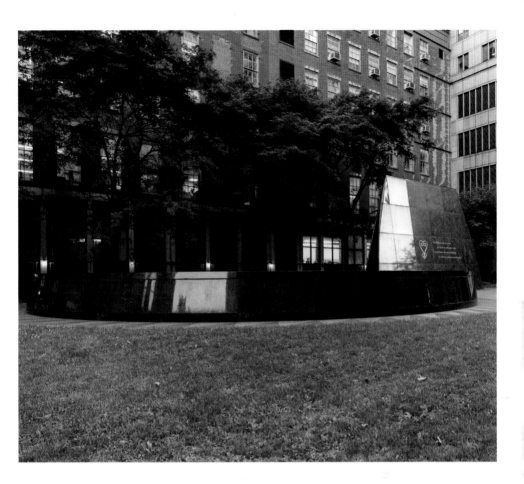

out Chambers Street, with rapid development building over the rest of the burial ground in the subsequent decades.

In 1989, archaeologists discovered human remains when doing an investigation prior to the excavation of 290 Broadway, a federal office building. It took a lot of civic engagement to stop construction and memorialize the site. In all, 419 fully intact remains were removed from the site and brought to Howard University to undergo research and genetic testing. Those remains were then reinterred at the .35-acre site in their own hand-carved coffins. Despite that, there are still an estimated fifteen thousand bodies underneath the original six acres. A memorial called the Ancestral Chamber was completed in 2007. The African Burial Ground was landmarked as part of the African Burial Ground and the Commons Historic District on February 25, 1993.

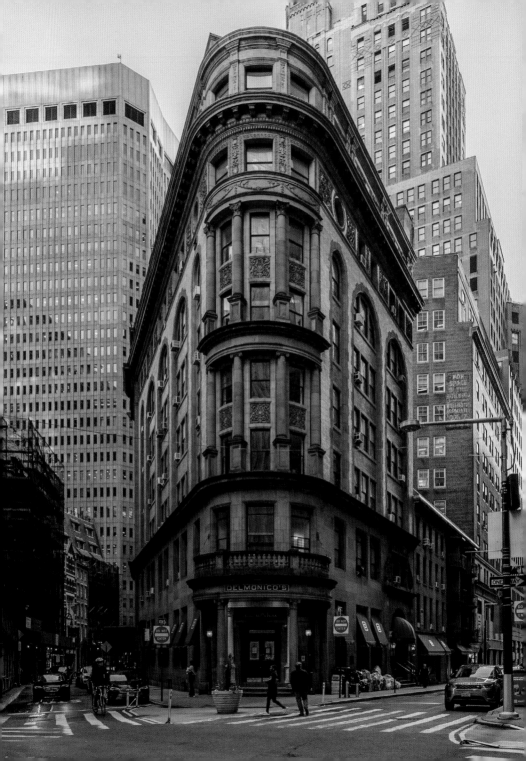

Delmonico's Building

BUILT: 1891
LANDMARKED: 1996
56 BEAVER STREET
FINANCIAL DISTRICT

If you were to enter a tavern in New York during the eighteenth century, your dining experience would consist of whatever was on the fire that night as you sat crammed in with all of the other guests at communal dining tables. That would change in 1827, when Italian Swiss immigrant brothers Giovanni and Pietro Delmonico opened their café, Delmonico's, on William Street. This would be New York's first foray into the world of fine dining. In 1835, their William Street establishment burned down, and the brothers opened up a new restaurant at this site. The current building dates to 1891 and was their Lower Manhattan headquarters. The white columns along the entrance were moved from the old 1835 building (which allegedly were brought by Giovanni Delmonico from Pompeii). Delmonico's pioneered things we take for granted, like being able to order à la carte rather than being served a full multicourse meal, as well as eating at your own separate table, covered with a white dining cloth. The restaurant has also been credited with the invention of lobster Newburg and baked Alaska, and has some claims to the creation of eggs Benedict, but that is disputed. The Delmonico family continued to own and operate the restaurant chain until 1923, when it became a victim of Prohibition. The dining area was converted into office space until it was reopened by proprietor Oscar Tucci in 1935. The restaurant closed again in the 2020 COVID pandemic and reopened in 2023. It was landmarked on February 13, 1996.

Captain Joseph Rose House

BUILT: CIRCA 1773-1781
LANDMARKED: 1977
273 WATER STREET
SOUTH STREET SEAPORT

Hidden away at 273 Water Street beneath the shadow of the Brooklyn Bridge sits the former home of Captain Joseph Rose. This neat little three-story home was built at some point between 1773 and 1781, making it potentially the third oldest building in all of Manhattan following St. Paul's Chapel and the Morris-Jumel Mansion. Captain Rose gained his wealth through the Honduran mahogany trade, as one does, and rented this home out to other sailors and merchants in what was then a very active seaport. Following the captain's ownership, the house was used for some more-nefarious activities, including betting on sports such as rat baiting, a barbaric and illegal practice in which people bet on how many rats a dog could kill while in a pen. It suffered two fires in the twentieth century and was extensively restored in 1998. It was landmarked as part of the South Street Seaport Historic District on May 10, 1977.

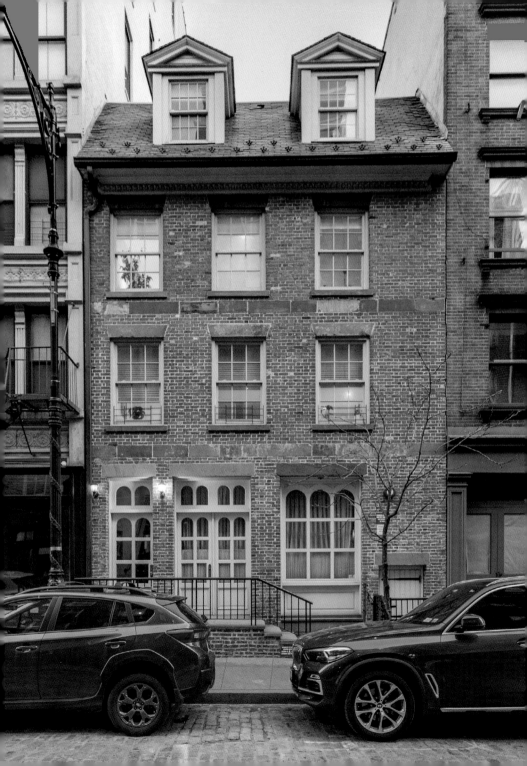

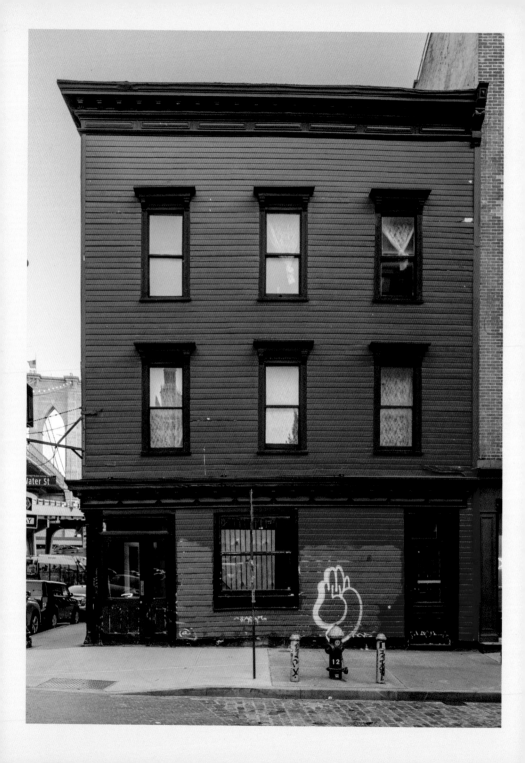

Bridge Cafe

BUILT: 1794
LANDMARKED: 1989
279 WATER STREET
SOUTH STREET SEAPORT

Water Street has some of the oldest buildings in Manhattan. In addition to the Captain Joseph Rose House, it is also home to 279 Water Street, better known as the former Bridge Cafe. The exact date of construction is a little unclear, with some estimates dating back to 1794 for a grocer. It has served at times as a brothel and gambling den. There are also rumors that there was a jar full of pickled ears from brawling patrons, back when it was known as the Hole in the Wall. Until Hurricane Sandy hit in 2012, it was the home of the Bridge Cafe. The basement was completely flooded, and there was over five feet of water in the first floor. As of now it remains closed. It is the only wooden building in the South Street Seaport Historic District and was landmarked on July 11, 1989.

The Tin Building

BUILT: 1907 (REBUILT: 2016)
LANDMARKED: 1977
96 SOUTH STREET
SOUTH STREET SEAPORT

Since 1835, there have been four buildings in the Seaport that housed the Fulton Fish Market, including the Tin Building, which was constructed in 1907. It was occupied by the Fulton Fishmongers Association and served as the one of the largest wholesale fish markets in the world. However, in 1995, the building would suffer from a massive fire, completely gutting it. Although it was rebuilt, the Fulton Fish Market would move to Hunts Point in the Bronx in 2005. Not much remained of the original building after that fire, and it was severely flooded due to Hurricane Sandy. In 2016, the Landmarks Preservation Commission gave permission for the building to be deconstructed and rebuilt farther east on the pier, raising it above the hundred-year floodplain and allowing it to be rehabilitated and turned into a food hall by chef Jean-Georges Vongerichten. Not much remains of the original building except for some roof trusses, but it was re-created with a high level of accuracy. Not all preservationists were pleased, however, arguing that the building was designed to be flooded and it was unnecessary to move it. It was landmarked as part of the South Street Seaport Historic District on May 10, 1977.

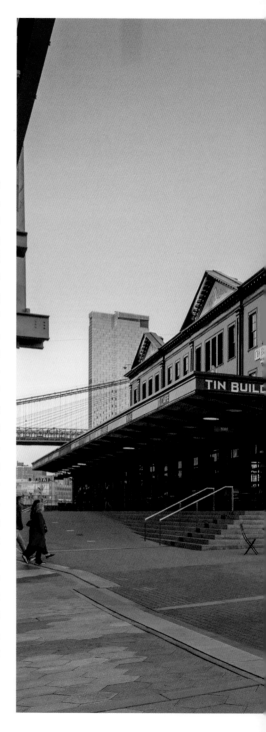

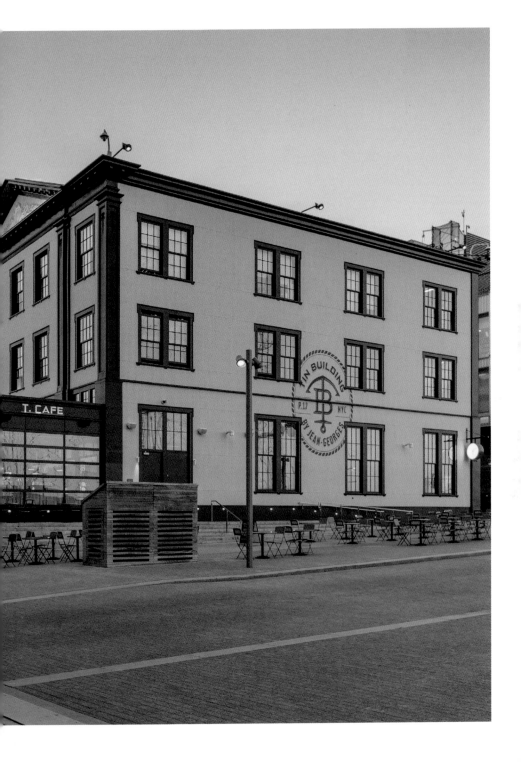

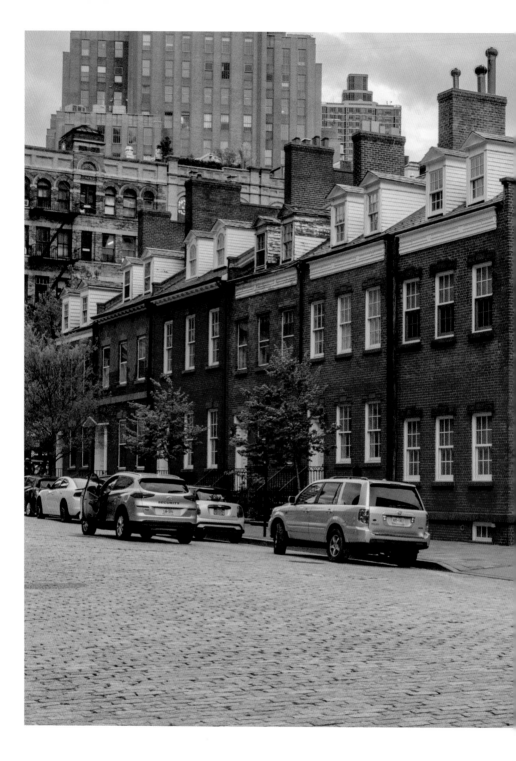

Harrison Street Houses

BUILT: 1796–1828
LANDMARKED: 1969
25–33 HARRISON STREET
TRIBECA

Tribeca is full of old converted warehouses and lofts as well as gleaming new apartment buildings. What you might not know is that it also houses a few of the oldest buildings left in Lower Manhattan. Harrison Street has a collection of eighteenth- and nineteenth-century homes, with the oldest dating back to 1796. These buildings were constructed on the site of an old Dutch farm, or bowery, which was eventually given to Trinity Church after the English takeover of the city in 1664.

Both 27 and 27a Harrison were designed by John McComb, who was also the co-architect of City Hall and one of the first native-born architects from New York. These are not the original addresses of the buildings, however. Of this collection of nine buildings, six were moved from Washington Street during redevelopment in the area in the late 1960s. The nine town houses were landmarked on May 13, 1969.

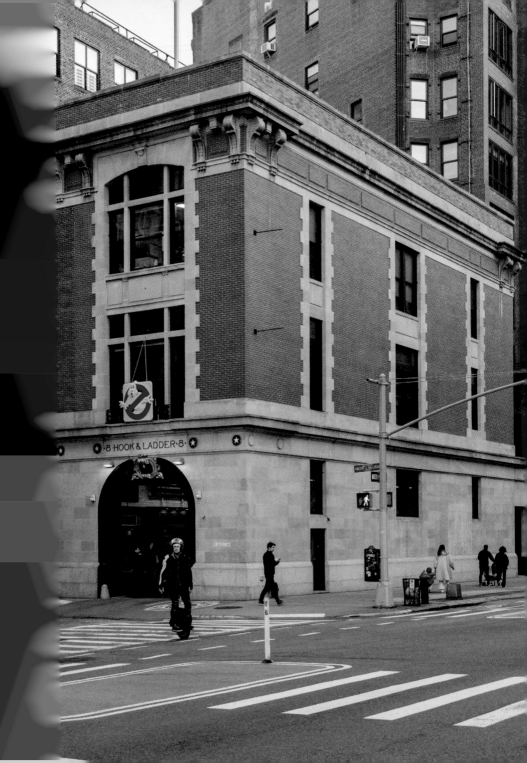

Hook and Ladder Company No. 8 (Ghostbusters Firehouse)

BUILT: 1903
LANDMARKED: 1991
14 NORTH MOORE STREET
TRIBECA

Whether you're a resident of Tribeca or of a fictional paranormal-infested Upper West Side apartment building, you'd end up calling the same place for an emergency, the Hook and Ladder Company No. 8 firehouse at the intersection of Varick and North Moore Streets. Made famous by the movie *Ghostbusters*, the firehouse was built in 1903 and was twice as large as it is today. Varick Street was widened in 1918 to help facilitate the expansion of the relatively new subway system. As a result, half of the fifty-foot-wide firehouse was destroyed to make room, with the rest of the building moved to the eastern part of the property. It remains an active firehouse to this day, and even adopted the Ghostbusters logo as its own. It was landmarked as part of the Tribeca West Historic District on May 7, 1991.

New York Mercantile Exchange

BUILT: 1885
LANDMARKED: 1991
2 HARRISON STREET
TRIBECA

Before Tribeca was trendy, it was heavily industrial. The warehouses that now make multimillion-dollar apartments were actually used as, well, warehouses. The area was full of different types of commodity storage, brought in by ferry and trains that would roll down Eleventh Avenue. A group of these merchants joined in the late 1800s to establish standards and formalize business practices. This would form the most un-Tribeca business ever, called the Butter and Cheese Exchange. Eventually it would broaden its horizons to other foodstuffs and form the New York Mercantile Exchange (NYMEX). In 1885, the board of the exchange commissioned architect Thomas Jackson to build its new headquarters at the intersection of Harrison and Hudson Streets. The large ground-floor windows that now give excellent light for local diners once served as doors to store the actual goods on the exchange. In 1977, the NYMEX would move to the World Trade Center. This building would go on to become condos and restaurant space. It was landmarked as part of the Tribeca West Historic District on May 7, 1991.

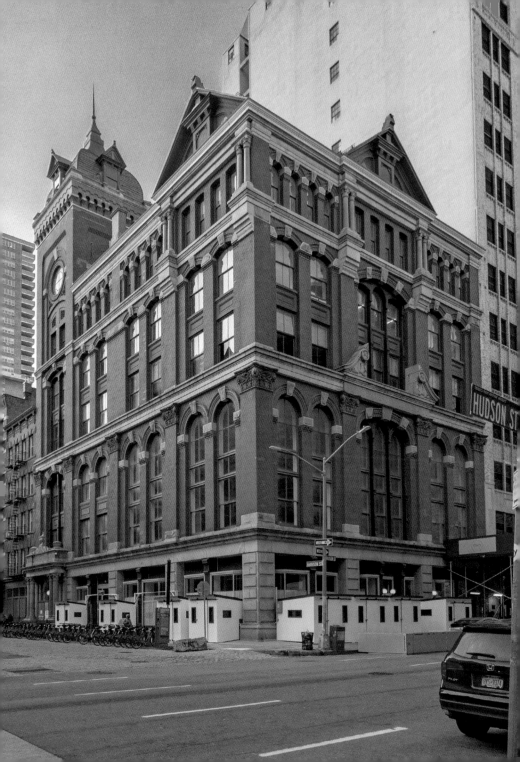

White Street House

BUILT: 1809
LANDMARKED: 1966
2 WHITE STREET
TRIBECA

In 1809, when this house was built, most of Tribeca that wasn't farmland would have looked similar. Although this type of housing was common in the nineteenth century, 2 White Street is one of the only remaining houses made of brick and wood that are still standing in the neighborhood. It was built for Gideon Tucker, an alderman and education commissioner. This would have likely been a part of a row of similar-looking houses, many of them built speculatively as the city continued its growth to the north. The ground floor was designed for retail in the original plans and has been home recently to a travel agency, bar, J.Crew and, as of this writing, a Todd Snyder store.

From 1842 to 1847, this house played a different role, as a stop on the Underground Railroad. It was home to Theodore Sedgwick Wright, the pastor of the First Colored Presbyterian Church and a staunch abolitionist. Wright was the first Black graduate of the Princeton Theological Seminary, which also made him one of the first Black college graduates in the United States. He was an active member and on the first executive committee of the New York Committee of Vigilance, which helped people fleeing enslavement in the South reach Canada. This home was a stopping point for some of the thousands of people whom Wright and the committee helped escape bondage. Wright died in 1847. The house was landmarked on July 19, 1966.

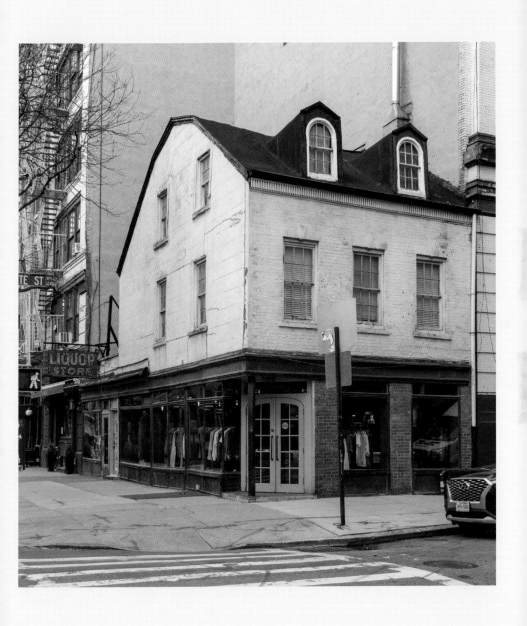

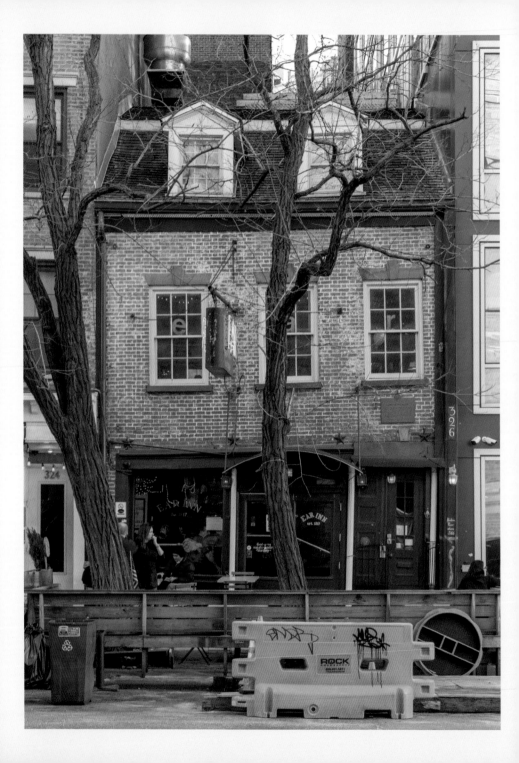

Ear Inn

BUILT: 1817
LANDMARKED: 1969
326 SPRING STREET
SOHO

The Ear Inn on Spring Street between Washington and Greenwich Streets has a fascinating yet somewhat muddled history, as most buildings from this era do. The house was built in 1817 for a free Black man named James Brown. Brown made his fortune in the tobacco trade, which led him to build his townhome feet from the Hudson River. The assessed value of his home when it was built was $2,000, a seeming bargain for us but an absolute fortune at the time. Many homes in the area would have looked like this at the turn of the nineteenth century. There are conflicting histories about Brown. Some sources say that he was an aide for George Washington during the revolution and was possibly even depicted in the Emanuel Leutze painting of the general crossing the Delaware.

You may want to know how this became a bar. After Brown sold the property, a man named Thomas Cooke turned it into a business selling home-brewed beers to the nearby dockworkers. It eventually became a local pub, even operating as a speakeasy during Prohibition. In the 1970s, the current owners bought the bar and named it the Ear Inn as a way to avoid dealing with the Landmarks Preservation Committee rules on altering the exterior of the building. The owners did this by not lighting up the curved section of the *B* on the neon BAR sign out front. If you visit now, you'll realize just how much the city has expanded into the river from the days when the inn was a dockside home. It was landmarked on November 19, 1969.

Gay Activists Alliance Firehouse

BUILT: 1850s
RENOVATED: 1888
LANDMARKED: 2019
99 WOOSTER STREET
SOHO

This rather unassuming building at 99 Wooster Street in SoHo is actually a former firehouse, if you can believe it. The building was constructed in the 1850s and modified in the 1880s by the New York Fire Department's chief designer, Napoleon LeBrun & Son. In the 1970s, after the fire department left, it became the meeting place for the Gay Activists Alliance (GAA), whose mission was "to secure basic human rights, dignity, and freedom for all gay people."

The firehouse served as the organization's headquarters from 1971 to 1979 and was considered one of the first gay community centers in the city. The organization lobbied for civil rights legislation to protect members of the LGBTQ community. The work the GAA did was so important and instrumental in the city that the building was landmarked twice. The first was as part of the SoHo–Cast Iron Historic District, and the second, on June 18, 2019, was to specifically recognize the impact it had on the LGBTQ population of New York.

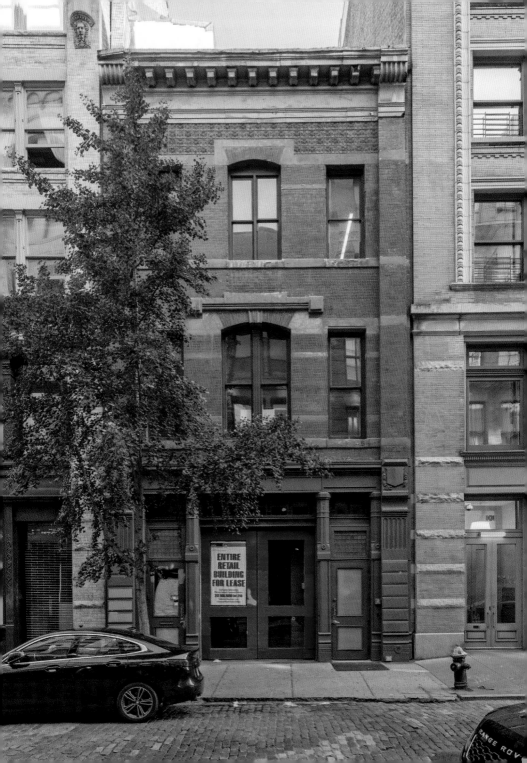

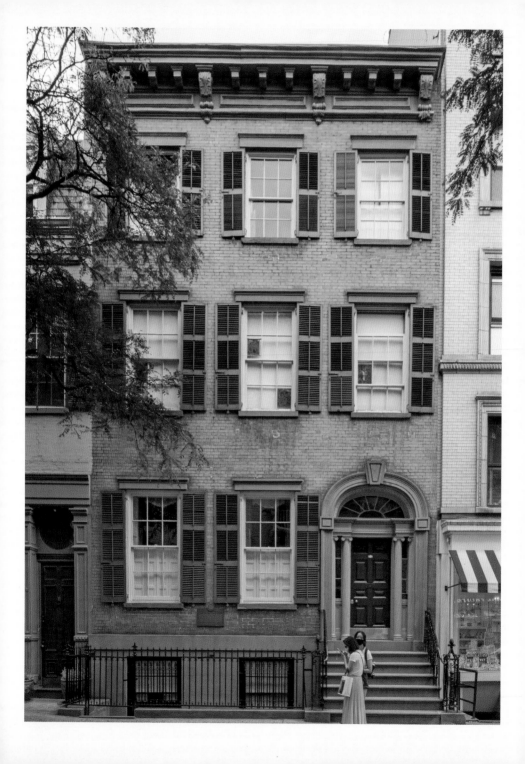

203 Prince Street

BUILT: 1834
LANDMARKED: 1974
203 PRINCE STREET
SOHO

If you want to find one of the best-preserved homes from the 1830s, head on over to 203 Prince Street. This house was built on the former estate of Aaron Burr by a gentleman named John Haff. Haff was a leather inspector who bought three plots of land in the area and developed all of them, including this one. Originally it was only two stories, with a peaked roof. The third story was added in 1888, matching the original design as closely as possible. The ornate doorway was used as a status symbol by the original owner. While exploring SoHo or the Village, one can get a sense of the wealth of the occupant based on how elaborate their entry was. Over this building's lifetime it served as a home, a mission house for the Church of Saint Ambrose, and, eventually, a funeral parlor. It was restored to a home and was considered an "almost perfect restoration" by the American Institute of Architects. It was landmarked on February 19, 1974.

E. V. Haughwout Building

BUILT: 1857
LANDMARKED: 1965
488 BROADWAY
SOHO

When you think of SoHo, you might think of trendy shops and beautiful old buildings. What you might not expect to see is the predecessor to skyscrapers. The E. V. Haughwout Building was once a high-end department store founded in 1857. This relatively modest building doesn't stand out from its neighbors at the corner of Broadway and Broome Street; however, it was the first building in the city with a passenger elevator by Elisha Otis (yeah, that Otis). It also used a new construction technique that would later be employed for the city's skyscrapers, with metal instead of masonry to support its weight, allowing it to be built higher. Just to throw in some added historical significance, Mary Todd Lincoln shopped here for decorations for the White House in 1861. The E. V. Haughwout Building was landmarked November 23, 1965.

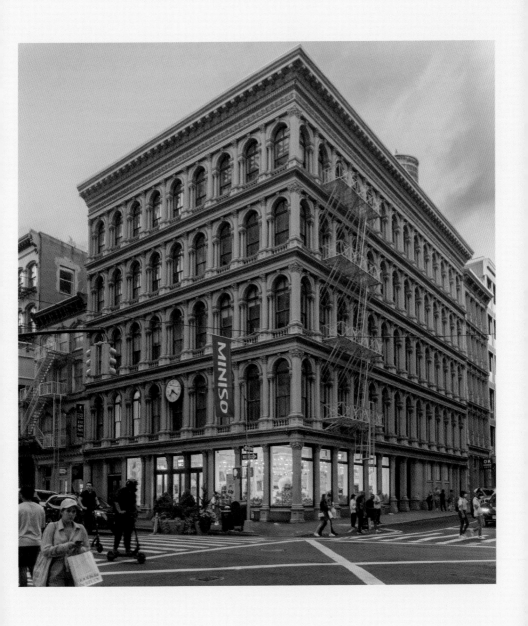

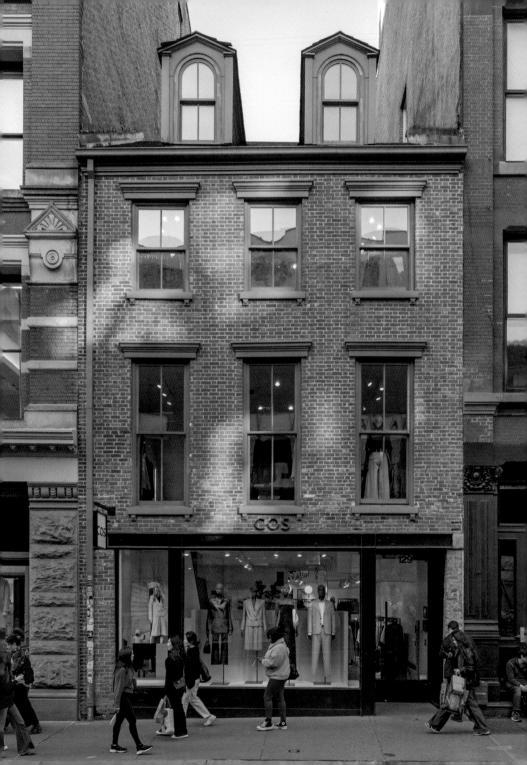

129 Spring Street

BUILT: 1817
LANDMARKED: 1973
129 SPRING STREET
SOHO

The building at 129 Spring Street stands out in SoHo by not standing out. This former town house wedged between two buildings near the corner of Greene Street is one of the older buildings in the neighborhood. It was constructed in 1817 for William Dawes in front of a well built by the Manhattan Company. This well tapped into the spring that gave the street its name. More famously, though, it was the sight of the murder of Gulielma Juliana Elmore "Elma" Sands, who was found strangled at the bottom of it on January 2, 1800, prompting the first recorded murder trial in the United States. Sands's fiancé, Levi Weeks, was accused of the murder, and Weeks's older brother Ezra was able to call in favors from Aaron Burr and Alexander Hamilton, who acted as the defense attorneys. Weeks was acquitted but was forced to leave the city because of public opinion.

The house was eventually expanded on top of the well and buried it. The well was rediscovered in the 1990s when a restaurant that occupied the building began expanding its wine cellar. There were multiple reports of wine bottles mysteriously being shattered and a few anecdotes of staff finding a drenched woman dressed in eighteenth-century clothing, although that seems to have settled down in recent years. There is some debate by archeologists whether this is the actual well. Some speculate that it could have been on Greene Street, as "wells from 1799 were typically made of stone, not brick." The house is now home to a clothing store, where you can still go investigate the well for yourself next to the discount menswear section. The building at 129 Spring Street was landmarked on August 14, 1973.

240 Centre Street

BUILT: 1909
LANDMARKED: 1978
240 CENTRE STREET
SOHO

I mentioned in the introduction that *hidden* can have a lot of meanings. If you live in Lower Manhattan, 240 Centre Street might be very familiar to you, but to first- or second-time visitors of our city, this might seem like something out of Paris, not New York. This is the New York City Police Department's former headquarters, which was constructed between 1905 and 1909 and designed by the firm of Hoppin and Koen. The year 1898 saw the creation of the modern New York City, which expanded from just Manhattan and parts of the Bronx to the modern five boroughs. As a result, the population of the city boomed, requiring a larger police force and headquarters. The design was very intentional, with architect Francis Hoppin stating that the building was meant to "impress both officer and prisoner . . . with the majesty of the law." The NYPD used this building until 1973 when it moved to its current location at 1 Police Plaza, closer to City Hall. In 1987 the building was converted into—you guessed it— luxury apartments. The former police headquarters building at 240 Centre Street was landmarked on September 26, 1978.

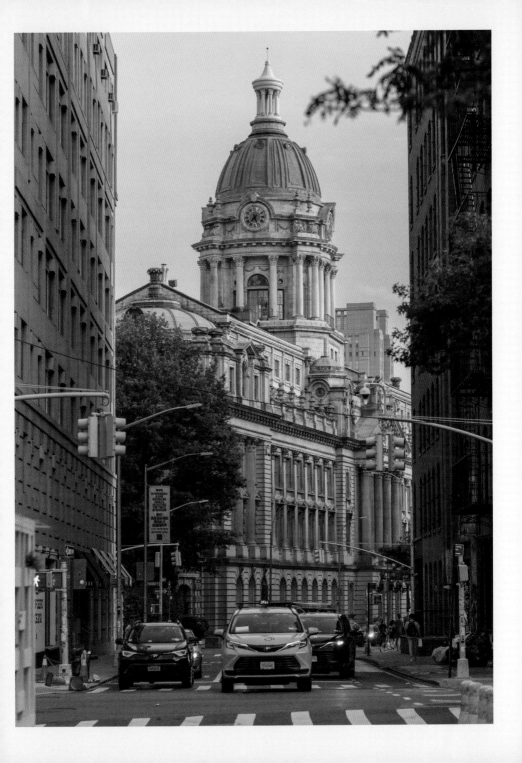

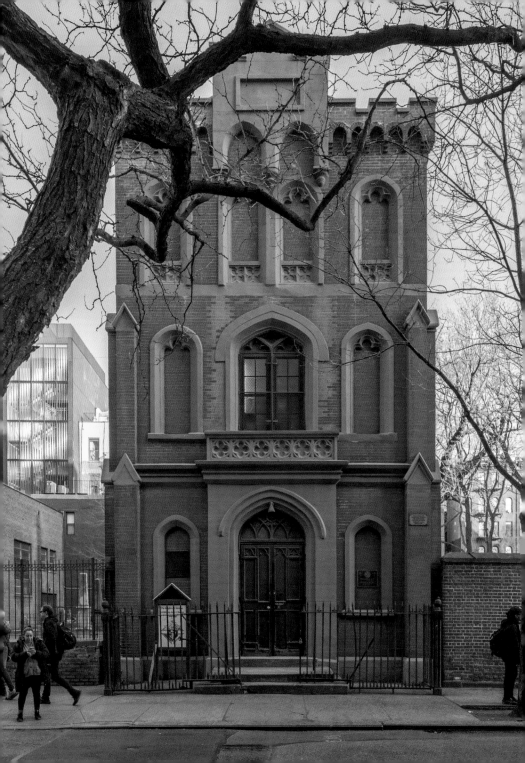

St. Michael's Chapel of Old St. Patrick's Cathedral

BUILT: 1859
LANDMARKED: 1966
266 MULBERRY STREET
SOHO

I had never heard the term Gingerbread Gothic before researching this building, but it suits it so well. This is the Old Chancery Building on the Mulberry Street side of the Basilica of St. Patrick's Old Cathedral complex. It was built in 1859 by renowned New York architect James Renwick Jr., who designed St. Patrick's (new) Cathedral on Fifth Avenue, Grace Church, and the Smithsonian Institution Building in Washington, DC. For over half of its life, the building served as St. Michael's, the only Russian Catholic church in New York. The parish moved into the Chancery Building in 1936 and served the increasingly large Russian community in the city. The congregation moved to the Upper East Side prior to 2020, and today the building is used as a meeting location for the Knights of Columbus. It was landmarked on June 21, 1966.

The Bowery Mission

BUILT: 1876
LANDMARKED: 2012
227 BOWERY
LOWER EAST SIDE

The building at 227 Bowery was constructed in 1876 for a casket maker named Jonas Stolts, but it would become the home of the Bowery Mission. The Bowery Mission is one of the oldest homeless aid organizations in the city and was founded in 1879 by Reverend Albert and Ellen Ruliffson with the support of Jerry and Maria McAuley. Its original headquarters was torn down to make space for the entrance to the Manhattan Bridge. The mission moved to its current home at 227 Bowery in 1909. At the time, the building had been home to the organization's chapel, which was dedicated with the help of President Taft. On the second story are stained glass windows that depict the prodigal son returning, built by Tiffany-trained craftsmen. While today the Bowery might be full of trendy shops and galleries, it had a rough reputation in the eighteenth and early nineteenth centuries. By the 1890s, some estimates put the number of homeless people on this street alone at nine thousand, making it an ideal location for the Bowery Mission. The site is still active today, providing food, shelter, and aid to those experiencing homelessness. The mission also runs a youth summer camp outside of the city. No. 227 Bowery was landmarked on June 12, 2012.

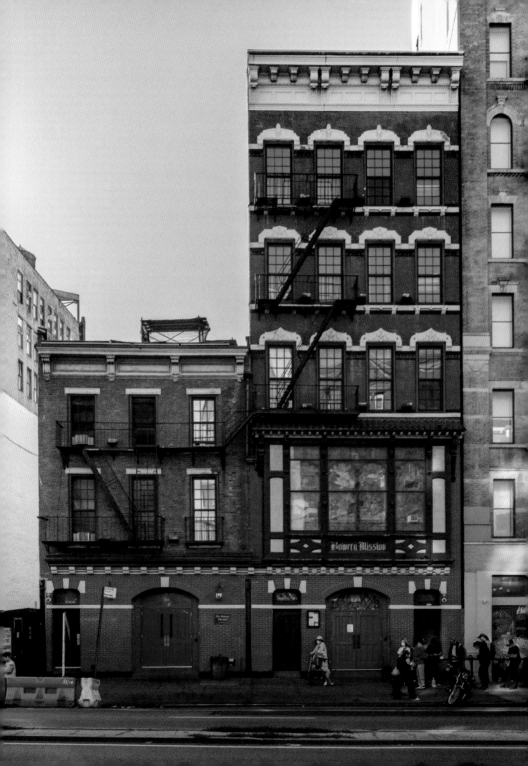

190 & 192 Grand Street

BUILT: CIRCA 1833
LANDMARKED: 2010
190–192 GRAND STREET
LITTLE ITALY

The homes at 190 and 192 Grand Street are some of the few remaining nearly unaltered Federal-style houses in Manhattan. These homes were built in 1833 by Stephen Van Rensselaer, the founder of Rensselaer Polytechnic Institute, and a member of one of the most prominent families in New York. Van Rensselaer built these homes as investment properties back when Grand Street was the domain of New York's upper classes. Not only did he own these houses, but Van Rensselaer was one of New York's largest landlords, with an emphasis on the "lord." The Van Rensselaer family had a massive estate surrounding Albany. It was founded as a patroonship by Kiliaen Van Rensselaer. This was a literal feudal estate, with tenant farmers who could only lease the land, not own it. This manor, as it was called under the English, would last until the death of Stephen, who was known as the last patroon, in 1839. After his death, the tenant farmers revolted and refused to pay rent, eventually leading to the collapse of the estate. Both 190 and 192 Grand Street were landmarked on November 16, 2010.

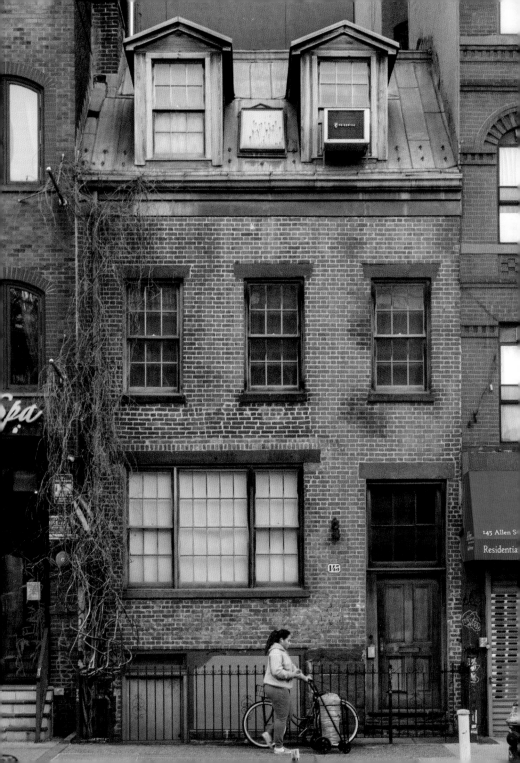

143 Allen Street

BUILT: 1831
LANDMARKED: 2010
143 ALLEN STREET
LOWER EAST SIDE

It's so common for buildings in New York to be torn down for larger ones, it's just in the DNA of a city that keeps reinventing itself. The Lower East Side is a neighborhood that has seen some of the most dramatic change over its history, which makes it all the more remarkable that this house still exists. No. 143 Allen Street was built in 1831 by Captain George Sutton, as part of a six-house speculative development. Sutton made his fortune by captaining a packet ship that made regular trips between New York City and Charleston. This was part of the larger trade between the two cities that linked them so closely that Mayor Fernando Wood suggested seceding from the Union during the Civil War to preserve those ties. It is unclear whether Sutton ever enslaved anyone in his lifetime, but by trading with Charleston, he definitely profited from the use of enslaved labor. Sutton also made money by renting this house out to other men who were in the maritime industry. This area of the city saw rapid change with the influx of immigrants, leading to the neighboring buildings to be torn down to make room for larger tenements. It sold most recently in 1999 and was landmarked on February 9, 2010.

Kehila Kadosha Janina Synagogue

BUILT: 1926–1927
LANDMARKED: 2004
280 BROOME STREET
LOWER EAST SIDE

Did you know this is the only synagogue of its kind in the Western Hemisphere? The Kehila Kadosha Janina Synagogue was founded in 1906 by a group of Romaniote Jews hailing from Greece. The Romaniote tradition differs from the Ashkenazic or Sephardic, and still has an active congregation. The building at 280 Broome Street was constructed in 1926 on a twenty-four-foot-wide lot, and named after Ioannina (sometimes written as Janina), the town in Greece where most of the first congregants originated from. A large wave of Romaniote immigrants arrived at the beginning of the twentieth century, and by the end of the Second World War they had set up other synagogues in other parts of the city. However, with the spread of the population, those other congregations contracted, leaving this as the only one left. It was designed by architect Sydney Daub and was landmarked on May 11, 2004.

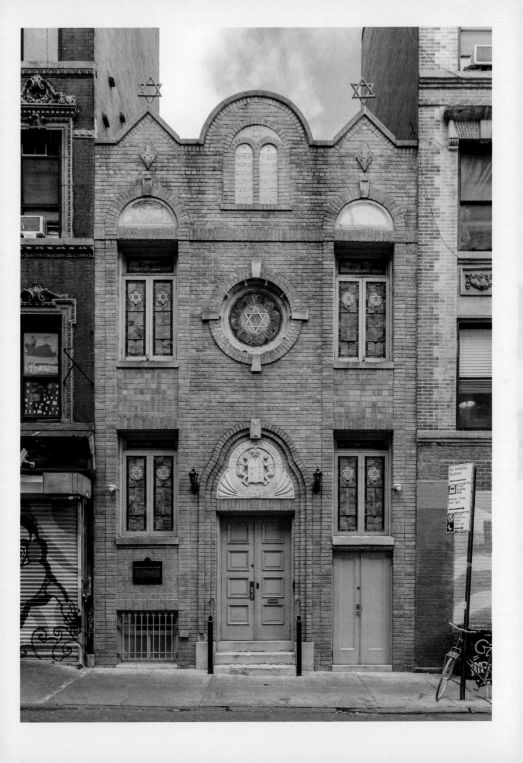

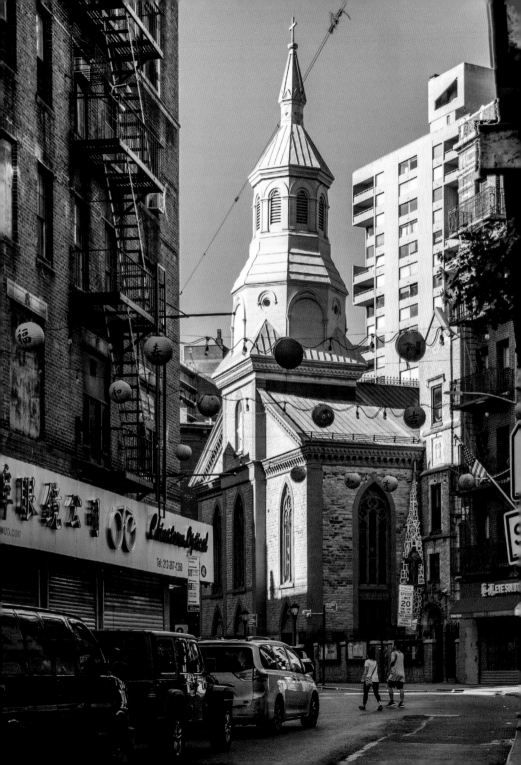

Church of the Transfiguration

BUILT: 1801
LANDMARKED: 1966
25 MOTT STREET
CHINATOWN

New York is constantly in a state of flux, and nothing illustrates that constant ebb and flow more than the very adequately named Church of the Transfiguration. The church building was completed in 1801 for a German-speaking Lutheran congregation. After a few years, the congregation decided they had enough with being Lutherans and converted en masse to Episcopalianism. The church wasn't done, though. It was sold to the Catholic Church in the mid-nineteenth century due to demographic changes and then primarily ministered to Irish and Italian immigrants. As this area of the Lower East Side saw another shift in demographics with the arrival of Chinese immigrants, the church adapted yet again, with Mass being said in Mandarin, Cantonese, and English, with the school serving a large Buddhist population. There are only a handful of buildings that still exist within the city that show this kind of remarkable change over time while still maintaining its original building. It was landmarked on February 1, 1966.

Edward Mooney House

BUILT: 1785–1789
LANDMARKED: 1966
18 BOWERY
CHINATOWN

During the American Revolution, a large part of New York was destroyed by fire. Most buildings that weren't destroyed in 1776 burned down in subsequent fires, which makes it rare to find any that date from the eighteenth century. The Edward Mooney House, seen here in red, was built between 1785 and 1789 on the corner of Bowery and Pell Street, and is one of the oldest early Federal style homes in all of New York. The land the house was built on was bought at an auction of the former estate of James Delancey by Edward Mooney, a meat merchant. Delancey was a prominent loyalist during the Revolution and, like many other Tories, was forced to leave after the war, and his property was confiscated. Following Mooney's ownership, the house seemed to follow the trend of late eighteenth-century buildings in New York, when it was turned into a brothel and gambling den. Today it is a condo building. It was landmarked on August 23, 1966.

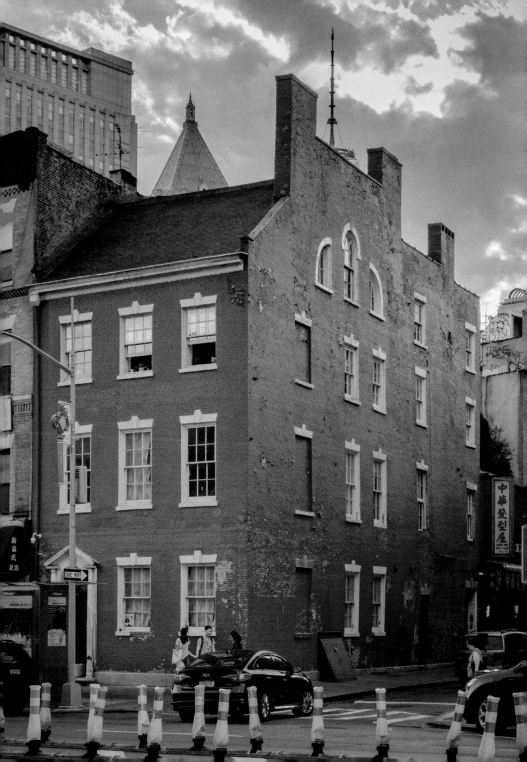

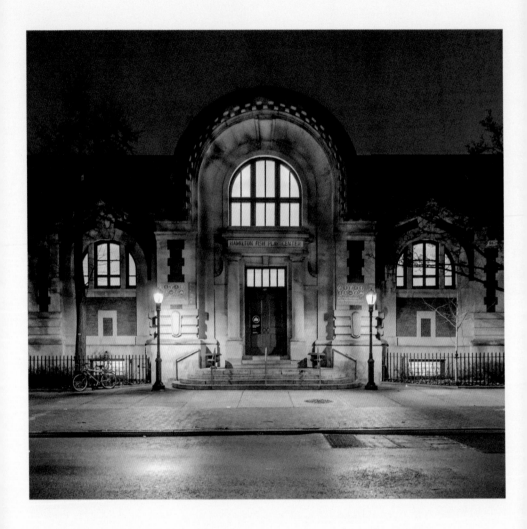

Hamilton Fish Park Play Center

BUILT: 1900
LANDMARKED: 1982
130 PITT STREET
LOWER EAST SIDE

In the nineteenth century, many people believed that cities were the root of all evil, a thought that I'm sure is still subscribed to by some today. Regardless, the Lower East Side had one of the highest population densities of anywhere on earth. Some of the prevailing wisdom of the day was to combat this "den of sin" by bringing nature to the people in the form of parks. This was thought to reduce crime and generally help make better citizens. While the city was well known for Central Park, many neighborhoods didn't have green space. Hamilton Fish Park opened in 1900, bordered by East Houston, Pitt, Stanton, and Sherriff Streets. The committee in charge of the park hired one of the most respected architectural firms in New York, Carrère and Hastings, which would go on to design the main branch of the New York Public Library. This would include a gymnasium and public bath. Carrère and Hastings believed that all buildings, regardless of purpose, should be designed to be beautiful and sophisticated. This lined up with a lot of the architectural philosophy of the day, which gave us some of the most impressive public buildings in New York. Unfortunately, the park had a hard time holding up to its extremely heavy use after it opened. It was renovated multiple times throughout its life and had a pool added in the 1930s. The gymnasium still serves as a locker room. It was landmarked on December 21, 1982.

339 Grand Street

BUILT: CIRCA 1831
LANDMARKED: 2013
339 GRAND STREET
LOWER EAST SIDE

This humble little building on Grand Street on the Lower East Side is one of the few remaining homes developed by John Jacob Astor. Astor was a German immigrant who at the time of his death in 1848 was the wealthiest man in America, primarily from Manhattan real estate. This building was one of five initially created in 1831 and is the only survivor. The area known as the Tenth Ward was filled with dry goods merchants in the middle of the nineteenth century, and there has been a store here since at least the 1880s. Merchants lived above it until 1905, when it was converted to a completely commercial building. No. 339 Grand Street stayed in the Astor family via John's granddaughter until the 1950s. It was last put for sale in 2018 and until 2019 had operated as the Ideal Hosiery Store, which occupied it for more than fifty years. It was landmarked on October 29, 2013.

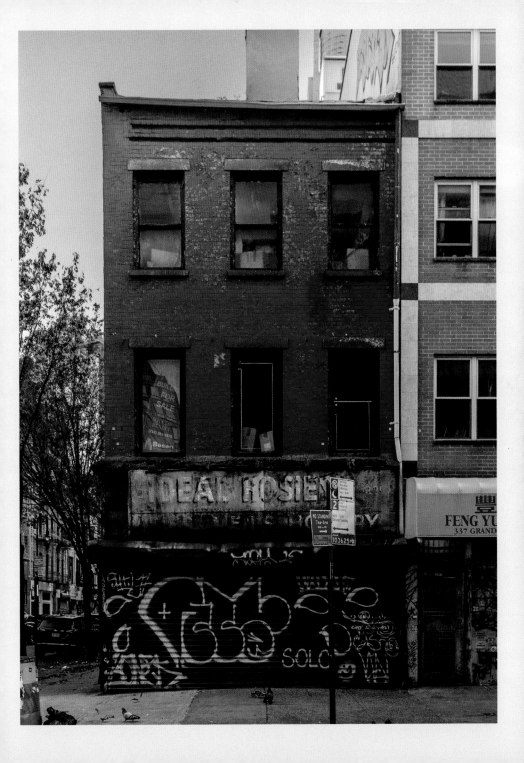

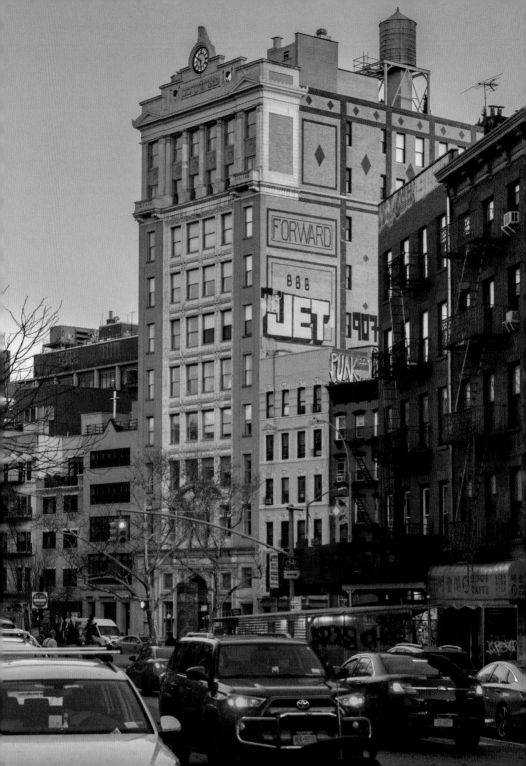

Jewish *Daily Forward* Building

BUILT: 1912
LANDMARKED: 1986
173 EAST BROADWAY
LOWER EAST SIDE

The Lower East Side was a magnet for immigrants during the nineteenth and twentieth centuries. One of the waves that began in the mid 1800s brought Jews from Germany, followed by increasing numbers from Eastern Europe. By the 1890s enough Yiddish speakers had arrived to support their own daily newspapers. The most influential of these was the *Forward*, which began publishing in 1897. The paper was a democratic socialist publication spearheaded by Abraham Cahan. Initially, the paper occupied a small tenement building located at 175 East Broadway, but a dramatic rise in circulation led to a 1904 expansion into the adjoining lot. The twelve-story building, which towers over its neighbors, was designed by architect George Boehm and finished in 1912. Though the *Forward* had seen expansion, the building wasn't entirely full, so some of the floors were rented out to help cover costs. The facade includes carvings of Karl Marx and Friedrich Engels. Ironically it is now a luxury condo building. It was landmarked on March 18, 1986.

Engine Company 31

BUILT: 1895
LANDMARKED: 1966
87 LAFAYETTE STREET
LOWER EAST SIDE

There are more than two hundred fifty fire stations throughout New York City, but Engine Company 31 on Lafayette and White Streets might be one of the most distinctive. It was built in 1895 by Napoleon LeBrun & Son, when looking as French as possible was all the rage in American architecture. LeBrun was hired to be the official architect of the New York City Fire Department in 1879, designing more than forty firehouses in the city, with Engine Company 31 being one of the last. This station house was designed to look like a château and remained in operation for almost seventy years, until the fire department moved in the 1960s. The firehouse was sold by the City of New York in 1983. It was landmarked on January 18, 1966.

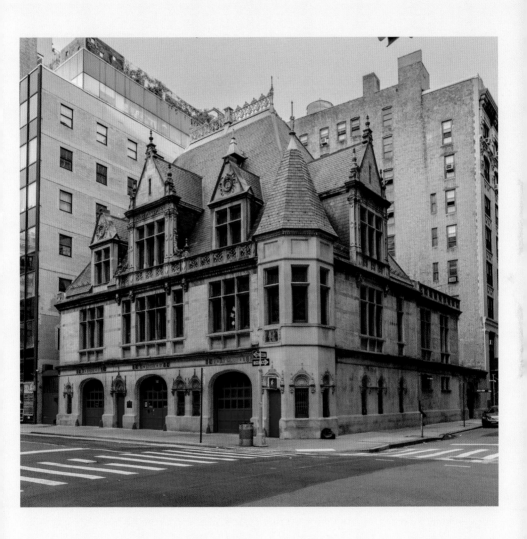

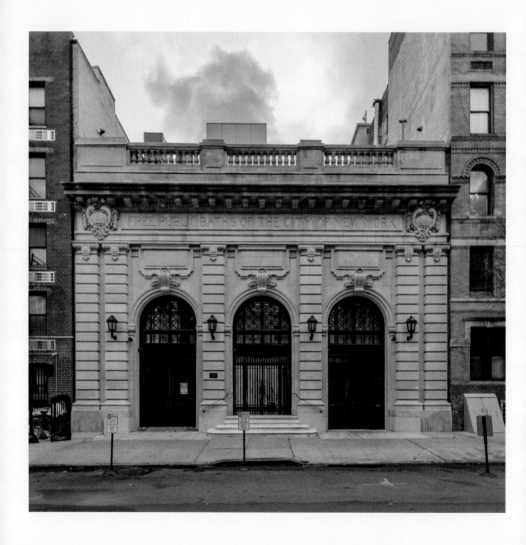

Free Public Baths of the City of New York, East 11th Street Bath

BUILT: 1904–1905
LANDMARKED: 2008
538 EAST ELEVENTH STREET
EAST VILLAGE

When you think of public baths, the first thing that might come to mind is ancient Rome, but probably not New York. However, at the beginning of the twentieth century, baths like this one on East Eleventh Street were the culmination of a progressive health movement to assist New York's exploding immigrant population. Though the East Village today is regarded as its own neighborhood, during the latter half of the nineteenth century, it was part of the Lower East Side, the most densely populated area on earth, with more than five hundred thousand residents. Many lived in tenement buildings, with multiple families living in one cramped apartment with no running water. Social reform advocates in the city, realizing the terrible unsanitary conditions that people were living in, pushed for reforms such as building codes to allow more light into apartments, as well as for public baths. The city would build thirteen public baths between 1901 and 1914, including this one in 1905, until they began to fall out of favor after improvements in apartment plumbing. This bath was converted into a fashion and photography studio by Eddie Adams in 1995. It was landmarked on March 18, 2008.

Former Congregation Beth Hamedrash Hagadol Anshe Ungarin

BUILT: 1908
LANDMARKED: 2008
242 EAST SEVENTH STREET
EAST VILLAGE

Nestled on Seventh Street between Avenues C and D sits the former Congregation Beth Hamedrash Hagadol Anshe Ungarin, also known as the Great House of Study of the People of Hungary. This congregation was founded in the 1880s by the first wave of Hungarian Jewish immigrants. Initially, the congregation met on Columbia Street, renting increasingly larger spaces until they purchased this building 1908. Like many synagogues on the Lower East Side, and even in the West Village, this one was a town house that was retrofitted. The architects Gross & Kleinberger removed the facade of this home and expanded the interior sanctuary. As the decades went on, a large portion of the Jewish population moved away from the Lower East Side to the Bronx and Brooklyn, meaning many of the synagogues were torn down. This one survived into the 1970s, when it was abandoned. It was purchased by a developer and converted into co-ops. It's a great surviving example of the many small houses of worship that dotted the immigrant communities of the Lower East Side. It was landmarked on March 18, 2008.

44 Stuyvesant Street

BUILT: 1795
LANDMARKED: 1969
44 STUYVESANT STREET
EAST VILLAGE

The phrase *hidden gem* tends to be overused, especially by me, but I think this building qualifies. If you live in or have walked through the East Village, you have probably passed 44 Stuyvesant Street countless times. But did you know this is the oldest house in the neighborhood and one of the oldest homes in continuous use in New York? It was built back in 1795 for Nicholas William Stuyvesant, the great-great-great-great-grandson of the former director general of New Amsterdam, Peter Stuyvesant. The house was built on property that was owned by Nicholas's father, also Peter

(Petrus) Stuyvesant, around the same time he donated the land for St. Mark's in the Bowery, across the street. The house has undergone minimal exterior renovations and still has some of the original interior beams and staircase. The facade shows some hints of its age. If you look above the windows, those beams that look like upside-down trapezoids are called splayed lintels, which were really popular at the end of the eighteenth century. No. 44 Stuyvesant Street was landmarked as part of the St. Mark's Historic District on January 14, 1969.

Bouwerie Lane Theater/
Bond Street Savings Bank

BUILT: 1874
LANDMARKED: 1967
54 BOND STREET
NOHO

This isn't lens distortion, that's a very skinny building. This is the former Bond Street Savings Bank at 54 Bond Street, which has experienced constant rebirth and interesting reuse. Built in 1874, the building first housed the Bond Street Savings Bank, followed by the German Exchange Bank after it failed. In the 1900s it was turned into lofts, and in the 1960s, it was occupied by an off-Broadway theater called the Bouwerie Lane Theatre. In 2007 the theater was closed, and it was turned into a large mansion. When that failed to sell, it was divided into three luxury condos with a retail space on the ground floor. Design critics, both at the time of construction and today, have called it one of the finest examples of that architectural form. The columns are made of cast iron. It is on the National Register of Historic Places and is a New York City landmark, a designation it received on January 11, 1967.

Cable Building, 611 Broadway

BUILT: 1892–1894
LANDMARKED: 1999
611–621 BROADWAY
NOHO

San Francisco might be famous for its cable cars, but it wasn't the only city with that technology. This is 611 Broadway, formerly the headquarters of the Broadway & Seventh Avenue Railroad Company, which operated cable cars from the Battery to Fiftieth Street along Broadway. The thing with cable cars is you need a moving cable, and this building had four thirty-two-foot wheels that would pull the cable in the basement. The upper floors were offices for the railway. The firm hired the famed architectural team of McKim, Mead & White to design the building, which was erected between 1892 and 1894. The railway sold the property in 1925, and it was converted for use by light manufacturing. Today it is office space. The Cable Building was landmarked as part of the NoHo Historic District on June 29, 1999.

Isaacs-Hendricks House

BUILT: 1799–1800
LANDMARKED: 1969
77 BEDFORD STREET
WEST VILLAGE

Bedford Street might be famous for the *Friends* apartment, but just two short blocks south on the corner of Commerce Street sits the oldest house in the entire neighborhood. This is the Isaacs-Hendricks House, built between 1799 and 1800 for Joshua Isaacs. Just to put the city in context, in 1800 the population was only about sixty thousand people, and this area was the independent village of Greenwich. Within a year of the house's completion, Isaacs lost it to his creditors, and in 1801 it was purchased by his son-in-law Harmon Hendricks, who was a leader of the Sephardic Jewish community in New York. Hendricks made his money in the copper trade, selling to Paul Revere and Robert Fulton. While the house was fully built from wood, it was updated in the 1830s with a brick facade. It last sold in 2013 for $7.3 million. It was landmarked as part of the Greenwich Village Historic District on April 29, 1969.

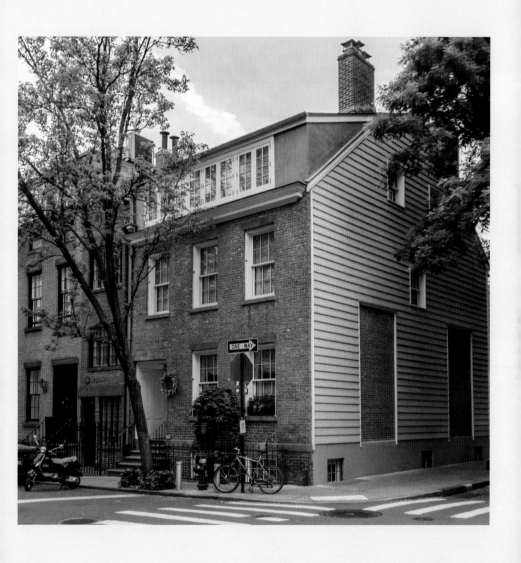

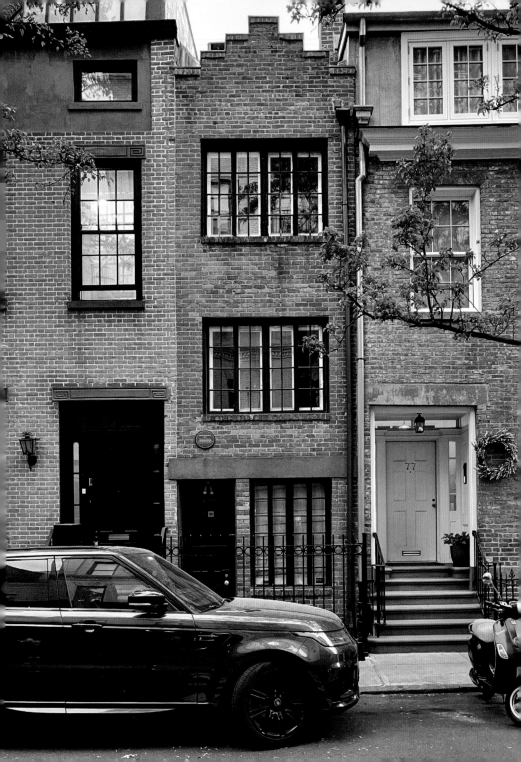

75 ½ Bedford Street

BUILT: 1873
LANDMARKED: 1969
75 ½ BEDFORD STREET
WEST VILLAGE

We all know space is at a premium in New York, but this house takes that to the next level. This is 75 ½ Bedford Street, which is only nine and a half feet (2.6 meters) wide. It was allegedly built in 1873, although there is some debate over whether it was built earlier. Regardless, it was built on the former site of a driveway for the neighboring Isaacs–Hendricks House for Horatio Gomez, who married into the Hendricks family. Apart from its tiny size, the house is most famous for some of its residents, most notably Edna St. Vincent Millay, a Pulitzer Prize–winning author, who lived here with her husband in 1923 to 1924. It was leased by the Cherry Lane Theatre and played host to other notable figures, including Cary Grant. The 999-square-foot home last sold publicly in 2023 for $4.1 million. It was landmarked as part of the Greenwich Village Historic District on April 29, 1969.

17 Grove Street

BUILT: 1822
LANDMARKED: 1969
17 GROVE STREET
WEST VILLAGE

I have two dream homes in the five boroughs. Both are wood-frame buildings from the beginning of the nineteenth century, with guesthouses and small backyards. Pictured here, 17 Grove Street is one of those buildings. It was built in 1822 for a sash maker named William Hyde. When I found out this man made sashes, I figured there had to be more to it than stringing together ribbon. Well, apparently, in the nineteenth century, a sash was the lower portion of a window. In fact, one year after the construction of this building, the poem "A Visit from St. Nicholas," also known as "'Twas the Night Before Christmas," was allegedly written a few miles north, in Chelsea. In that poem, there is a line where the protagonist "tore open the shutters and threw up the sash." So someone who manufactures windows makes more sense in this context. In fact, the guesthouse on the property was built about a decade later in 1833 as his workshop. At the time of construction, it was only two stories high, and the third story was added in 1870. According to publicly available sales data, it sold in 2021 for about $5 million, even though it was listed for over $8 million—a bargain, if you will. If you'd like to donate to the "buy landmarks and expensive house fund," I would be very grateful. It was landmarked as part of the Greenwich Village Historic District on April 29, 1969.

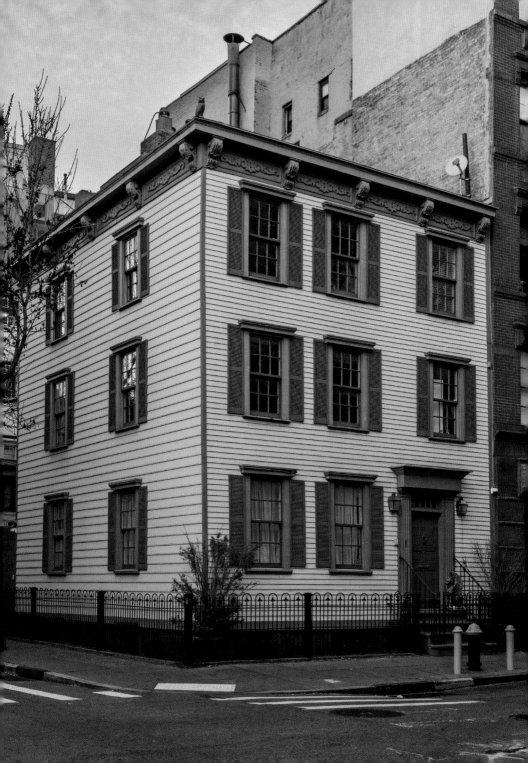

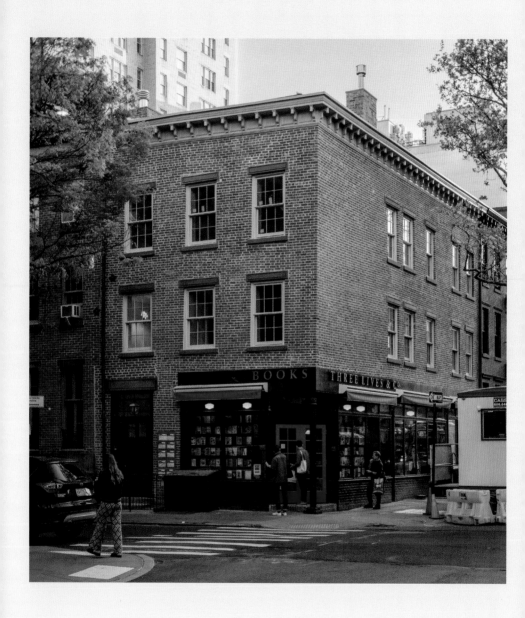

Three Lives & Company Bookstore, 184 Waverly Place

BUILT: CIRCA 1828
LANDMARKED: 1969
153 WEST TENTH STREET
WEST VILLAGE

Art fans will love this building. It dates back to before 1828, when it was built by a man named Abraham Clark to be his home. Over the years, different stores occupied the ground floor on the corner of Waverly Place and West Tenth Street. It is also likely the subject that Edward Hopper captured in his painting *Drug Store*. Hopper, who lived in the Village, used his neighborhood as inspiration for many of his works, and the column and store number match this building. It also incorporates something called start bolts or anchor points into its design. Those little metal stars are retrofits to older brick buildings that attach the facade to the interior beams and support to ensure that the brick does not bow out.

In 1978, Three Lives & Company Bookstore—named for its three founders Jill Dunbar, Jenny Feder, and Helene Webb—opened on Seventh Avenue, before the shop moved here in 1983, where it has been ever since. To insert a little of my own bias to this, Three Lives is an incredible bookstore, and if you are in the city and somehow haven't visited yet, I highly recommend it. No. 184 Waverly Place was landmarked as part of the Greenwich Village Historic District on April 29, 1969.

The Row, Washington Square North

BUILT: 1832
LANDMARKED: 1969
WASHINGTON SQUARE NORTH
GREENWICH VILLAGE

During the height of the COVID-19 pandemic, New York City was starting to feel a bit like the film *I Am Legend*, so let's talk about the house Will Smith uses in that film. Washington Square North was never meant to be a bunker against hordes of viral zombies. Instead, it was land owned by Sailors' Snug Harbor (see page 246) and was leased out to individuals to build homes. These houses were mostly built in 1832 as part of the redevelopment of Washington Square from a potter's field to park and parade ground. It became one of the most fashionable addresses in the entire city. This particular row of buildings is oftentimes referred to as simply "The Row" and is considered one of the best preserved and earliest set of Greek Revival homes in New York City. The house used in the movie was no. 11, which was owned by the same family from its construction in 1832 all the way until the 1930s, when their lease from Snug Harbor ran out. A few buildings have had some alterations, but most look like they did in the nineteenth century. Today, the houses are a mix of apartments and single-family homes. All of the houses on Washington Square North were landmarked as part of the Greenwich Village Historic District on April 29, 1969.

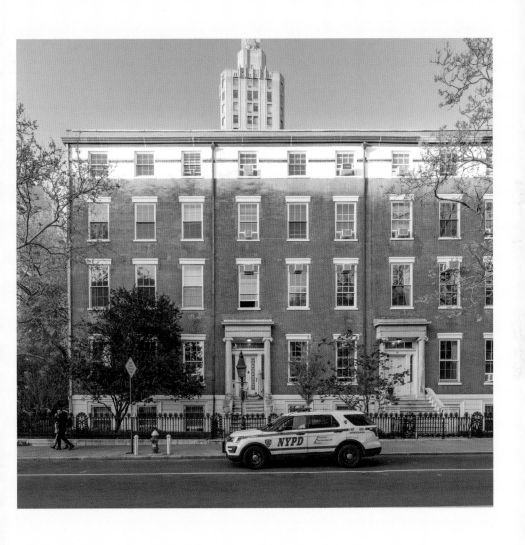

12 Gay Street

BUILT: 1827
LANDMARKED: 1969
12 GAY STREET
GREENWICH VILLAGE

No. 12 Gay Street in Greenwich Village has a very salacious history. It was built in 1827 by Daniel Weed and Joseph Baldwin for owner Abraham Hitchcock. Gay Street began its life as a narrow lane with stables for the houses surrounding Washington Square Park, but was widened and became more residential. In the 1920s, Mayor Jimmy Walker purchased the building and opened a speakeasy called the Pirate's Den. Alcohol was illegal at the time, but here was the mayor of New York running an underground bar. He also used the house as a home for one of his mistresses, Broadway actress Betty Compton. Shockingly, Walker's mayoral career was cut short when he was forced to resign due to scandal. The house is considered to be very haunted, with reports of residents experiencing various spectral events. In keeping with its crazy history, in 2021, the house was seized and raided by the FBI in connection with sanctions violations by Russian oligarch Oleg Deripaska. It was landmarked as part of the Greenwich Village Historic District on April 29, 1969.

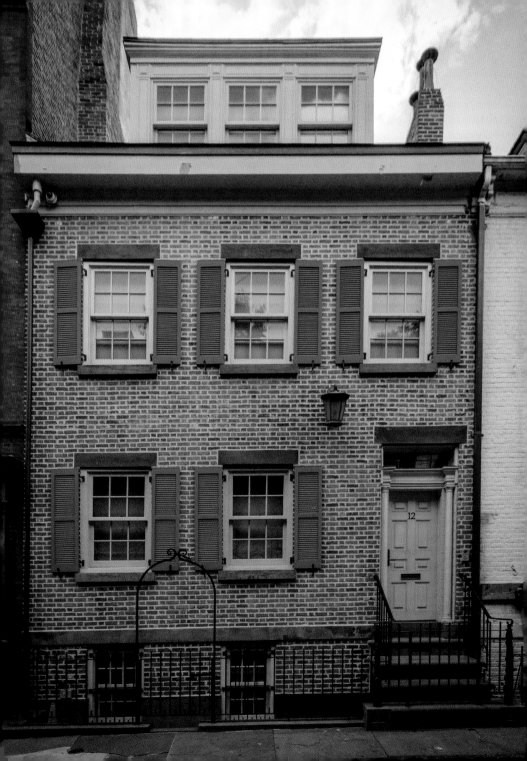

Julius' Bar

BUILT: 1826
LANDMARKED: 2022
159 WEST TENTH STREET
WEST VILLAGE

If you're familiar with the LGBTQ+ rights movement, then you've heard of the Stonewall Inn. But you may not know that just around the corner at the intersection of West Tenth Street and Waverly Place is the site of one of the movement's earliest public protests. Julius' Bar began life as a speakeasy during Prohibition and became a popular spot for both gay and straight patrons during the 1950s and 1960s. During those decades, New York began to crack down on members of the LGBTQ+ community, arresting same-sex couples for kissing or dancing in public. This effectively meant that being an openly out person was illegal. There were laws requiring you to leave your house with at least three pieces of clothing matching your assigned gender, otherwise you could be arrested. It was during this time that the State Liquor Authority (SLA) began a crackdown on gay bars in the Village. The SLA determined that being openly gay was an indecent act, and began revoking liquor licenses of bars that catered to the community. If you were known to be out, you could not be served at a bar, period.

In 1966, a group of four men decided to challenge that at Julius'. The men were members of the Mattachine Society of New York, an early LGBTQ+ rights organization. Dick Leitsch, Randy Wicker, Craig Rodwell, and John Timmons decided to publicly break the law. The plan was simple: they were going to enter a bar and hand the bartender a note stating they were gay. They needed the press and ended up getting *Village Voice* photographer Fred W. McDarrah to accompany them. On April 21, 1966, the men ended up visiting multiple bars before ultimately deciding on Julius'. There was concern about drawing attention to the bar, as it was a frequent meeting spot of gay patrons. Ultimately, they decided to go forward with it, ordering a drink and then informing the bartender of their sexual orientation. McDarrah would snap a photo of the bartender covering the glass and stating that he couldn't serve them. That photo would become known as "the sip-in," one of the first examples of the media documenting LGBTQ+ discrimination. While in the short term the sip-in did not

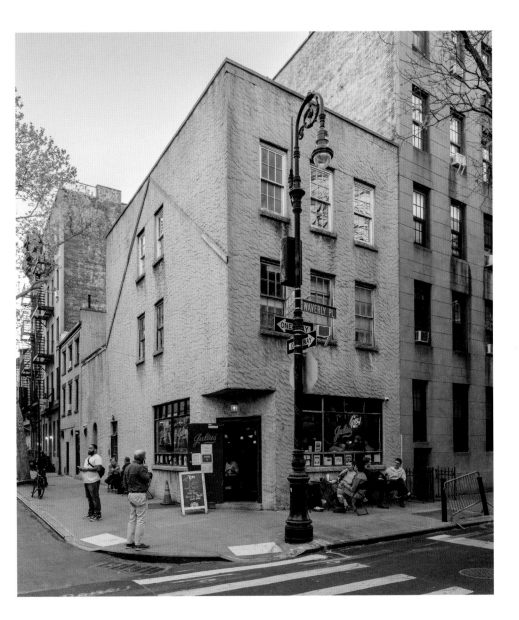

end discrimination based on sexual orientation in bars, it was the start of more public protests, which would culminate three years later in the Stonewall uprising. The 1826 building housing Julius' Bar was landmarked as part of the Greenwich Village Historic District on April 29, 1969, but the bar itself was individually landmarked on December 6, 2022.

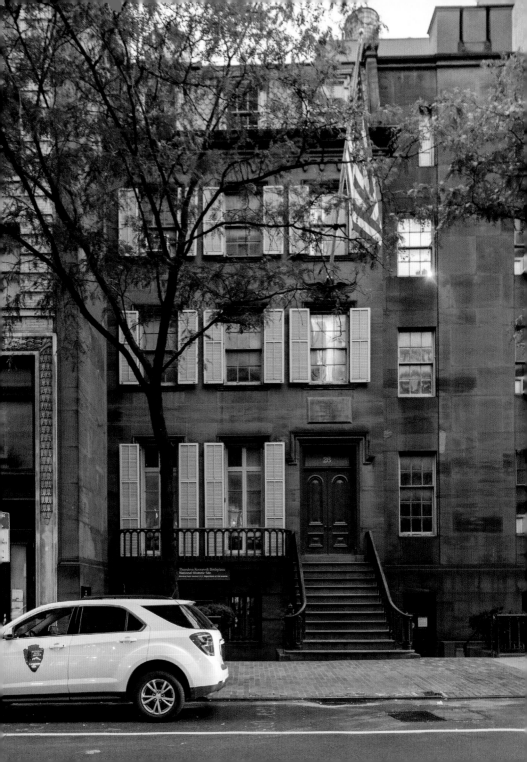

Theodore Roosevelt Birthplace National Historic Site

BUILT: 1848 (REBUILT: 1923)
LANDMARKED: 1966
28 EAST TWENTIETH STREET
FLATIRON DISTRICT

This is the Theodore Roosevelt Birthplace National Historic Site on East Twentieth Street, between Broadway and Park Avenue. It is a replica of the home that Teddy was born in. The original was built in 1848, and the future president lived there from 1858 to 1872. When the area changed from residential to commercial, the building was torn down.

In 1919, following the president's death, the building's plot was bought, and a plan to reconstruct it as a museum was hatched. Theodate Pope Riddle, one of the first female American architects, was tasked with the design. She was able to replicate the home in 1923 based on the building next door, which was a twin to the Roosevelts'. Today it is run by the National Park Service. It was landmarked on March 15, 1966.

Lord & Taylor

BUILT: 1870
LANDMARKED: 1977
901 BROADWAY
FLATIRON DISTRICT

Lord & Taylor has a long history in New York City. It was originally a dry goods store, opened in 1824 by Samuel Lord in Lower Manhattan. Up until 2019, it had an impressive Fifth Avenue flagship store, which closed due to financial difficulties. However, the store had a few different locations prior to that. This one on Broadway and East Twentieth Street was its primary location from 1870 to 1914. The mid-1800s saw Manhattan expanding north at a rapid pace. As a result, all of the main department stores in the city began to move with it. This area of the Flatiron earned the name the Ladies' Mile for all of the shopping that was available. After Lord & Taylor moved to Fifth Avenue in 1915, half of the facade on Broadway, designed by architect James Giles, was torn down. What remained of the former Lord & Taylor building was landmarked on November 15, 1977.

Marble Collegiate Reformed Church

BUILT: 1851–1854
LANDMARKED: 1967
272 FIFTH AVENUE
FLATIRON DISTRICT

If you were to guess what the oldest Christian congregation in New York City is, what would your answer be? If you answered Trinity Church, you would have made a good guess, but would be wrong. This is the Marble Collegiate Church. Located at corner of Fifth Avenue and East Twenty-Ninth Street, it is one of the oldest continuing parishes in the United States and the oldest in New York. It was founded in 1628 within the fort walls of New Amsterdam. It was a member of the Dutch Reformed Church and has moved buildings multiple times throughout its existence. This building dates back to 1854 and was designed by architect Samuel A. Warner. The name has an interesting backstory as well: the building is made of marble, and its ministers are referred to as colleagues, hence Marble Collegiate Church. While this church is 170 years old as of this writing, its bells are even older. They were brought over from the prior church that the congregation occupied, and were cast in 1768 in Amsterdam. The Marble Collegiate Church is on the National Register of Historic Places, and was landmarked on January 11, 1967.

3-5 Gramercy Park West

BUILT: CIRCA 1844–1850
LANDMARKED: 1966
4 GRAMERCY PARK WEST
GRAMERCY

It's hard not to be obsessed with the Greek Revival town houses on Gramercy Park West. While not as grand as some of the other properties surrounding the exclusive park, the town house at no. 4 packs a historical punch. This home was designed in the 1840s by Alexander Jackson Davis and was home to New York City mayor and major publisher James Harper. If Harper's name sounds familiar, it's because he founded what is now HarperCollins Publishers. The pair of gas lamps outside indicated that this was a mayoral residence—this was nearly one hundred years prior to Gracie Mansion being used for that purpose. In addition to the civic nature of this building, it was also reportedly used as the setting for Stuart Little's home in the classic book written by E. B. White and served as the backdrop for Bob Dylan's album cover for *Highway 61 Revisited*. The home sold in 2017 for an eye-watering $23 million. It was landmarked as part of the Gramercy Park Historic District on September 20, 1966.

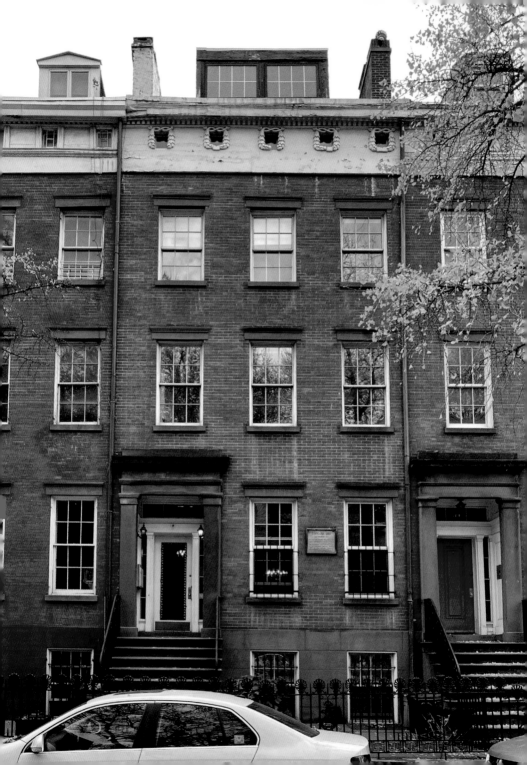

Cushman Row

BUILT: 1840
LANDMARKED: 1970
406–418 WEST TWENTIETH STREET
CHELSEA

Did you know that the neighborhood of Chelsea used to be one man's estate? Major Thomas Clarke was a Brit who served in the Seven Years' War and decided to stick around. Clarke named his manor Chelsea in honor of an English army hospital. His grandson, Clement Clarke Moore, widely credited with writing "'Twas the Night Before Christmas," oversaw the development of the estate into a full-fledged neighborhood. This row of town houses was built in the 1840s after Moore sold the land to his friend Don Alonzo Cushman, giving it the name Cushman Row. These houses are among the oldest in all of Chelsea and are considered some of the best-preserved Greek Revival buildings in the city. They were landmarked as part of the Chelsea Historic District on September 15, 1970.

New York House
and School of Industry

BUILT: 1878
LANDMARKED: 1990
120 WEST SIXTEENTH STREET
CHELSEA

New York in the middle of the nineteenth century was a city in flux. No longer a provincial backwater, it was beginning to attract waves of immigration from Europe. As a result, New York was overwhelmed by thirty thousand new residents a year, mostly poor people fleeing political unrest and famine. Due to the massive rise in poverty the city was seeing, wealthy New Yorkers began to form charitable societies to assist them. In 1850, the New York House and School of Industry was founded. It was run by women from prominent families to assist poor women by teaching them how to sew. They moved to this building, designed by architect Sidney V. Stratton, on West Sixteenth Street in 1878. It was one of the first examples of the Queen Anne style of architecture in New York at the time. The New York House and School of Industry operated for more than a century before merging with Greenwich House in 1951. Today, the building still serves the disadvantaged by housing the Young Adults Institute, an organization that assists young people with developmental disabilities. It was landmarked on October 2, 1990.

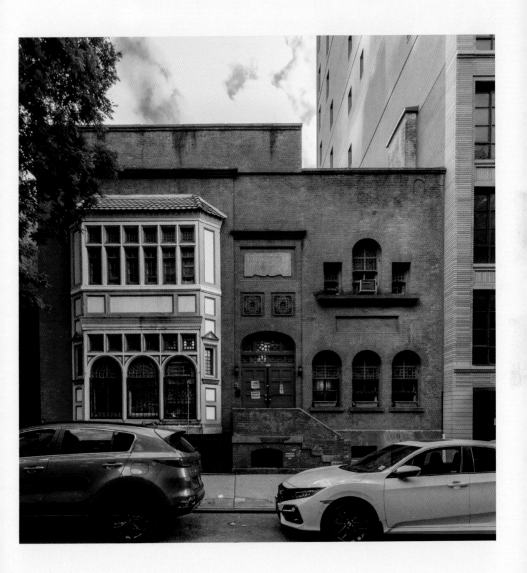

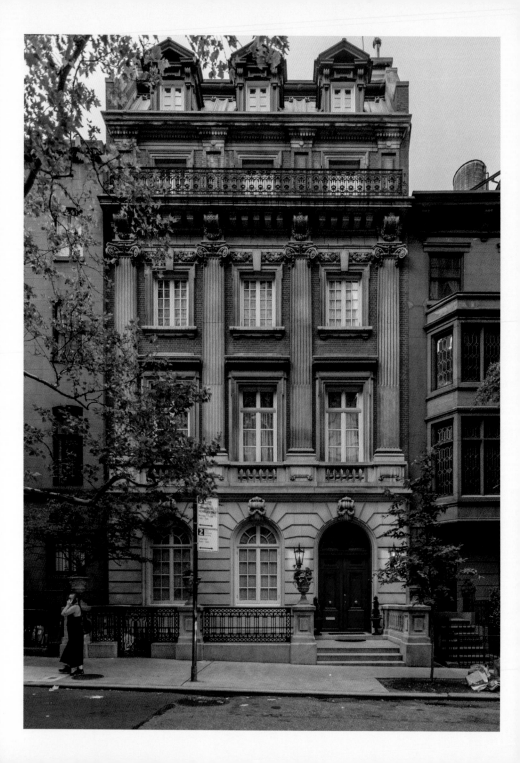

James F. D. Lanier Residence

BUILT: 1901–1903
LANDMARKED: 1979
123 EAST THIRTY-FIFTH STREET
MURRAY HILL

Murray Hill used to be a fashionable neighborhood for New York's wealthy. J. P. Morgan built his mansion on Madison Avenue, and the side streets were filled with brownstones, most built in the middle of the 1800s.

The James F. D. Lanier Residence is an example of what was in vogue in residential architecture at the turn of the twentieth century. Rather than settle for just a brownstone, banker James Lanier combined two lots and built his Beaux Arts town house, hiring the architects of Hoppin and Koen to design it for him. Beaux Arts, for those unfamiliar with the term, was derived from the influential French art school École des Beaux-Arts and emphasized grand designs reminiscent of ancient Greece and Rome. Other examples of this style in New York include Grand Central Terminal or the old Penn Station. Construction of the Lanier residence lasted from 1901 to 1903, about fifty years after the surrounding buildings were completed. It was landmarked on September 11, 1979.

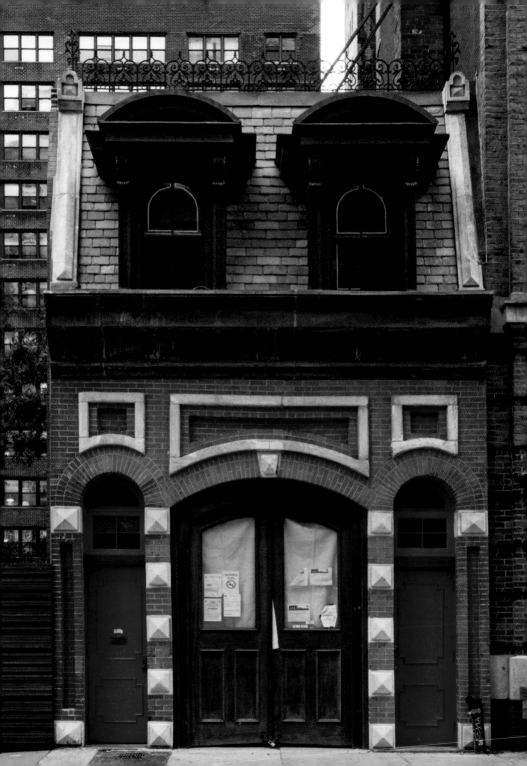

Jonathan W. Allen Stable

BUILT: 1871
LANDMARKED: 1997
148 EAST FORTIETH STREET
MURRAY HILL

Midtown Manhattan, filled with office towers and skyscrapers, might not be the place you would expect to find a nineteenth-century stable. This two-story building on East Fortieth Street and Third Avenue was built in 1871 for Jonathan W. Allen, a wealthy broker who lived on Forty-Second Street. His horses lived on the ground floor, and the second story housed his employee who looked after them. The stable looks a little French, doesn't it? It has what is called a mansard roof. These were all the rage in Paris, and the trend sailed across the Atlantic in the second half of the nineteenth century with architect Charles Hadden incorporating it into the plans for the building. Next time you take walk through New York, keep an eye on the roofs of older buildings to see if you can spot similar ones. The Jonathan W. Allen Stable was landmarked on June 17, 1997.

Alwyn Court Apartments

BUILT: 1907–1909
LANDMARKED: 1966
180 WEST FIFTY-EIGHTH STREET
MIDTOWN

I f you're looking for a building that is the opposite of the glass towers going up around New York, look no further than the Alwyn Court Apartments. Commissioned by Alwyn Ball Jr. and designed by the firm of Harde & Short, the building on the corner of Fifty-Eighth Street and Seventh Avenue has every inch of its exterior ornately detailed. It was completed in 1909 and used terra-cotta for the facade, which was cheap compared with stone, allowing it to be built for less than $1 million. Despite the low price tag, it was one of the most desirable buildings in New York upon its completion, with two massive apartments per floor, with fourteen rooms each. While the exterior has remained the same, multiple bankruptcies and changing tastes led the building to be subdivided then undivided and subdivided yet again. It has undergone multiple restorations since the 1980s to keep the intricate terra-cotta intact. It was landmarked on June 7, 1966.

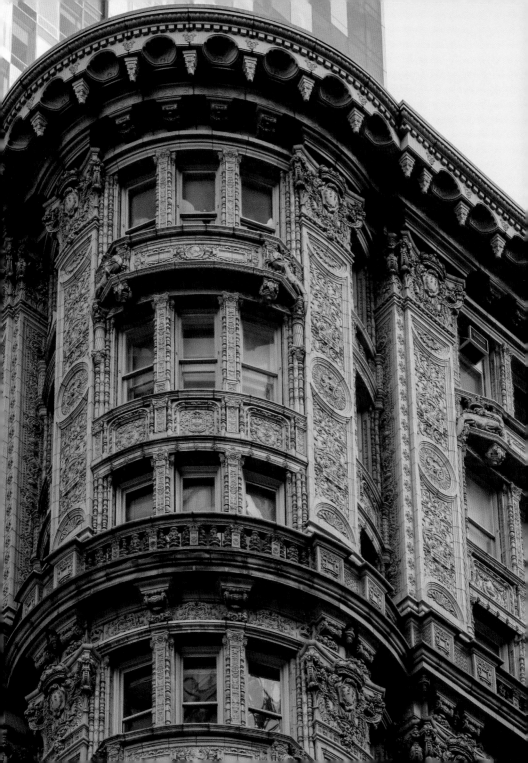

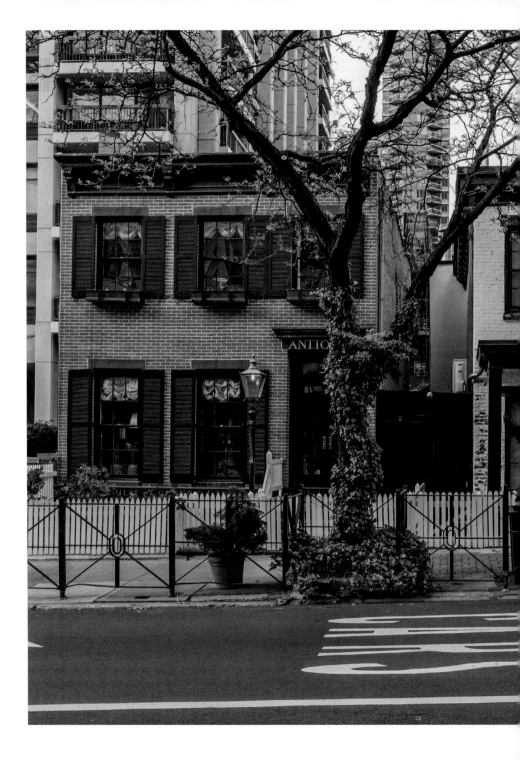

311 & 313 East Fifty-Eighth Street

BUILT: 1857
LANDMARKED: 1967; 1970
311–313 EAST FIFTY-EIGHTH STREET
MIDTOWN

Every so often, you can find a window into a neighborhood's past. This is the case on East Fifty-Eighth Street, right by the Queensboro Bridge on-ramp. Nos. 311 and 313 can give you an idea of what this area used to look like back in the mid-1800s. Both completed in 1857, the white building on the right was the home of its builder, Hiram Disbrow. These are typical low-rise buildings that would have been seen on the side streets of the Upper East Side in the mid-nineteenth century. When they were constructed, these would have been at street level. They were slightly obscured after the building of a new approach to the bridge in 1930. They are in stark contrast to the high-rise apartment buildings surrounding them. No. 311 was landmarked on May 25, 1967, and 313 was landmarked on July 14, 1970.

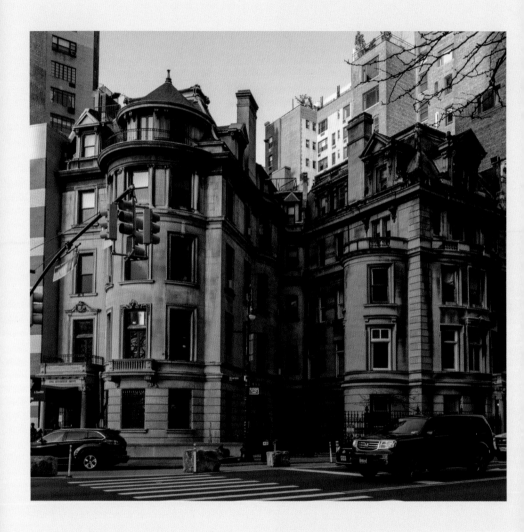

Islamic Cultural Center, Prentiss Residence

BUILT: 1889–1901
LANDMARKED: 1991
1 RIVERSIDE DRIVE
UPPER WEST SIDE

Islam has a long history in New York City, with the first Muslim resident reportedly being Anthony Janszoon van Salee, who was half-Dutch and half-Moroccan and immigrated to New Amsterdam in the 1600s. Widespread immigration from the Islamic world would not really pick up until the mid-eighteenth century. By the 1960s the Muslim population in the city had continued to grow, creating the formation of the Islamic Cultural Center, which still operates out of this building today. This town house was built in 1901, and designed by notable architect C. P. H. Gilbert for Lydia Smith Floyd Prentiss. Gilbert designed many of the Gilded Age mansions on Fifth Avenue. We unfortunately don't know much about Lydia. The Prentiss family owned this home until the death of Lydia's daughter (also named Lydia) in 1955. The town house was built following the development of the Upper West Side, spurred by the extension of public transportation and the completion of Riverside Park. It was landmarked on January 8, 1991.

The Dakota

BUILT: 1880–1884
LANDMARKED: 1969
1 WEST SEVENTY-SECOND STREET
UPPER WEST SIDE

This is the granddaddy of all luxury apartments in New York City: the Dakota. It might not be as large or as imposing as its neighbors along Central Park West, but when it was designed in 1880 by architect Henry Janeway Hardenburgh, it was literally the only thing around. At the time, most wealthy New Yorkers lived in town houses or mansions, usually below Fifty-Ninth street. The idea of living luxuriously in an apartment hadn't come around yet. The super tall glass skinny towers popping up all over Manhattan owe their existence to this building.

The name comes from typical New York snark. When Edward S. Clark, the heir to the Singer Sewing Machine fortune, commissioned the building's construction, it is rumored that his friends said that, had he built it a few blocks north and west, he could have built it in the Dakota territory.

The Dakota also has an infamous past. John Lennon was a resident here and his murder took place just outside its gates. It was landmarked on February 11, 1969.

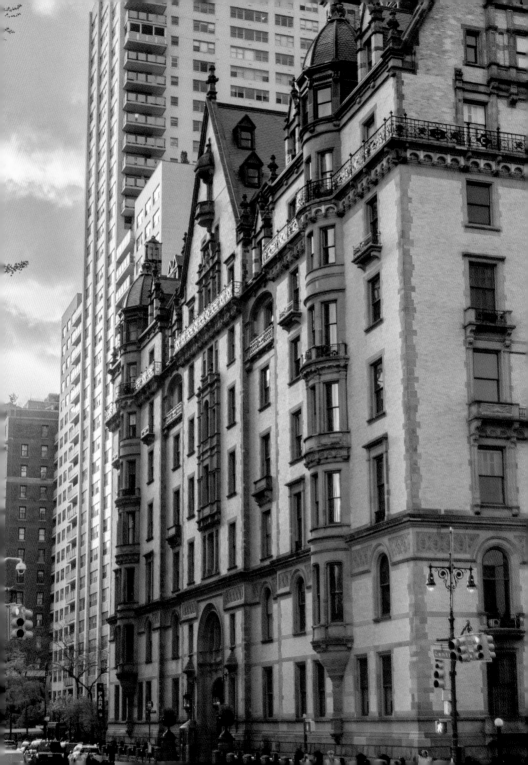

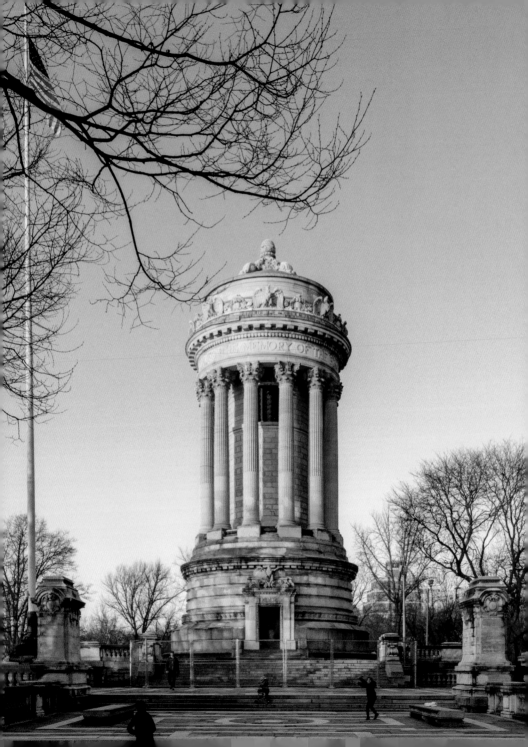

Soldiers' and Sailors' Memorial

BUILT: 1900–1902
LANDMARKED: 1976
CORNER OF WEST EIGHTY-NINTH STREET AND RIVERSIDE DRIVE
UPPER WEST SIDE

Riverside Park is home to multiple stately memorials and monuments. This particular monument was designed by architects Charles and Arthur Stoughton and Paul E. M. Duboy and is dedicated to the soldiers and sailors of New York's regiments, who fought in defense of the Union in the Civil War. The cornerstone was placed in 1900 in a ceremony presided over by Teddy Roosevelt and the monument has played an important role in Memorial Day celebrations since its completion in 1902. Unfortunately, it has fallen into disrepair not once, but twice over its lifetime. In a 2017 assessment by the New York City Parks Department, the estimated cost to repair the memorial ranged from $29 to $30 million. The memorial has received a boost, with over $62 million allocated to it in New York's fiscal year 2024 budget. This oft-neglected but beautiful memorial at the intersection of Riverside Drive and Eighty-Ninth Street was landmarked on September 14, 1976.

Schinasi Mansion

BUILT: 1907–1909
LANDMARKED: 1974
351 RIVERSIDE DRIVE
UPPER WEST SIDE

I n New York, there's luxury housing, and then there is Luxury housing. The Schinasi mansion on 107th Street and Riverside Drive is one of the few fully detached single-family homes in Manhattan. It was built in 1909 for tobacco magnate Morris Schinasi, a Jewish immigrant from Turkey. He hired architect William B. Tuthill, who also designed Carnegie Hall, to design his manor made of marble. At the time, most ornate mansions were on the Upper East Side, but Schinasi apparently didn't want all of the hustle and bustle and decided on the Riverside Drive site. In 2013 the mansion sold to a Goldman Sachs executive, who purchased the property for $14 million. It was landmarked on March 19, 1974.

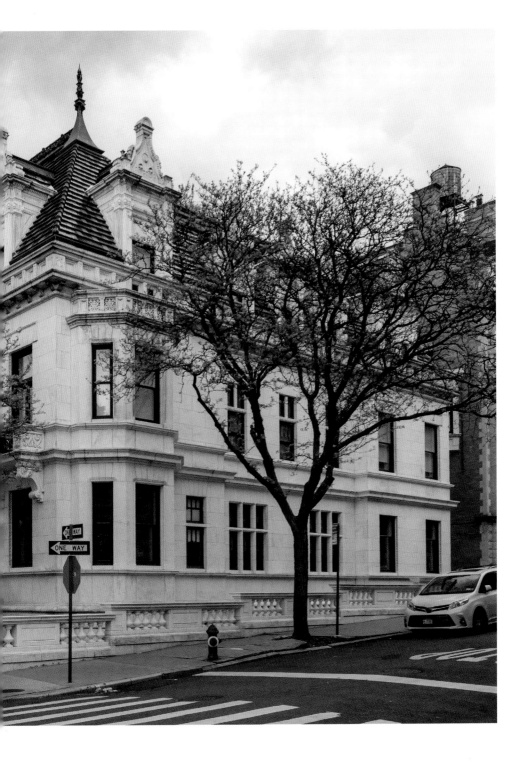

Congregation Shearith Israel

BUILT: 1896–1897
LANDMARKED: 1974
2 WEST SEVENTIETH STREET
UPPER WEST SIDE

Did you know that the first Jewish congregation in New York was founded in 1654? Shearith Israel existed when New York was still New Amsterdam. Its original members were mostly of Portuguese and Spanish descent living in Dutch-controlled Brazil. Once the Portuguese defeated the Dutch in South America, much of the Jewish population moved to either Amsterdam or New Amsterdam. It wasn't easy, as the governor general of the colony, Peter Stuyvesant, wanted to block their entry. He was overruled by the Dutch West India Company, and the new Jewish population was given permission to worship "in all quietness within their houses." It is the oldest Jewish congregation in North America and was the only one in New York City until 1825.

In 1897, construction was completed on the fourth synagogue in the congregation's history on Central Park West and West Seventieth Street. (The first one was completed in 1729 on South William Street.) Members of the congregation helped found a variety of New York institutions such as the Mount Sinai Hospital and the Ninety-Second Street Y. It was landmarked on March 19, 1974.

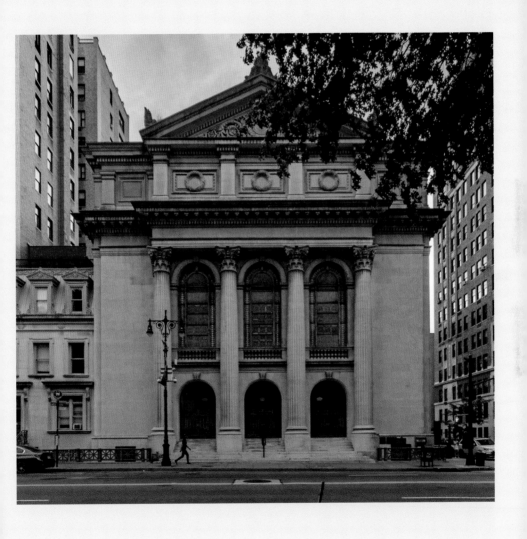

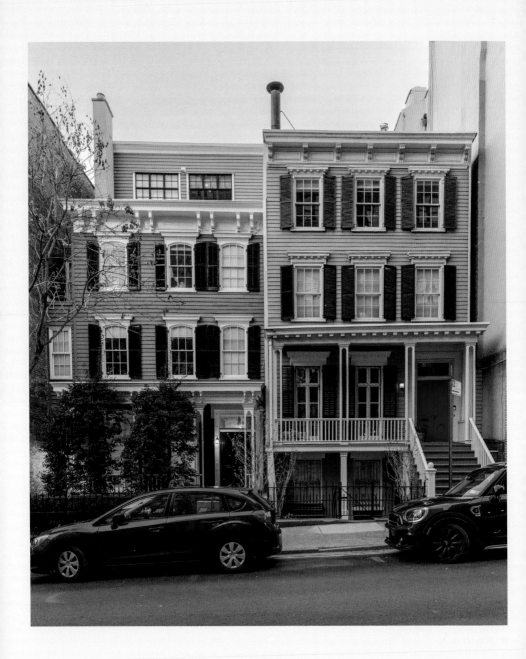

120 & 122 East Ninety-Second Street

BUILT: 1871; 1859
LANDMARKED: 1969
120–122 EAST NINETY-SECOND STREET
UPPER EAST SIDE

Wooden buildings are difficult to find in Manhattan north of Greenwich Village. New York suffered from three major fires before the year 1860, which wiped out large chunks of city made mostly from wood; it is one of the reasons that there isn't a single building left from the era of Dutch colonization on the island. As the city grew, it determined it needed to move away from wood as a building material, and began implementing laws to ban wooden buildings as early as 1819. However, these laws took a staggered approach. By the time these two homes were built on Ninety-Second Street, the ban only extended as far as Thirty-Second Street. As a result, people on the relatively undeveloped Upper East Side were able to continue building cheaper frame homes. There are less than a dozen left by my count in the neighborhood. After 1882, all buildings below 155th Street needed to be made of masonry, and many people moving to the neighborhood would have viewed the

wood-frame houses as a bit middle class (save Gracie Mansion). As a result, many of them were torn down.

We know that 122 was built for custom-house officer Adam C. Flanagan, who sold the neighboring plot to wine merchant John Rennert and his wife Catherine. No. 122 East Ninety-Second Street was built in about 1859, and 120 followed a little over decade later, in 1871. The people who originally occupied these homes would have had relatively easy access to Manhattan via the Harlem Railroad, which stopped at Eighty-Sixth Street on its way to Grand Central. The railroad opened in 1831, spurring commercial development in the area, followed by residential. By 1881, the opening of the Third Avenue elevated railroad would lead to large-scale residential development, helping push the new 1882 fire code. Both 120 and 122 Ninety-Second Street were landmarked on November 19, 1969.

Sara Delano Roosevelt and Franklin and Eleanor Roosevelt Houses

BUILT: 1907–1908
LANDMARKED: 1973
47–48 EAST SIXTY-FIFTH STREET
UPPER EAST SIDE

This may look like an ordinary town house. It might look like a building that you walk past every day on your way to work (I did for years). New York is full of buildings like this; you could pass it a million times and not realize the story behind it.

This particular town house at 47–49 East Sixty-Fifth Street was the former home of Franklin D. Roosevelt, Eleanor Roosevelt, and FDR's mother, Sara. Sara hired architect Charles Platt to design the house in 1907 and construction wrapped up in 1908. She gave half the house to the newly-ish married couple, and lived in the other half. If these walls could talk, they would have a lot to say—Sara could be a tad overbearing. FDR recovered from polio here and received the news that he had become governor of New York and, later, the president.

In 1941, Sara passed away. A nonprofit group purchased the house and donated it to Hunter College. FDR, happy that the house was being used for a purpose his mother would support, personally donated books to its library. It is now home to the Roosevelt House Public Policy Institute at Hunter College. It was landmarked on September 25, 1973.

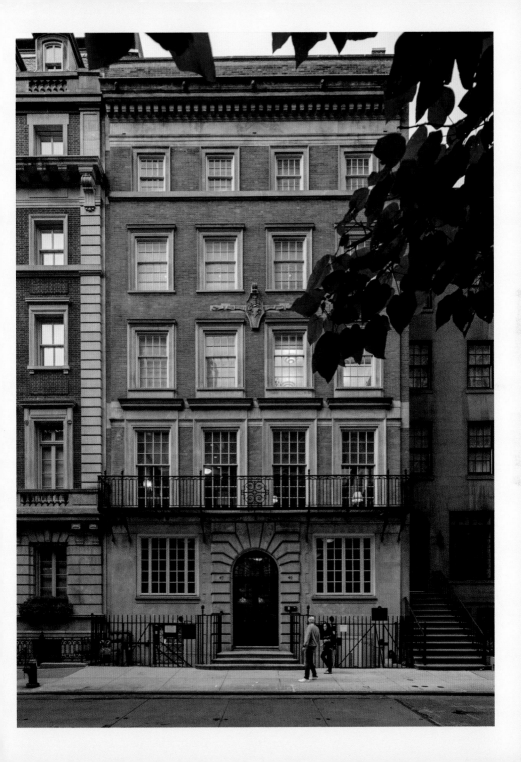

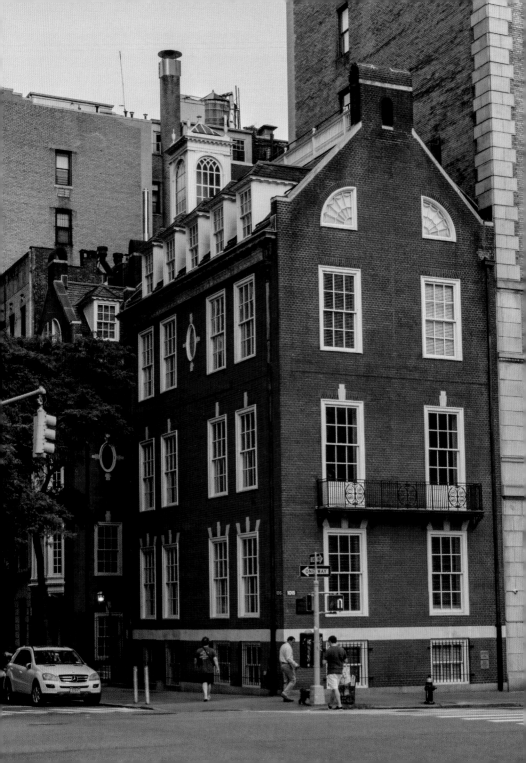

Lewis G. Morris House

BUILT: 1914
LANDMARKED: 1973
100 EAST EIGHTY-FIFTH STREET
UPPER EAST SIDE

If you have made it this far in the book, you might realize that there are not a lot of early American buildings in New York. This fact was not lost on the citizens of New York at the beginning of the twentieth century. They wanted to capture some of that lost history, which helped spur a new architectural style, called Neo-Federal. This house, at the corner of Eighty-Fifth Street and Park Avenue, was built for a family with deep revolutionary roots. Lewis G. Morris was the descendant of Lewis Morris, a signer of the Declaration of Independence. The Morris family was also very active in New York State politics throughout its history. In 1913, Morris hired architect Ernest Flagg to design this home for him and his wife Nathalie Bailey Morris. The home was completed in 1914. Flagg was notable at the time for the Singer Building in Lower Manhattan. The Morris family remained here until the death of Lewis Morris in 1968. The family desired to have the house preserved and sold it the same year to the New World Foundation. In 1999, the Avi Chai Foundation moved in. It was landmarked on April 19, 1973.

Marshall Orme Wilson House

BUILT: 1903
LANDMARKED: 1981
3 EAST SIXTY-FOURTH STREET
UPPER EAST SIDE

If you have watched HBO's *The Gilded Age*, you might be familiar with Caroline "Carrie" Astor, the daughter of the socialite Mrs. Caroline Astor. Carrie married Marshall Orme Wilson and, despite their disapproving of the match (Wilson's father had worked for the Confederate government), the Astors built the couple their first house at 414 Fifth Avenue.

The Wilsons would go on to build this house at 3 East Sixty-Fourth Street in 1903 following the extended Astor family's moves uptown. They hired the architectural team of Warren and Wetmore, who had just completed the New York Yacht Club and would go on to design Grand Central Terminal, to build the sixty-five-foot-wide home for them. Carrie Astor Wilson would become just as much a socialite as her mother, hosting large parties at the Wilsons' Sixty-Fourth Street mansion. She would live here until her death in 1948. Two years later, the home was sold to the Indian government and was converted into a consulate. It was landmarked as part of the Upper East Side Historic District on May 19, 1981.

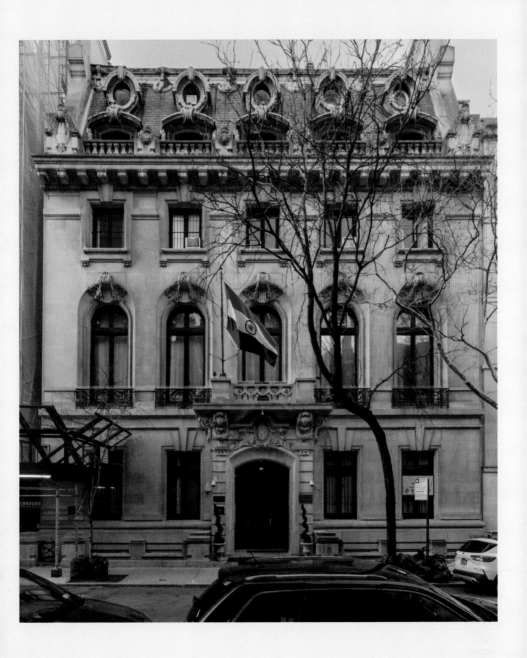

Henderson Place

BUILT: 1880–1882
LANDMARKED: 1969
HENDERSON PLACE
UPPER EAST SIDE

If you have never heard of Henderson Place, you're not alone. It is located as far east as you can go on the island of Manhattan, on East End Avenue between Eighty-Sixth and Eighty-Seventh Streets. Tourists usually have gotten lost on their way to the Met long before they make it over here. These houses were built between 1880 and 1882 by developer John Henderson. Originally, there were thirty-two buildings in the complex but eight were torn down. Henderson built these houses for "persons of moderate means" which is insane given these generally fetch over $4 million on the open market today. Henderson hired the architects Lamb and Rich, the same firm that designed Sagamore Hill, Teddy Roosevelt's country estate, leading to ornate flourishes on these buildings' facades. The Henderson Place Historic District was landmarked on February 11, 1969.

17 East 128th Street

BUILT: CIRCA 1864
LANDMARKED: 1981
17 EAST 128TH STREET
HARLEM

This is one of the oldest homes in Harlem, constructed in either 1864 or 1865. Harlem was an independent village founded in 1656 by Peter Stuyvesant, the director general of New Amsterdam, and it would remain pretty rural until the end of the nineteenth century. Although there were some rail lines running through the town, getting from Harlem down to New York City was a tedious journey. In the 1830s for example, only ninety-one families lived there. In the 1860s, due to a decline in good farmland, speculators began buying up subdivided properties and began to build homes similar to this one. However, the real development would not occur until the arrival of elevated trains in the 1880s. Most of the town houses in Harlem date from that construction boom. Most wood-frame homes were torn down, but no. 17 survived. Throughout its entire history, it remained a single-family home, with those families doing a decent job of keeping it original. It was owned for decades by Carolyn Adams and her husband. Adams was a principal dancer with the Paul Taylor Dance Company from 1965 to 1982 and has been an advocate for Harlem preservation and pride. The home sold in 2015 for $3.6 million. It was landmarked on December 12, 1981.

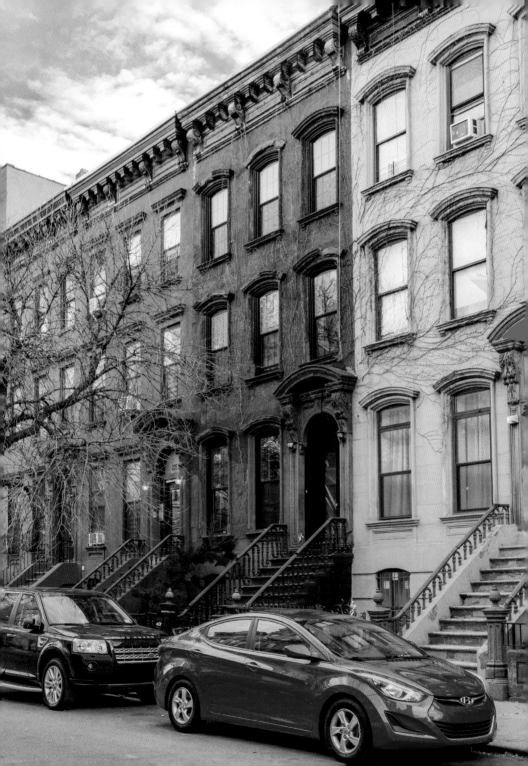

Langston Hughes House

BUILT: 1869
LANDMARKED: 1981
20 EAST 127TH STREET
HARLEM

This handsome town house on 127th Street (second from the right) is the former home of Langston Hughes. The town house was designed in 1869 by Alexander Wilson for developers James Meager and Thomas Hanson. This Italianate brownstone was a very common style for post–Civil War New York. Though Hughes was born in Missouri, he always dreamed of living in Harlem: "More than Paris, or the Shakespeare country, or Berlin, or the Alps, I wanted to see Harlem." There, he participated in the Harlem Renaissance. Hughes moved here in 1947 along with his "adopted" uncle and aunt, Emerson and Toy Harper. Hughes would occupy the top floor and have some of his most productive writing years here. He passed away in 1967, and the Harper family continued to own the home until at least 1981. No. 20 East 127th Street sold most recently in 2003. The building was landmarked on August 11, 1981.

New York Public Library, Schomburg Collection for Research in Black Culture

BUILT: 1905
LANDMARKED: 1981
104 WEST 135TH STREET
HARLEM

The New York Public Library, Schomburg Collection for Research in Black Culture is one of the original Carnegie libraries in New York. You may have never heard of the Carnegie libraries, but more than 1,600 were built in the United States, with 106 in New York, thanks to a grant from Andrew Carnegie. This one is located on 135th Street and was built in 1905. At the time, this part of Harlem was primarily an upper-middle-class Jewish neighborhood, but demographic trends began to change, with the area becoming home to a large Black population by the 1920s.

Ernestine Rose, the branch librarian from 1920 to 1942, sought to make this library a center of the community as she had done for other libraries throughout her career. She integrated the library staff and sought to acquire collections of Black authors. With the assistance of her first hire, Catherine Latimer, she was able to begin collecting works on Black history. Eventually, Rose succeeded in getting a $10,000 gift from the Carnegie Corporation for the purchase of the personal archive of Arturo Schomburg and hired him to head the collection in 1926.

Arturo Alfonso Schomburg was born in Puerto Rico in 1874. His mother was Black, and his father was the son of a German immigrant. Schomburg became a historian, writer, and activist, spurred on by an event during his early education. In elementary school, Schomburg was told by a teacher that Black people didn't have history. He would spend his career documenting, writing, and collecting works of Africans and the diaspora, proving his teacher wrong. Schomburg, in addition to working with the NYPL, was also a curator at Fisk University in Nashville, Tennessee. Arturo Alfonso Schomburg passed away in 1938 following dental surgery, and his massive collection of artwork, manuscripts, and rare books was the cornerstone of the 135th Street branch, which was named in his honor in 1940. The New York Public Library, Schomburg Collection for Research in Black Culture was landmarked on February 3, 1981.

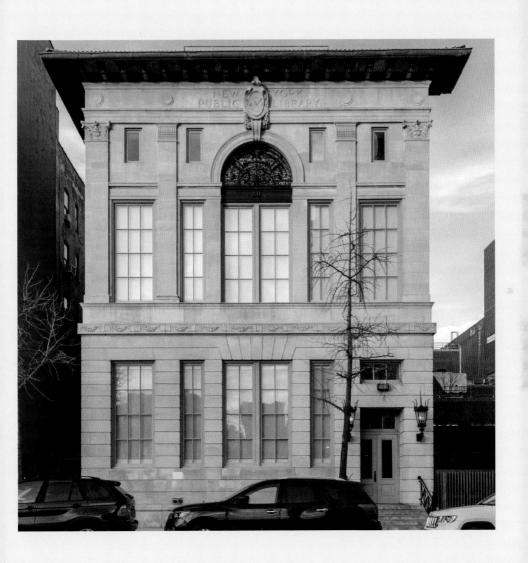

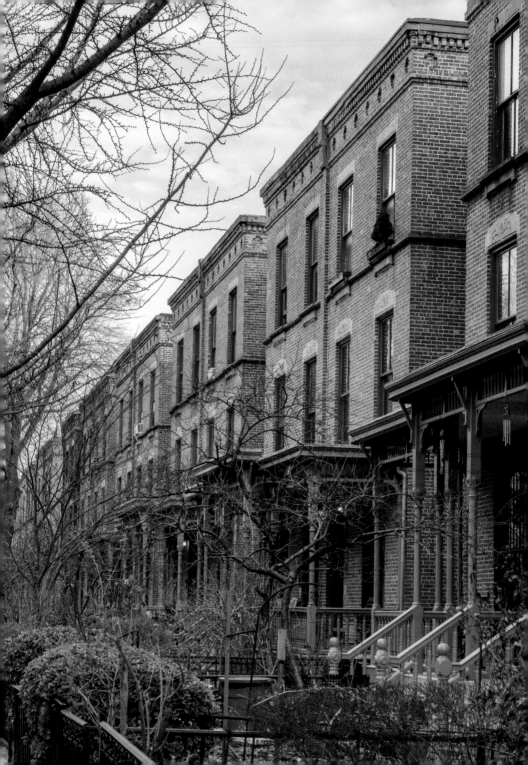

Astor Row

BUILT: 1880–1883
LANDMARKED: 1981
8–62 WEST 130TH STREET
HARLEM

This row of twenty-eight town houses on 130th Street is known as Astor Row. They were built between 1880 and 1883 by William Backhouse Astor on land purchased in 1844 by his grandfather John Jacob Astor. As mentioned in previous entries, Harlem saw a real explosion in growth after the 1880s with the advent of elevated railways reaching the neighborhood, which made these some of the first speculative developments. While many of the other homes being built in this period were made of brownstone, Astor Row was unique in its use of brick. They also featured large front yards and wooden porches on each one, a rarity in New York City. The houses were incredibly popular but dealt with decay throughout the middle of the twentieth century. After they were landmarked, the city, under Mayor David Dinkins, began to raise funds to help restore them, with the help of Brooke Astor, the widow of Vincent Astor. She provided grants for the New York Landmarks Conservancy, which was overseeing the restoration efforts. Unfortunately, one of the homes, no. 28, was destroyed in 2021 due to a long period of neglect and a lack of funding to fix the roof. Each building on Astor Row was landmarked on August 11, 1981.

Hamilton Grange

BUILT: 1801
LANDMARKED: 1967
414 WEST 141ST STREET
HAMILTON HEIGHTS

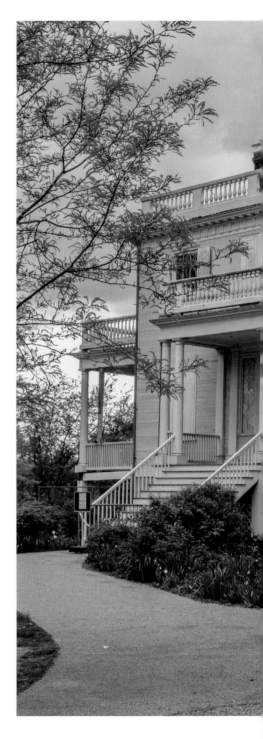

St. Nicholas Park is the picturesque set-ting for the Hamilton Grange, Alexander Hamilton's former home. Although it doesn't look out of place, the home was actually moved twice. Built in 1801 and designed by John McComb Jr., architect of City Hall and Gracie Mansion, the Hamilton Grange was the only home that the founding father owned. It was first moved in 1889 due to the extension of the city street grid, where it was used by St. Luke's Church as a chapel and rectory.

It was moved to its current home in 2008. The move was not easy, as the house had been wedged over the course of a few decades between the church and an apartment building. It was slowly raised up above the church on jacks, slid over the roof, dropped on remote-controlled wheels, and driven down the block to its pres-ent location. It reopened in 2011 and is now a national memorial. The Grange was land-marked on August 2, 1967.

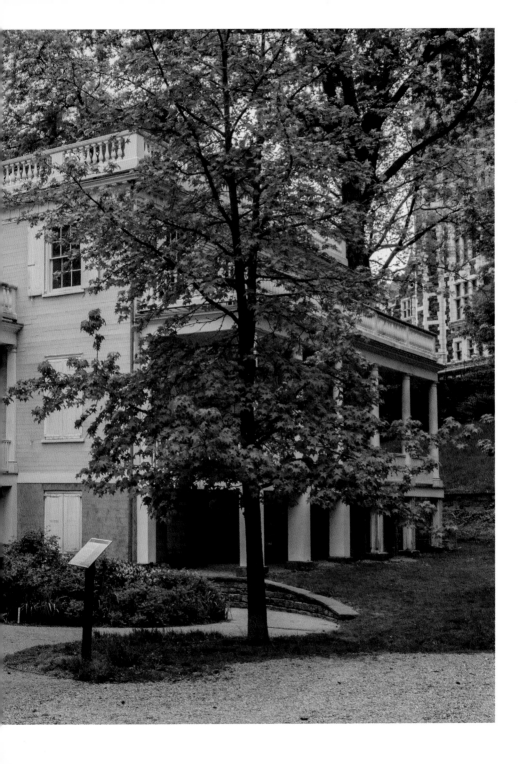

Royal Tenenbaums House

BUILT: 1887–1890
LANDMARKED: 1974
339 CONVENT AVENUE
HAMILTON HEIGHTS

Wes Anderson fans will recognize this building as the mansion from *The Royal Tenenbaums*. Located on the corner of 144th Street and Convent Avenue, 339 Convent Avenue was built in 1890 for Jacob D. Butler with help of architect Adolf Hoak, on what used to be the estate of Alexander Hamilton. In the early 1800s, Hamilton Heights was the premiere country getaway for wealthy New Yorkers who had secondary homes overlooking the Hudson River. Toward the end of the nineteenth century, with the advent of rapid transit, it developed a more urban character with higher-density construction. The home's most famous resident was Charles H. Tuttle, a lawyer and Republican nominee for president in 1930. Due to a financial panic in 1907, many of these homes were sold to wealthy Black families who began moving up from the West Fifties in Manhattan. In 2021, the entire house was put on the rental market for $20,000 a month. The mansion was landmarked as part of the Hamilton Heights Historic District on November 26, 1974.

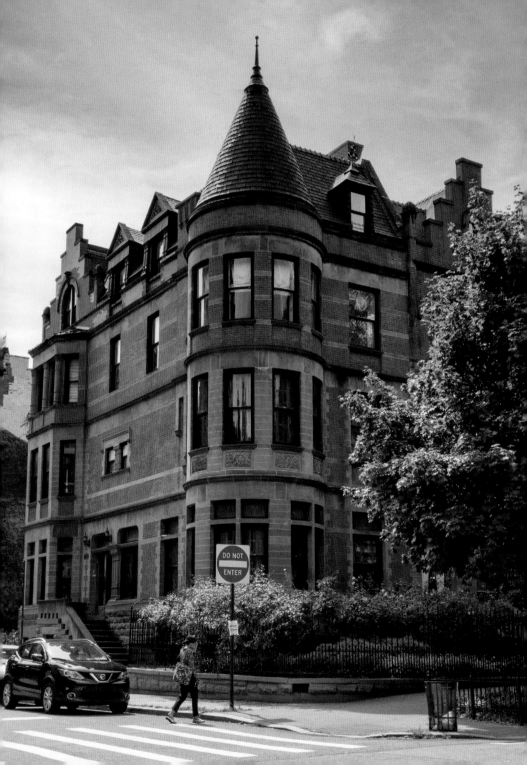

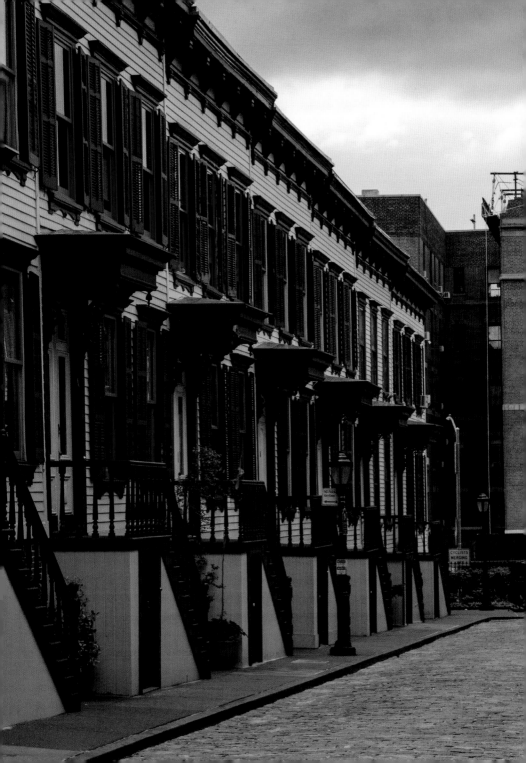

Sylvan Terrace

BUILT: 1882
LANDMARKED: 1970
SYLVAN TERRACE
WASHINGTON HEIGHTS

Washington Heights is one of the most unusual and underrated neighborhoods in New York City. The rigid grid system of the rest of Manhattan had to become a little more flexible to accommodate its unique topography, which includes rolling hills. Back at the city's founding, the area around Sylvan Terrace near 160th Street was farmland in the village of Harlem. The area would remain very rural up until the end of the 1800s, when this street was built. This was one of the first examples of an investor-developer operating in the neighborhood. The homes were designed by G. Robinson Jr. for owner James E. Ray. Ray had these twenty identical row houses built on both sides of the road from the neighboring Morris-Jumel Mansion to St. Nicholas Avenue. All of these houses were built in 1882, and they remain very true to their original design. Much like the other wooden buildings found farther uptown, these were built outside of the reach of the New York City fire codes, allowing them to be built relatively late in the nineteenth century. Sylvan Terrace was landmarked as part of the Jumel Terrace Historic District on August 18, 1970.

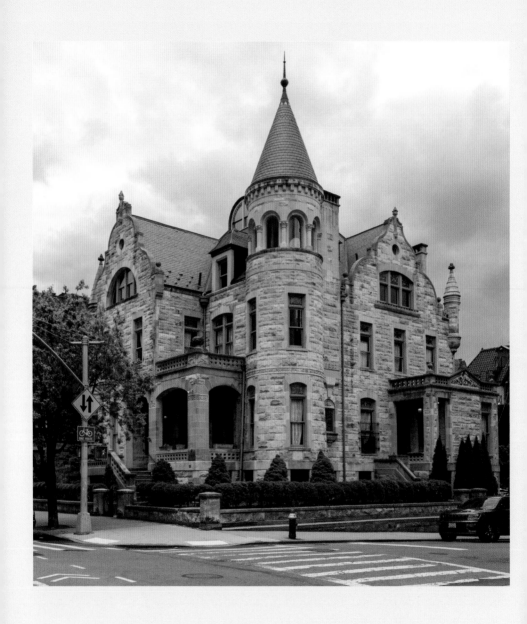

James Bailey House

BUILT: 1886–1888
LANDMARKED: 1974
10 ST. NICHOLAS PLACE
SUGAR HILL

Who knew picking up peanut shells could pay so well? James Bailey was a circus magnate whom you've probably heard of, from the Barnum & Bailey Circus. In 1886, he commissioned architect S. B. Reed to design his castle-like dwelling on St. Nicholas Place in Sugar Hill, where he could enjoy his retirement. This would be a lovely country retreat for the Baileys, as the entire neighborhood was mostly rural farmland when his home was built. At the time, the mansion had clear views of Long Island Sound to the east. Bailey also had Joseph Tiffany, cousin of Louis Comfort Tiffany, do some of his interior finishes. The Baileys would move out of the home in 1904, and it was later used as a doctor's office and then a funeral home, which gave it a reputation for being a bit haunted. It sold in 2009 for $1.5 million. At 8,200 square feet, it is one of the largest freestanding homes remaining in Manhattan. It was landmarked on February 19, 1974.

Morris-Jumel Mansion

BUILT: 1765
LANDMARKED: 1967 AND 1975
65 JUMEL TERRACE
WASHINGTON HEIGHTS

If you live on the East Coast of the United States, you almost inevitably have that one building in town that "George Washington slept in." In New York City, not only can you see where Washington slept, but you can see where he commanded the Continental Army. Located in Washington Heights, the Morris-Jumel Mansion was built in 1765, making it the oldest remaining house in Manhattan. It was built by Colonel Roger Morris as a summer home, which he later had to abandon due to his being a loyalist to the British Crown. During the war, Washington used the house as a headquarters from September 15 to October 18, 1776. After the war, the house was sold to Eliza and Stephen Jumel, a merchant couple. When Stephen died, Eliza was the one of the richest women in New York. She married former vice president Aaron Burr the following year. The marriage would last only a few months thanks to Burr's mismanagement of their assets.

In 1903, the home was purchased by the city for conversion into a museum. More recently, Lin-Manuel Miranda wrote parts of his hit musical *Hamilton* in the mansion. The grounds and building remained almost untouched since it was built and have a commanding position in the neighborhood. It is on the National Register of Historic Places and is a rare double landmark, with its exterior receiving its designation on July 12, 1967, and the interior on May 27, 1975.

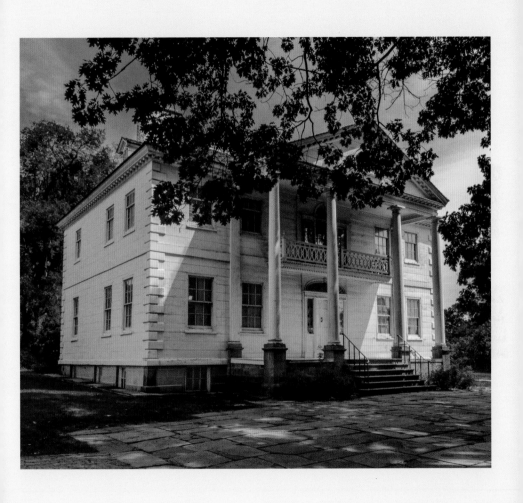

The Little Red Lighthouse

BUILT: 1880 (REBUILT: 1921)
LANDMARKED: 1991
FORT WASHINGTON PARK
WASHINGTON HEIGHTS

I want to share my favorite building in the entire city with you, the Little Red Lighthouse. When my grandfather was growing up in Washington Heights in the 1930s and '40s, my great-grandfather would take him for a walk every night down to the banks of the Hudson to visit the lighthouse. He passed that love onto me when I was growing up by getting me the children's book *The Little Red Lighthouse and the Great Gray Bridge*.

My grandfather's love of the lighthouse was not unique. It was a favorite of many children thanks to that book, published in 1942 and written by Hildegarde Swift and Lynde Ward. It had such an impact that when a proposal to tear down the lighthouse appeared in 1951, children all over New York pushed for its preservation, with a four-year-old offering to buy it himself. Editorials ran in multiple New York newspapers calling for a stay of execution, with one child psychiatrist stating that the lighthouse symbolized for children "the reassurance that even though you are little in a big world, you won't be annihilated." Luckily, child psychiatrists stopped using the word *annihilated* with children, and the push to preserve the lighthouse was successful.

The lighthouse began life in 1880 in Sandy Hook, New Jersey, where it served until 1921, when it was disassembled and shipped up the Hudson to Jeffrey's Hook. It stayed in operation as a navigational aid complete with light and foghorn until 1947. It was purchased by the city in 1951 with the support of parks commissioner Robert Moses. The Little Red Lighthouse became a national landmark in 1971 before becoming a landmark on May 14, 1991.

United Palace Theater

BUILT: 1929–1930
LANDMARKED: 2016
4140 BROADWAY
WASHINGTON HEIGHTS

New York has a rich history with the movies. In fact, the first paying audience for a projected film happened on Thirty-Fourth Street at Koster & Bial's Music Hall in 1896. In addition to being one of the first places to screen films, New York is the place where the film industry really developed, before moving to Los Angeles. Marcus Loew, the founder of his eponymous chain of cinemas, was born on the Lower East Side and worked his way up from a newsboy to showing projected movies in his vaudeville theaters. In 1910, his company went public, and he began a building spree. The Loew's theater on 175th Street, now referred to as the United Palace theater, was one of Loew's "Wonder Theatres." These were designed not just to seat thousands of people, but to be works of art from the outside. This theater is one of the few freestanding ones, part of architect Thomas Lamb's vision for it to be admired from all angles. The uniqueness of the space is amplified by utilizing the "Indo-Persian"

revival-style, something rarely seen in buildings anywhere else in New York City.

During the 1960s, the theater experienced a decline and, despite the company's best efforts, could not remain open. It was sold on April 4, 1969, to the Reverend Frederick Joseph Eikerenkoetter II. He was apparently so impressed with the place after a screening of *2001: A Space Odyssey* that he decided to purchase it, rename it the United Palace, and use it as his congregation's new meeting place. Eikerenkoetter preserved the interior, which remains virtually unchanged since the movie days. Today it still hosts worship by the congregation as well as film screenings and art performances. In 2023, the Tonys were hosted here for the first time, and it was only the fourth time the awards were held outside of Radio City Music Hall since it started hosting in 1997. The United Palace theater was landmarked on December 13, 2016.

Dyckman Farmhouse

BUILT: CIRCA 1783
LANDMARKED: 1967
4881 BROADWAY
INWOOD

At the top of Manhattan sits the last farm-house on the entire island. This is the Dyckman Farmhouse, which was built in c. 1783 by William Dyckman. It replaced an earlier home built in 1748 that was destroyed by the British Army. The farm was occupied by both armies during the Revolutionary War. It is believed that parts of the original house were salvaged to help build this one. In addition to the Dyckman family living on the farm, they relied on the labor of free and enslaved Africans.

One of the most interesting aspects, apart from the fact that it is a farmhouse in the middle of New York, is that it is one of the last houses in the city that show its Dutch past. This type of home would have been a very common sight in the mid-seventeenth to eighteenth centuries throughout New York. After much of the farmland was auctioned off in the 1870s, the house fell into disrepair. In 1915, the descendants of William Dyckman refurbished the house and gave it to the city to protect it from development. It is on the National Register of Historic places and received its designation on July 12, 1967.

Blackwell House

BUILT: 1796
LANDMARKED: 1976
500 MAIN STREET
ROOSEVELT ISLAND

Roosevelt Island has had more names over its history than a neighborhood undergoing gentrification. During Dutch rule it was known as Hog Island (translated from Varkens Eyelandt), then Blackwell's Island. In the early 1900s it earned the nickname Welfare Island, and most recently Roosevelt Island. This is the farmhouse of James Blackwell, the owner of the island in the late eighteenth and early nineteenth centuries. Blackwell had inherited the island and used it for agriculture. In 1796 he built his house, which was one of a half dozen buildings on the island at the time.

New York City purchased the island in 1828 and built a penitentiary on it. Eventually the island would house prisons, a smallpox sanitorium, psychiatric hospitals, and an assortment of other undesirable institutions. It's no wonder people stopped beating around the bush and just referred to it as Welfare Island. At the end of the twentieth century, the island underwent another transformation, this time more residential, with multiple apartment buildings sprouting up along the island's spine and some of the other landmarks being repurposed as lobbies for luxury developments.

The house fell into disrepair until the late 1960s, when it underwent a full renovation under the advice of the Landmarks Preservation Commission. Blackwell House was landmarked on March 23, 1976.

BROOKLYN

Brooklyn Borough Hall

BUILT: 1845–1848
LANDMARKED: 1966
209 JORALEMON STREET
DOWNTOWN BROOKLYN

Brooklyn often feels like a city within a city—probably because it once was. For more than fifty years, this Greek Revival building served as city hall for an independent Brooklyn. The building was initially designed by architect Calvin Pollard after he won a competition in 1835. However, the project suffered from cost overruns and delays, including a complete halting of construction in 1836 after the foundation was laid. Construction resumed in 1845 under the watchful eye of architect Gamaliel King. City hall opened in 1848, and construction would wrap up officially in 1851.

A later addition to the building was a wooden fire lookout station (cupola and clock tower). Ironically, after it was retired from that use, it burned down in 1895—the current one is a cast-iron replica. Upon the merger of Brooklyn with the city of New York on January 1, 1898, the building became known as Borough Hall and was landmarked on April 19, 1966.

Harriet and Thomas Truesdell House

BUILT: 1845–1851
LANDMARKED: 2021
227 DUFFIELD STREET
DOWNTOWN BROOKLYN

The cities of New York and Brooklyn both benefited from the labor of enslaved Africans throughout the early parts of their histories. Despite the outlawing of the practice in New York State in 1827, both cities still profited from trade with Southern states. In the port of Brooklyn, this would lead to an interesting dichotomy. The city of Brooklyn continued to profit from the by-products of enslaved labor, while simultaneously becoming an area for people escaping enslavement to enter New York on their way north. In fact, the port would end up becoming a hub of abolitionist activity.

This house at 227 Duffield Street was home to two abolitionists, Harriet and Thomas Truesdell, who lived here from 1851 to 1863. The Truesdells were founding members of multiple antislavery societies, both in Brooklyn and in their home state of Rhode Island. In 1850, the Fugitive Slave Act was passed, imposing stiff penalties on anyone harboring escaped enslaved peoples seeking freedom. There is anecdotal evidence that the Truesdells' home was used as a stop on the Underground Railroad; however, concrete evidence has not yet been found by the Landmarks Preservation Commission.

The home underwent multiple modifications throughout the stewardship of the Truesdell family, who would own this home until the 1920s. Originally a Greek Revival town house, the home later had its first two stories converted into a storefront. In 2019 there were plans to demolish the building, but due to overwhelming opposition from activists in the community, the building received a hearing by the Landmarks Preservation Commission, which voted to landmark it on February 2, 2021. Later that year, the city purchased the building for $3.2 million with plans to turn it into a cultural center. As of this writing, the building is still under renovation.

Bridge Street Church

BUILT: 1847
LANDMARKED: 1981
311 BRIDGE STREET
DOWNTOWN BROOKLYN

This is the former Bridge Street Church, located in Brooklyn Commons (formerly MetroTech Center) in Downtown Brooklyn. Constructed in 1847 for the First Free Presbyterian Church, it was purchased in 1854 by the African Wesleyan Methodist Episcopal Church. They renamed it to the First Free Congregational Church, also known as the Bridge Street Church. The AWME Church was the first free Black congregation in Brooklyn when it was founded in 1818. The congregation was heavily involved in the abolitionist movement and the Underground Railroad, with many freedom-seeking enslaved people hiding in the basement of the church on their way to Canada. The Bridge Street Church remained in this building until 1948, when it moved to the Bedford Stuyvesant neighborhood. Despite the congregation's move, the building was able to survive the redevelopment of the MetroTech complex, which required tearing down close to one hundred old buildings to create a new superblock. The church was landmarked on November 24, 1981.

Brooklyn Fire Department HQ

BUILT: 1892
LANDMARKED: 1966
365–367 JAY STREET
DOWNTOWN BROOKLYN

This building on Jay Street in Downtown Brooklyn was the former headquarters for the Brooklyn Fire Department. Right before the unification of New York in 1898, Brooklyn was growing rapidly. It was considered a rival city to New York, and with Manhattan seemingly running out of space, the Brooklyn elite thought it only natural that their city would eclipse the island. Little did they know that instead of building out, Manhattan would build up, but that's a story for another time. The City of Brooklyn was erecting grand municipal buildings at a rapid clip, including this one in

1892 designed by Frank Freeman. It would be only six short years before Brooklyn became a part of greater New York and the HQ was converted into a regular, if not expansive, firehouse. It would remain in operation as a firehouse for the FDNY until the 1970s. After that, it was converted into housing, initially for elderly residents being displaced by the development. In 2013 it underwent substantial renovations to bring it into compliance with guidelines from the Landmarks Preservation Commission. It was one of the first landmarks in New York, receiving its designation on April 19, 1966.

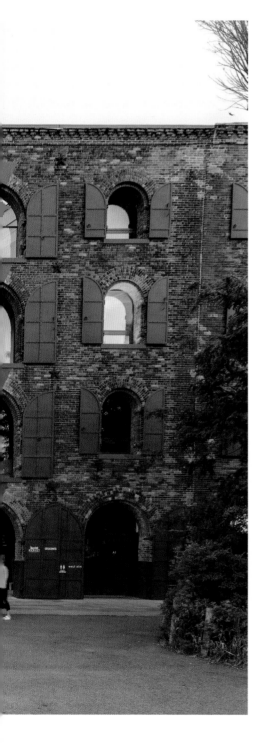

Empire Stores

BUILT: 1885
LANDMARKED: 1977
53–83 WATER STREET
DUMBO

In the late nineteenth century, the Brooklyn waterfront was packed with massive warehouses like the one you see here. These particular warehouses were called the Empire Stores, and they stockpiled raw goods like coffee, sugar, and molasses. It was ideally situated, with a sugar refinery located across the street, and had easy access to ships delivering coffee from all over the world. Currently, the warehouse is home to West Elm's corporate office and the massive Time Out Market. It also has amazing views of the Brooklyn and Manhattan Bridges. The proliferation of these monolithic warehouses around Dumbo and the Fulton landing area briefly gave rise to Brooklyn's nickname "the walled city." Empire Stores was landmarked as part of the Fulton Ferry Historic District on July 28, 1977.

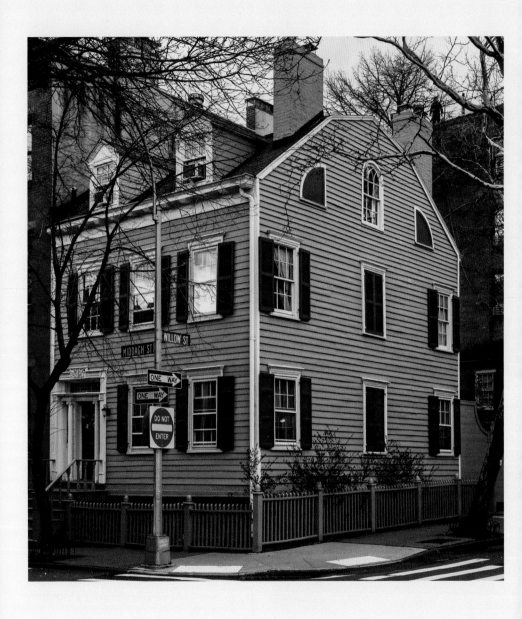

24 Middagh Street

BUILT: CIRCA 1820
LANDMARKED: 1965
24 MIDDAGH STREET
BROOKLYN HEIGHTS

The word *compound* is generally associated with a military base, or the Kennedys, not usually someone's living situation in New York. And yet on Middagh Street in Brooklyn Heights, a family had exactly that. This home is one of the oldest in the neighborhood. We don't know exactly when it was built, but it was likely sometime in the 1820s. The wooden home also has a small carriage house, which dates to roughly the 1850s, but it was much smaller than it is now. In 1946, the Fitz Randolph family, who were the owners at the time, began a tradition of mailing information about the home to new owners. In 1958, that packet landed with the Weisman family, who would go on to own the home for more than sixty years. In 2022, the home came on the market and eventually sold for $4.2 million. It remains one of the most charming and coveted houses in Brooklyn. It was landmarked as part of the Brooklyn Heights Historic District on November 23, 1965.

Truman Capote House

BUILT: 1839
LANDMARKED: 1965
70 WILLOW STREET
BROOKLYN HEIGHTS

This stately 1839 town house in Brooklyn Heights packs a historical punch. Located at 70 Willow Street, it is most notable for being the former home of author Truman Capote, who wrote his novel *Breakfast at Tiffany's* here. While he claimed to own the building when discussing it with city socialites, he actually rented the basement apartment from set designer Oliver Smith, who created the backdrops for Broadway shows like *West Side Story* and *Guys and Dolls*. In an essay he wrote called "A House on the Heights," Capote discusses how he was able to persuade Smith to let him stay there. He effectively got him martini drunk and asked him, *How many rooms do you really need all to yourself?*

The home was originally built for Adrian Van Sinderen, who hailed from an old Dutch New York family. Over the years it has also played host to the anti-suffragette movement thanks to resident Caroline Putnam at the end of the nineteenth century. It is a single-family home today and sold in 2012 for $12.5 million. It was landmarked as part of the Brooklyn Heights Historic District on November 23, 1965.

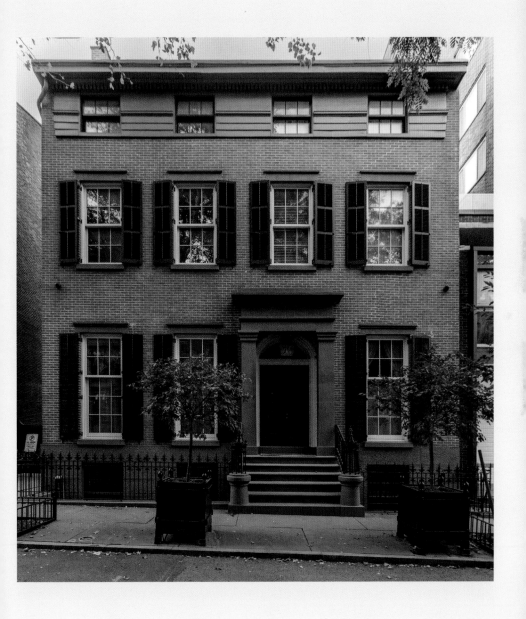

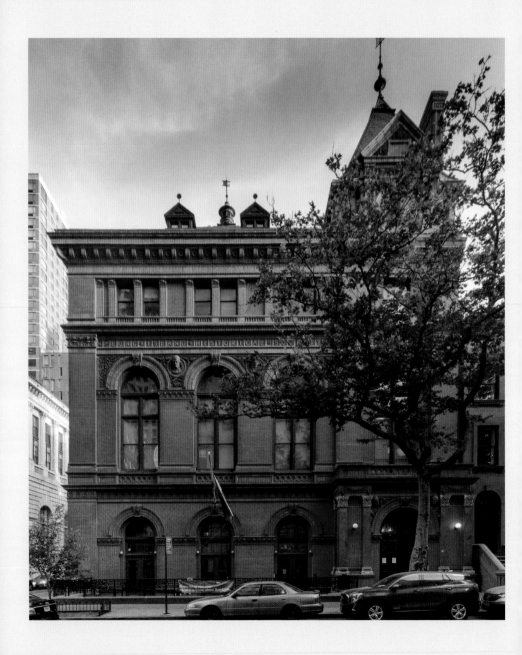

The Brooklyn Historical Society

BUILT: 1878
LANDMARKED: 1965
128 PIERREPONT STREET
BROOKLYN HEIGHTS

The Center for Brooklyn History, formerly the Brooklyn Historical Society, formerly the Long Island Historical Society, was founded in 1863. The purpose of its creation was to document the history of "all Long Island." In the mid-nineteenth century, Brooklyn did not have as distinct an identity as it does today. In fact, it was one of six towns within Kings County. This is why the Battle of Brooklyn during the Revolutionary War is also referred to as the Battle of Long Island. The city of Brooklyn would expand and begin to absorb these other towns, coinciding with a massive wave of immigration, making it the third-largest city in the country. The citizens of Brooklyn were always looking to distinguish their city from its sibling across the river, in Manhattan. Organizations like the Long Island Historical Society were an attempt to do that.

Prior to moving to this building, the Long Island Historical Society was located in the Hamilton Building, on the corner of Court and Joralemon Streets. However, that building caught fire in 1874, prompting the construction of the historical society's current home. In 1878, this building was constructed on Pierrepont Street in Brooklyn Heights. It was designed by renowned architect George B. Post, who would go on to design the New York Stock Exchange. You can see "notable Brooklyn residents," like Ludwig van Beethoven, Christopher Columbus, and William Shakespeare, etched into the facade. The name Long Island Historical Society stuck until 1985, when it was renamed the Brooklyn Historical Society, which is why both names are listed on the building. In 2020, it merged with the Brooklyn Public Library to become the Center for Brooklyn History which now offers Brooklyn historical programming at all branches. It was landmarked as part of the Brooklyn Heights Historic District on November 23, 1965.

Colonnade Row, Willow Place

BUILT: 1846–1848
LANDMARKED: 1965
43–49 WILLOW PLACE
BROOKLYN HEIGHTS

Willow Place is a small street in Brooklyn Heights lined with some amazing pre–Civil War buildings. These buildings at the end, nos. 43–49, are commonly referred to as "Colonnade Row" due to the massive portico that stretches across the four houses. They were all built between 1846 and 1848 for four different owners. Porticoes like this one used to be far more common throughout the city, making these homes a rare glimpse into the 1800s and spicing up what would otherwise be run-of-the-mill Greek Revival homes. Willow Place has the two surviving examples in the neighborhod. A third Colonnade Row existed on Columbia Heights and Middagh Street but burned down in 1853. While these homes now sell for millions, this was a decidedly working-class area in the late 1800s, when large waves of Italian immigrants began to settle the streets around Willow Place. The area was known for a time as "Willow Town" and was viewed as a distinct neighborhood from Brooklyn Heights, at least according to the old money that lived there. All of Colonnade Row was landmarked as part of the Brooklyn Heights Historic District on November 23, 1965.

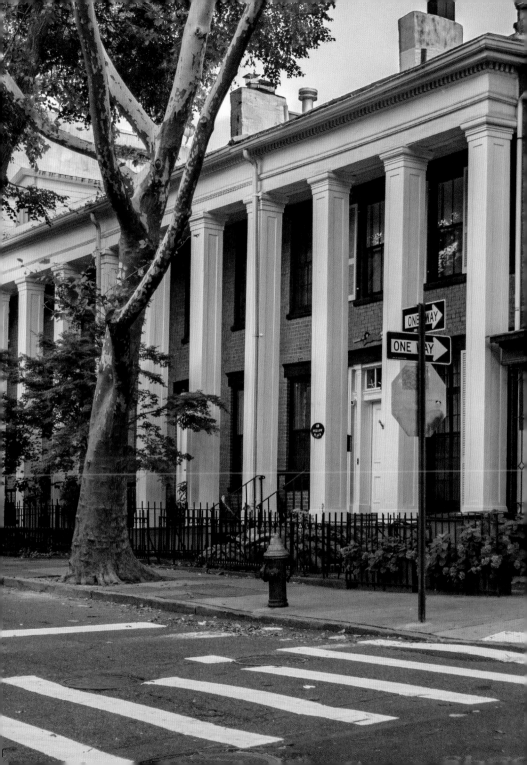

16 Hunts Lane

BUILT: UNKNOWN
LANDMARKED: 1965
16 HUNTS LANE
BROOKLYN HEIGHTS

One of the best aspects of Brooklyn Heights is its charming little side streets. Houses such as this one at 16 Hunts Lane feel like they're from a completely different city. You can find a handful of these streets in the neighborhood like College Place or Grace Court Alley. The only problem is that it is nearly impossible to get much information on them. There are a few reasons why. These carriage houses generally don't show up on early Brooklyn City records, making it almost impossible to put a date on their construction. Additionally, since these were built for horses and buggies and then converted into garages, there doesn't seem to have been much interest in them until recently. Clay Lancaster's book *Old Brooklyn Heights: New York's First Suburb*, one of the most detailed surveys of most buildings in the neighborhood, omits Hunts Lane completely. For most landmark districts, the Landmarks Preservation Commission puts out a designation report that mentions the history of each building in said district. That is usually the best place to start while researching the city's landmarks;

however, Brooklyn Heights is unique. It was the first landmark district in New York, so the Landmarks Preservation Commission was still working out how it was going to create these reports on a neighborhood level. What results is a three-page document outlining the high-level history of the neighborhood without going into specifics around the buildings. Contrast that with Greenwich Village, the second landmark historic district, which came around four years later, in 1969, and which has a designation report of more than four hundred pages. As a result, we have to make some inferences from the sources we have. Generally speaking, these carriage houses would have belonged to whoever lived in the brownstone or mansion on a neighboring street, so it is most likely that this belonged to someone on either Remsen or Joralemon Street. Many of these homes served as garages until they were converted in housing in the later portion of the twentieth century. No. 16 Hunts Lane was landmarked as part of the Brooklyn Heights Historic District on November 23, 1965.

Warren Place

BUILT: 1878
LANDMARKED: 1969
WARREN PLACE
COBBLE HILL

I t's always fun to find a place that doesn't con-
form to New York's grid system. Warren
Place in Cobble Hill is one such gem. It was
built in 1878 between Warren and Baltic
Streets by Alfred Tredway White. White was a
wealthy investment banker and an active mem-
ber of the Unitarian Universalist Church. He
built many units of housing for low-income
New Yorkers, trying to prove that private devel-
opers could help solve the city's housing crisis
by taking a lower profit margin and providing
well-ventilated, livable homes for the working
class. Journalist Jacob Riis witnessed White
speak at a church meeting: "How are these
men and women to understand the love of God
you speak of, when they see only the greed of
men?" Wouldn't it be nice if today's developers
had that attitude? There are thirty-four identi-
cal homes, each eleven and a half feet wide and
thirty-two feet deep. Because of their place-
ment, each home has access to a shared court-
yard and small back lots. However, because this
is New York, these "working-class houses" now
sell for millions. They were all landmarked as
part of the Cobble Hill Historic District on
December 30, 1969.

Leonard Jerome House

BUILT: 1849
LANDMARKED: 1969
197 AMITY STREET
COBBLE HILL

Winston Churchill is probably not the first person who comes to mind when you think of Cobble Hill, but the famed British prime minister can trace his family lineage to this house on Amity Street. No. 197 Amity Street was the rented home of Churchill's maternal grandfather, Leonard Jerome. Jerome made his early fortune in the telegraph business and would go on to make a fortune in the stock market as well as to become a minority owner of the *New York Times*. He was so prevalent in New York that Jerome Avenue in the Bronx was named after him. Before moving to his opulent mansion on Madison Square Park, he lived in this rented brownstone. It was here that his daughter Jennie Jerome was born in 1854. Jennie was fascinating in her own right. She would frequently visit Europe with her family, eventually meeting Lord Randolph Churchill and marrying him in April 1874. Winston would come along a few short months later, in November. She and Consuelo Vanderbilt were the original "Dollar Princesses," aka wealthy American women who would marry into British noble families that had run into financial difficulties. The home Jennie grew up in still retains its original appearance and was landmarked as part of the Cobble Hill Historic District on December 30, 1969.

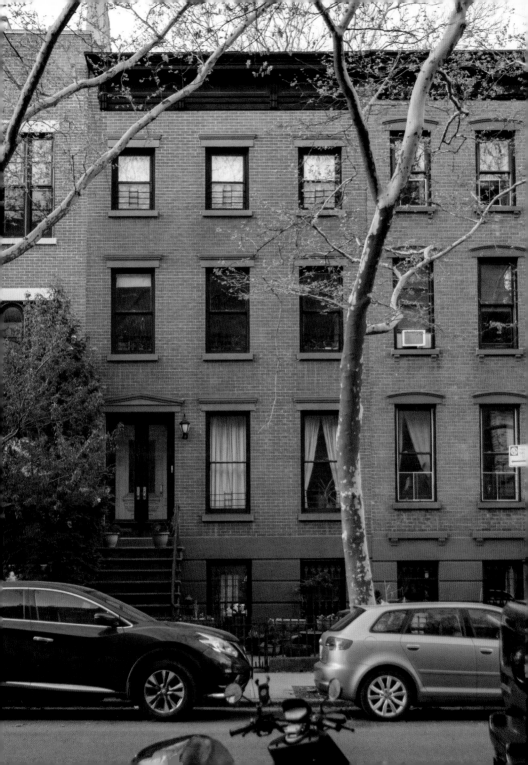

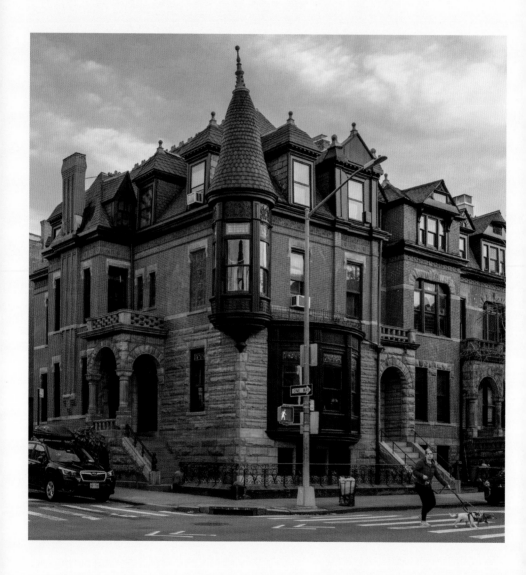

Lillian Ward Mansion

BUILT: 1887
LANDMARKED: 1973
21 SEVENTH AVENUE
PARK SLOPE

This house is giving some serious Gilded Age vibes. Built in 1887, this mansion is located in Park Slope at the intersection of Seventh Avenue and Sterling Place. It was designed by architect Laurence Valk in the Romanesque Revival style as part of four other buildings on Seventh Avenue, giving the block a very coherent look. This house is most famous for being the home of Lillian Ward, a nineteenth-century singer. In December of 1960, this house would also experience what was at the time one of the worst aviation disasters in US history, when a United Airlines DC-8 crashed into the intersection of Seventh and Sterling after colliding with a TWA Lockheed Constellation over Staten Island. The building survived undamaged but was widely photographed with the tail of the United plane outside of its front door. The building was recently renovated, and has three units. It was landmarked as part of the Park Slope Historic District on July 17, 1973.

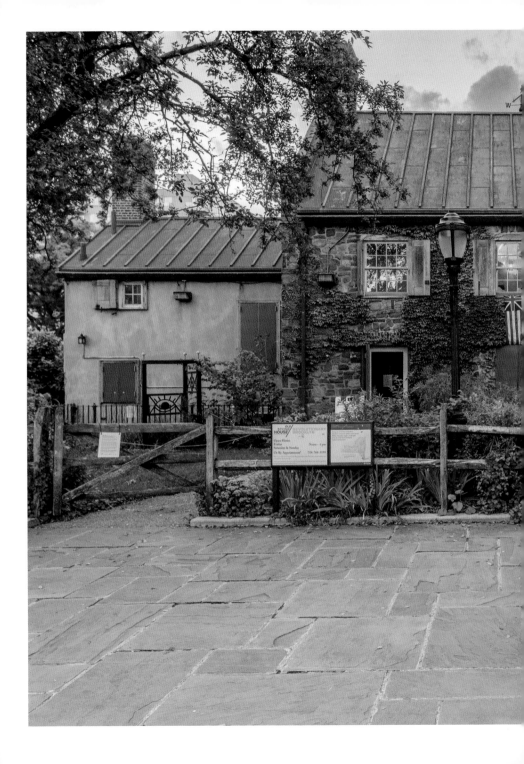

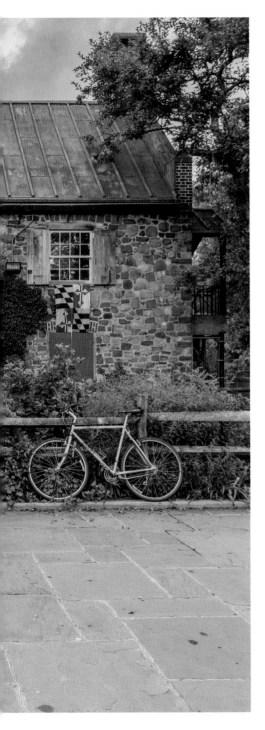

Old Stone House

BUILT: 1934
NOT LANDMARKED
336 EAST THIRD STREET
PARK SLOPE

This is the Old Stone House in Washington Park, on Fifth Avenue in Park Slope. You would think, with a name like that, this building would be old, made of stone, and a house. It is actually only one of those things—stone. This is a replica and one of the few nonofficial city landmarks featured in this book. The Old Stone House was originally a farmhouse built by Hendrick Claessen Vechte in 1699. The Vechtes were enslavers and had more enslaved people on their farm than freed ones. The house played a large role during the Revolutionary War, as the area around the farm was the location of a valiant battle fought by a regiment from Maryland that served as a rear guard, allowing Washington to evacuate the rest of his army to its defensive positions in Brooklyn Heights. This is why you'll find a Maryland flag flying from the house (well, the replica). In addition to serving as a farm, it was the first clubhouse of the baseball team that would become the Brooklyn Dodgers in the 1880s. It was demolished in 1897 just to be brought back thirty years later. (Seems like a bit of a waste of resources.)

Today the home is used by the First Battle Revival Alliance to help educate the public to the history of the site.

Soldiers' and Sailors' Arch, Grand Army Plaza

BUILT: 1889–1892
LANDMARKED: 1973
GRAND ARMY PLAZA
PARK SLOPE

Ever since I moved to Brooklyn, I've been obsessed with Grand Army Plaza, because who doesn't love a good arch? New York has plenty but only two "triumphal" arches, one in Washington Square Park, and one here. This arch was built in 1891 to honor the men of Brooklyn who fought for the Union in the Civil War. It was designed by John Duncan, who also designed Grant's Tomb in Riverside Park, and the cornerstone was placed in 1889 by General William T. Sherman. The statues were added in 1898 by sculptor Frederick William MacMonnies, with the left side dedicated to the army, and the right to the navy. Atop the arch is a statue called a quadriga, which incorporates four horses and a chariot. You can see this type of statue throughout the world, including the Brandenburg Gate and the Piazza San Marco in Venice. What makes this quadriga unique is it features the allegorical figure Columbia being pulled in a chariot, while two of the horses are led away by winged Victory.

If you actually go under the eighty-foot arch, you'll see a carving of Abraham Lincoln on one side and Ulysses S. Grant on the other. Although the roof used to be accessible as an observation deck, it has fallen into disrepair. In 2018, the city announced funds to repair and reopen the roof, and as of 2023, the entire arch is undergoing restoration and is completely covered by scaffolding. It was landmarked on October 16, 1973.

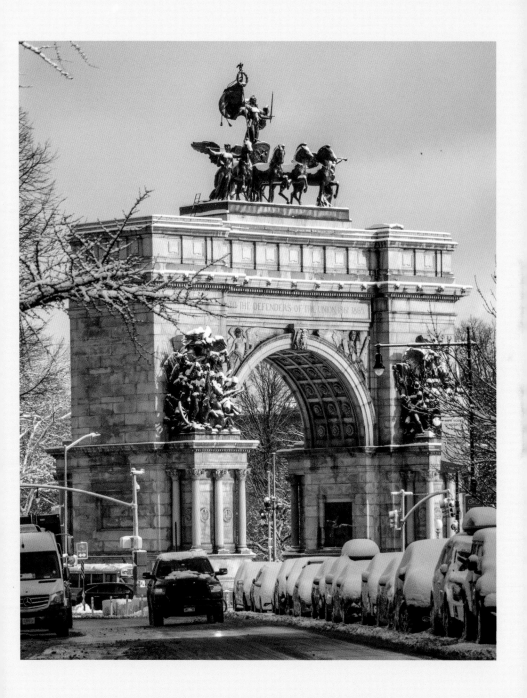

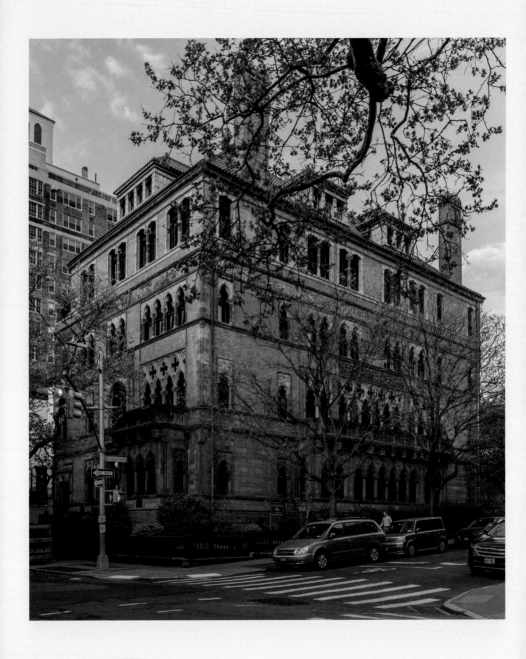

Montauk Club

BUILT: 1891
LANDMARKED: 1973
25 EIGHTH AVENUE
PARK SLOPE

In the late 1800s, Park Slope was rapidly developing, drawing the crème of Brooklyn society with it. Many of these people wanted to join social clubs, and by the end of the nineteenth century, there were hundreds all over the borough. Today, only the Montauk Club remains. Founded in 1889, it attracted some of Brooklyn's preeminent families and was founded by blue bloods Charles Pratt, Edwin Litchfield, and Richard Schermerhorn. The clubhouse was designed by architect Francis Kimball, who also oversaw the construction of Trinity College in Hartford, Connecticut. The building was completed in 1891 on the outer loop of Grand Army Plaza. It was reportedly designed after a Venetian palace, the Ca' d'Oro, and includes sculptures of the Indigenous Montauk people on the facade. The club was fairly "progressive" in its day, being one of the first to allow women to use its facilities. Despite being visited by a multitude of political dignitaries throughout its history, in the mid 1900s, with declining membership, the club began to fall into disrepair. In order to continue operating, part of the building was sold to create condos, with the club retaining the first and second floors. It was landmarked as part of the Park Slope Historic District on July 17, 1973.

457 Twelfth Street, Park Slope

BUILT: PRE-1869
LANDMARKED: 2012
457 TWELFTH STREET
PARK SLOPE

This house, tucked away on Twelfth Street in Park Slope, is one of the earliest homes in the neighborhood, dating back to before 1869. The views from this enviable front porch have definitely changed over the years. In the mid 1800s, they would have overlooked rolling farms, and you could probably see parts of the relatively new Green-Wood Cemetery. Park Slope developed later than other parts of Brooklyn, and really didn't see a major building boom until the 1880s and 1890s after expanded railways made transportation substantially easier, ushering in the brownstone era. We can at least appreciate this little piece of its earlier history at 457 Twelfth Street. It was landmarked as part of the Park Slope Historic District Extension on April 17, 2012.

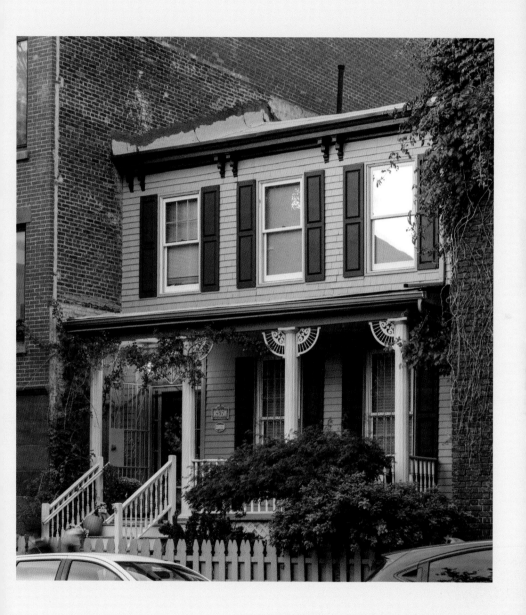

590-648 Second Street

BUILT: 1903
LANDMARKED: 1973
594 SECOND STREET
PARK SLOPE

Park Slope is beautiful in all seasons, but there is something particularly special seeing it in the snow, dressed up for the holidays. This house is one of twenty-six on the south side of Second Street built for developer William H. Reynolds in 1903. His Brooklyn-based architect, Benjamin Driesler, was able to give the illusion of uniqueness by varying the color and window design of each alternating home. Buildings such as these would have been speculative developments, in a way, the McMansions of their day. Reynolds was looking to capitalize on the building boom of the neighborhood, especially with the mansions on neighboring Prospect Park West, which drew some of Brooklyn's most elite families. Second Street between Prospect Park West and Eighth Avenue was landmarked as part of the Park Slope Historic District on July 17, 1973.

Litchfield Villa

BUILT: 1856
LANDMARKED: 1966
95 PROSPECT PARK WEST
PARK SLOPE

A long time ago in the city of Brooklyn, railroad and real estate developer Edwin Litchfield decided he was going to build himself a grand home. This house would be one of the most fashionable of its time, influenced by the designs of Italian villas and designed by one of the most popular architects of the day, Alexander Davis. Grace Hill, or Litchfield Villa as it came to be known, was completed in 1856 and would prove to be a major headache for the city of Brooklyn in the years ahead. After the completion of Central Park in Manhattan, Brooklyn decided it needed a grand park of its own, so much so that it hired the same exact team of Frederick Law Olmsted and Calvert Vaux. That was all well and good,

but the park's designers were going to run into a costly problem, mainly that Litchfield Villa was in their way. More than 40 percent of the park's budget for land acquisition, or $1.7 million, would have to go toward the purchase of the Litchfield estate, despite the fact that the estate would make up only 5 percent of the total land of the park. The purchase of the estate was not looked on favorably by the family, who fought against it. However, they were permitted to continue living in the house for a rent of $2,500 per year. After the Litchfields moved out in 1885, the mansion became the headquarters for the Brooklyn Parks Department and Prospect Park's information center. It was landmarked on March 15, 1966.

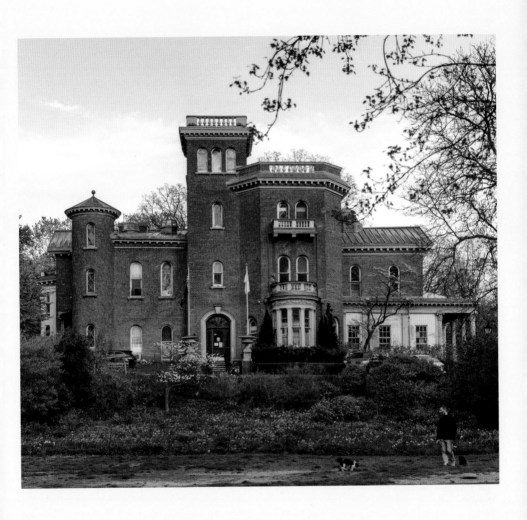

Flatbush Dutch Reformed Church

BUILT: 1793–1798
LANDMARKED: 1966
890 FLATBUSH AVENUE
FLATBUSH

The Flatbush Dutch Reformed Church is one of the oldest churches in New York and the oldest continuously used religious site in the city. There has been a church here since 1655, following an order by the director general of New Amsterdam, Peter Stuyvesant, the prior year. The current church on the site is actually the third one and was built between 1793 and 1798. Portions of the foundation were constructed from material from the second church on the site. The congregation served the oldest families in Flatbush, with the oldest legible graves dating to 1754. It is also the resting place of some soldiers killed in action from the Battle of Brooklyn during the Revolution. It was landmarked on March 15, 1966.

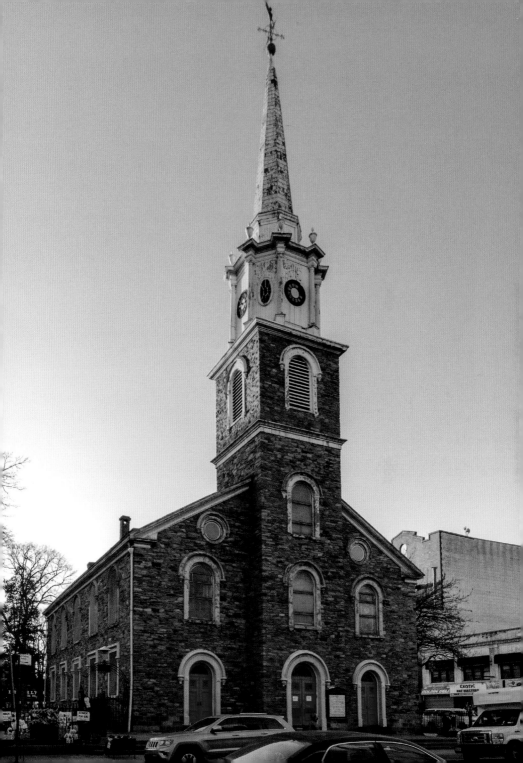

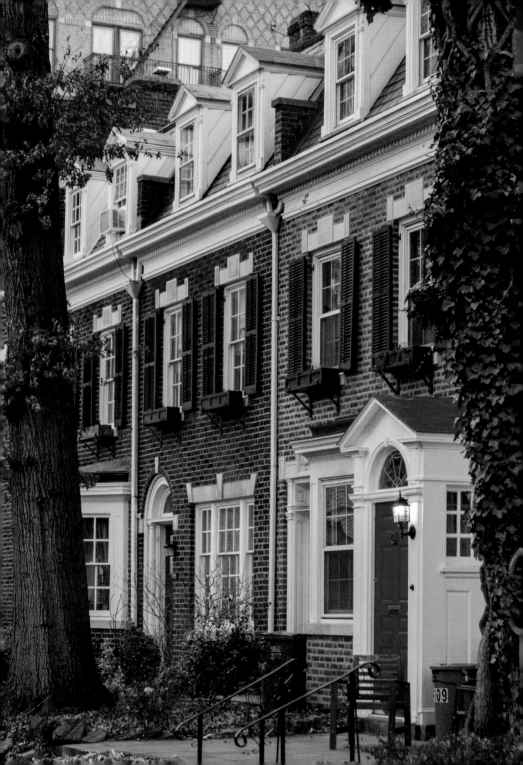

Albemarle-Kenmore Terraces Historic District

BUILT: 1916–1918
LANDMARKED: 1978
ALBEMARLE TERRACE
FLATBUSH

One of the most surprising areas I've stumbled upon is Albemarle Terrace in Flatbush, Brooklyn. These town houses were developed in the 1910s by owner Mabel Bull, who hired Brookyn-based Midwood Associates to build the twenty-three buildings. They were built at a time when Flatbush was gaining popularity with middle-class families seeking a more suburban experience than what they could get in the rest of Brooklyn and Manhattan. This architectural style was very popular in the latter half of the nineteenth and early twentieth centuries and looks like it could be right at home in London. The Albemarle-Kenmore Terraces Historic District was landmarked on July 11, 1978.

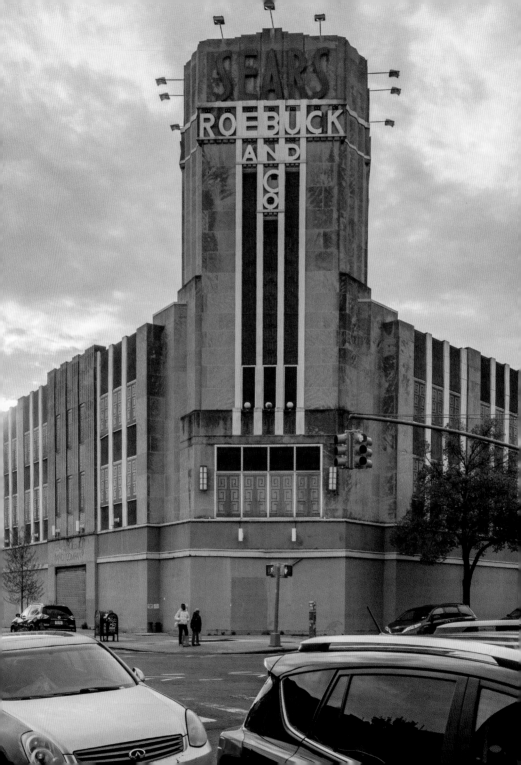

Sears

BUILT: 1932
LANDMARKED: 2012
2388-2420 BEDFORD AVENUE
FLATBUSH

New York City is full of amazing Art Deco buildings, from the Chrysler Building to One Wall Street, so it may surprise you to find a relatively suburban, former Sears on that list. This building is what used to be the Flatbush Sears Roebuck department store. Located on the corner of Beverly Road and Bedford Avenue, it was built in 1932, just eight years after Sears moved from being a mail-order company to a retail giant. What makes this store unique is the fact that it was built from the beginning with the car in mind, making it easily accessible to major roads as well as having a parking lot that was large for its time.

Its large central tower was designed to stick out with its large signs to attract customers. The store opened its doors on November 5, 1932, with Eleanor Roosevelt making remarks to those gathered. She would be the store's first customer, purchasing a pair of baby booties. This would be her last appearance prior to the election of her husband as president. Despite its history, the Flatbush Sears was the last New York City location of the company and officially closed its doors in 2021. In 2022, plans were made to convert the building into apartments. The Flatbush Sears was landmarked on May 15, 2012.

Wyckoff House

BUILT: 1652
LANDMARKED: 1969
5816 CLARENDON ROAD
EAST FLATBUSH

The first building landmarked in New York City is here at the Pieter Claeson Wyckoff house, and for good reason. The small portion of the house on the right was built in 1652, making it the oldest building in New York City. There is some debate on whether it's oldest in New York State, which depends on how you measure the age of the Staats House in Columbia County (Hornbeck). The Wyckoff farm was originally on the land of the Canarsie tribe, and was bought by the director general of New Netherland, Wouter Van Twiller, in 1636. Like many "purchases" made by the Dutch in this period, it is debatable whether the native Canarsie viewed this as a flat-out land purchase or a tenant agreement. After the invasion of New Netherland by the British in 1664, the land was given to the town of Flatlands, which is when the Wyckoff family moved in.

Pieter Claeson Wyckoff emigrated from Germany to New Netherland in 1637. At that time, he went by Pieter Claeson but changed his name to Wyckoff after the British take-over of the colony. Before moving to Flatlands,

Wyckoff was initially an indentured servant of the Van Rensselaer family in what is now upstate New York. He would go on to be the superintendent of the farm of Peter Stuyvesant, the last Dutch director of the colony. Stuyvesant was the largest enslaver in the colony of New Netherland, and, despite managing his farm, there is no evidence that Wyckoff himself enslaved anyone, though he would have been in charge of enslaved people in his professional capacity. We do have evidence, though, that later generations of Wyckoffs would own enslaved people, with his son enslaving two people and Abraham Wyckoff owning three enslaved men in the early 1800s. While we do not have their last names, we know that the first names of those men were Sam, Elijah, and Jack.

The Wyckoff family would remain at the house all the way until 1901, when they sold it. However, in 1961, the Wykcoff family descendants would repurchase the home to help preserve it. It was donated to the Parks Department in 1965 and was officially landmarked on October 14, 1969.

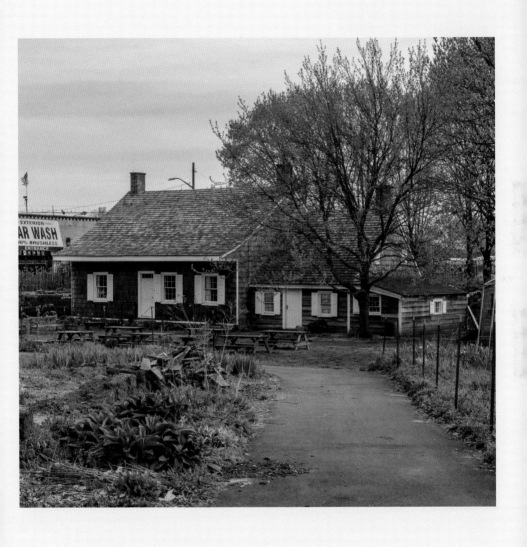

Sunset Park North Historic District

BUILT: 1908
LANDMARKED: 2019
FORTY-FOURTH STREET
SUNSET PARK

The area of Brooklyn now known as Sunset Park saw rapid development at the end of the nineteenth century. The opening of the Fifth Avenue Elevated Railroad, which connected to the Brooklyn Bridge, and the opening of the massive Bush Terminal on the waterfront spurred both the creation of jobs and ease of access in and out of the neighborhood. This led to a lot of speculative development, including these homes on Forty-Fourth Street. The completion of the terminal drew a lot of skilled laborers, which gave the neighborhood, and consequently these buildings, a decidedly middle-class flavor. These homes were built in 1908 by Thomas Bennent, as two-family dwellings. These were designed to allow people of more modest means to afford a building while renting out the upper floor. This was also around the time that apartment living was becoming more prevalent, but people weren't too sure about it. Making these homes look the same as a single-family town house helped with that stigma. The town houses on Forty-Fourth Street were landmarked as part of the Sunset Park North Historic District on June 18, 2019.

Fort Greene Park

BUILT: 1908 (PRISON SHIP MARTYRS MONUMENT)
LANDMARKED: 1978
DEKALB AVENUE AND SOUTH PORTLAND AVENUE
FORT GREENE

During the early years of the Revolutionary War, capturing New York was a key priority for the British high command. This would come to a head in the summer of 1776 with the Battle of Long Island. This battle, which took place throughout Brooklyn, involved the fledgling Continental Army erecting defenses around the high ground of the future borough. Where Fort Greene Park stands today used to be one of these defenses, Fort Putnam. George Washington tasked General Nathanael Greene with supervising its construction. The defense of Brooklyn would not last long, as an undefended road near Jamaica allowed the British to surprise Washington, forcing him to evacuate the army to Manhattan and eventually leave New York altogether.

After the Revolution, those same defenses were used again in the War of 1812. After both wars people realized that the area around the fort was in need of some spiffing up. Walt Whitman was one of the leading advocates for the creation of a park where the fort sat, and successfully lobbied both the public and the

Brooklyn city government via his position as editor with the *Brooklyn Daily Eagle* newspaper until it was a reality. The park was officially opened in 1846 and named in honor of General Nathanael Greene.

Because of the park's revolutionary history, we have what you see here, which is part of the Prison Ship Martyrs Monument. During the remainder of the Revolution, New York was occupied by British forces, and American prisoners were put on ships in the harbor. Conditions on those ships were so terrible that more Americans died on them than in combat during the entire war. The monument includes eagles and a large column with an urn at the top. Under this monument sits a vault that houses some of the remains of over 11,500 people who died on those ships. The first vault was completed in 1873, and the monument was unveiled in 1908 with a crowd of more than 15,000. The Prison Ship Martyrs Monument and Fort Greene Park were landmarked as part of the Fort Greene Historic District on September 26, 1978.

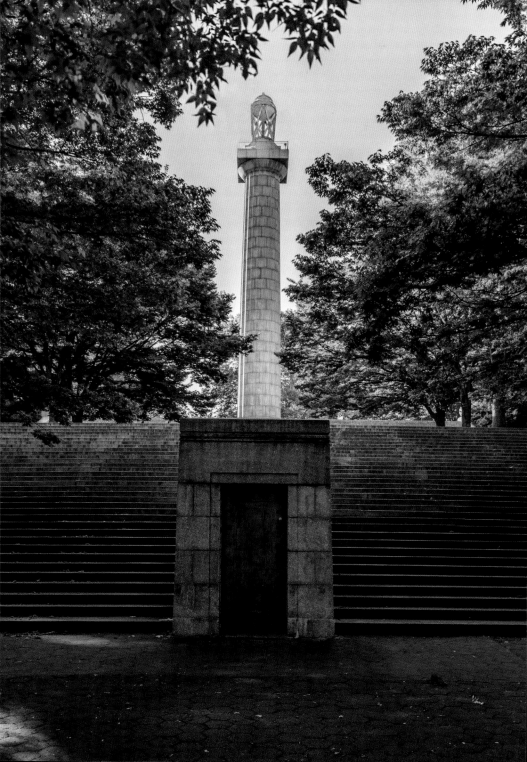

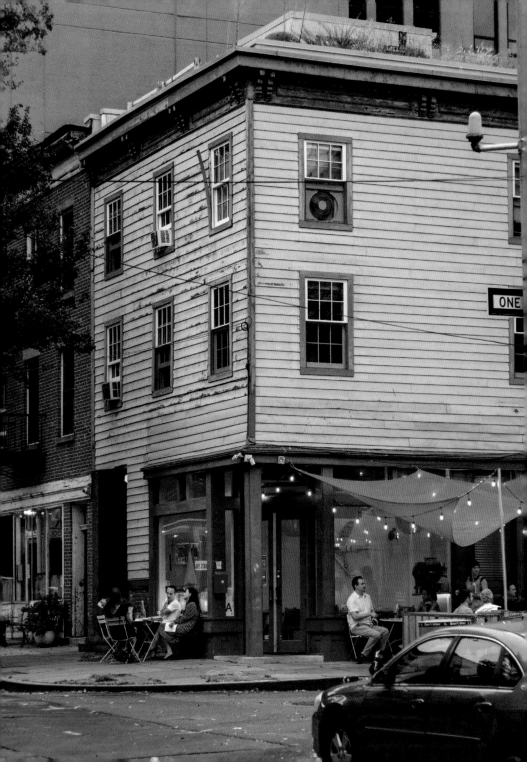

Vinegar Hill

BUILT: CIRCA 1828–1841
LANDMARKED: 1997
70 HUDSON AVENUE
VINEGAR HILL

There are many neighborhoods in New York that have been associated with the Irish at one point or another, but to the casual observer, Vinegar Hill might not be one that comes to mind. Vinegar Hill is the literal definition of a hidden gem in Brooklyn. The neighborhood started as a private estate at the end of the 1700s and was the site of a sizable Irish population at the turn of the nineteenth century.

Vinegar Hill never actually produced vinegar. It got its name from a battle called Vinegar Hill in the Irish rebellion of 1798. It would end up attracting a large Irish population, giving it the nickname Irishtown.

This is 70 Hudson Avenue. We don't have an exact date for construction, but estimates range from 1828 to 1841. The Jackson family owned the property beginning in 1781 and would sell this building in 1844. It was mostly used as a grocery store for its first hundred years. In more recent history, it has played host to a wine bar, and is now home to a café. It was landmarked as part of the Vinegar Hill Historic District on January 14, 1997.

Joseph Steele House

BUILT: CIRCA 1845
LANDMARKED: 1968
200 LAFAYETTE AVENUE
CLINTON HILL

The Joseph Steele House in Clinton Hill is one of the best examples of what suburban mansions in Brooklyn looked like in the mid-1800s. When this house was built around 1845, it was a country home, surrounded by farmland. It's been said that you could see the harbor from its cupola. The home was built by and is named for Brooklyn Heights resident Joseph Steele. Steele sold the home to the president of the Brooklyn Union Gas Company in 1853 and in 1903 it was sold to the Skinner family, who appear to have owned it until 2022, when it sold. It was landmarked on March 19, 1968.

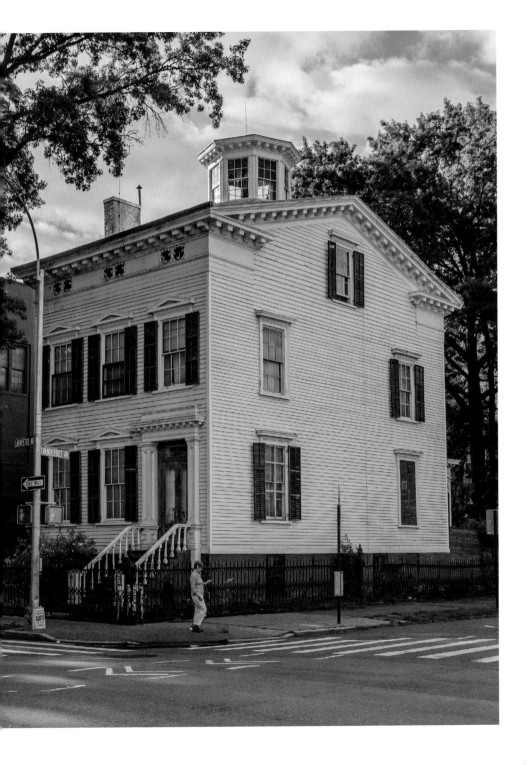

407 Vanderbilt Avenue

BUILT: 2006
LANDMARKED: 1981
407 VANDERBILT AVENUE
CLINTON HILL

I know what you're thinking: "Oh, look. Another stable converted into a super-fancy house, horses lived better than us, etc." But that's where you'd be wrong. This is 407 Vanderbilt Avenue in Clinton Hill, Brooklyn, and it was erected in 2006. The builders of this house worked with the Landmarks Preservation Commission to design a home that would fit in with the character of the street. The neighboring buildings were stables for the mansions a block over on Clinton Avenue. It sold in 2014 for $4.6 million. The house is technically landmarked as part of the Clinton Hill Historic District, which was created on November 10, 1981.

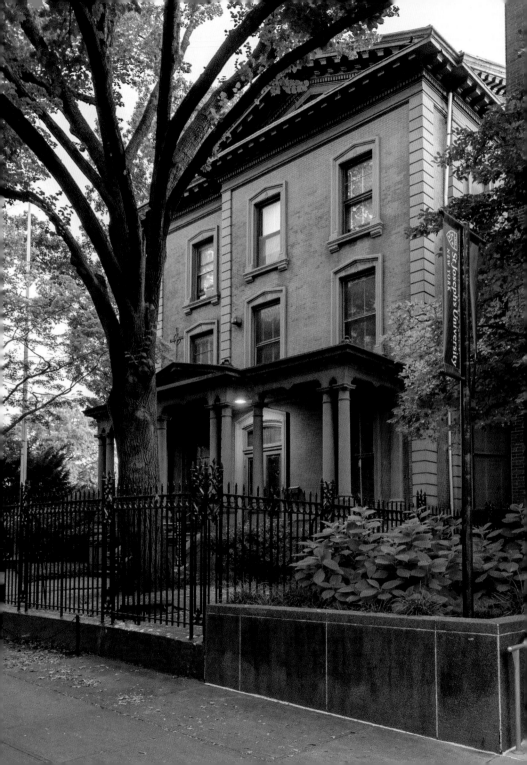

The Pratt Mansion

BUILT: 1874
LANDMARKED: 1981
232 CLINTON AVENUE
CLINTON HILL

If the Steele House is a representation of what early residential development in Clinton Hill looked like, then the Pratt Mansion is a great example of how the neighborhood reached its status as Brooklyn's Gold Coast. Clinton Hill was always a retreat for upper-middle-class residents from the city of Brooklyn. Turns out people believed that germs originated in low-lying swamps, so if you could build a house on a hill, you were in good shape. This notion caused an increase of home building in the area. By the 1870s, the neighborhood would see another building boom, this time in the high-end mansion space. This can largely be attributed to Charles Pratt.

Pratt was originally a partner at a whale oil firm before he went into the kerosene-refining business. He was bought out by John D. Rockefeller and became a high-ranking executive at Standard Oil. This made Pratt spectacularly wealthy, and he decided to build a stately mansion for himself on Clinton Avenue. The home was designed by architect Ebenezer L. Roberts and built in 1874. This would cause other Standard Oil executives and Brooklyn elites to build their own large homes on the avenue. Over time most of them were either purchased by surrounding academic institutions or the Catholic Church. The Diocese of Brooklyn purchased the mansion in 1936. Today it serves as Founders Hall at St. Joseph's University. It was landmarked as part of the Clinton Hill Historic District on November 10, 1981.

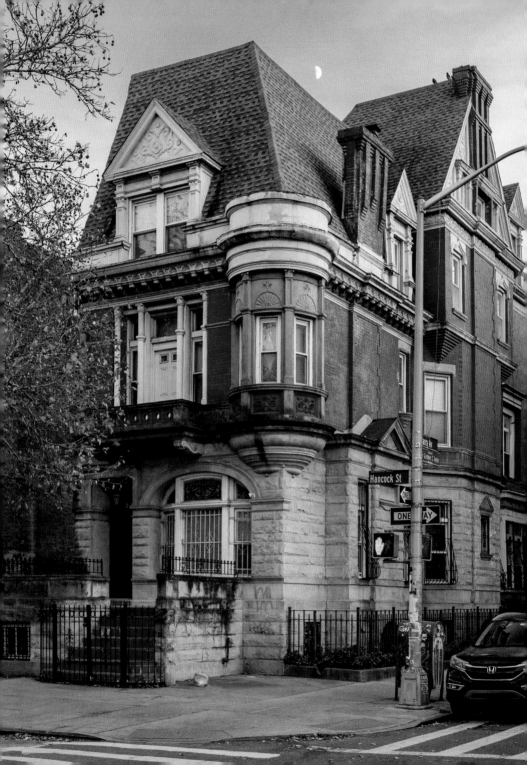

232 Hancock Street

BUILT: 1888
LANDMARKED: 2015
232 HANCOCK STREET
BEDFORD-STUYVESANT

Bedford-Stuyvesant grew from a small unincorporated village to a thriving, bustling urban neighborhood over the course of the nineteenth century. A lot of the development of the neighborhood and other buildings in Brooklyn can be attributed to the design of prolific Brooklyn architect Montrose Morris. This home at 232 Hancock Street in Bed-Stuy was designed and developed by the architect to serve as a model home in 1888. Morris himself lived next door with his wife until his death in 1916. That home unfortunately burned down in the 1960s. Over the years, 232 Hancock has been home to a doctor's office and private residence. It was landmarked as part of the Bedford Historic District on December 8, 2015.

Alhambra
Apartments

BUILT: 1889–1890
LANDMARKED: 1986
500–518 NOSTRAND AVENUE
BEDFORD-STUYVESANT

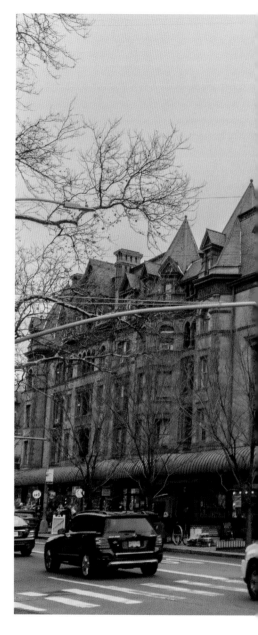

Montrose Morris's model home was a huge success, gaining him multiple commissions around the city, and later borough, of Brooklyn. With the neighborhood of Bedford expanding, Morris was tapped to design multiple rows of town houses and a newfangled type of housing unit, the apartment building. Developer Louis Seitz had seen what Morris could do and hired him to draw up plans for three buildings in the neighborhood, including this one, the Alhambra, completed in 1890. The Alhambra was designed with the objective of attracting middle-class residents. There was some hesitation around this time to move from a row house to what was commonly referred to as a "flat house" (an apartment). To combat this, developers like Seitz would look to build amenity-rich buildings, made of premium materials inside and out to show that living in a building with others was not something for just the lower classes. Morris's design worked, and it was one of the premiere apartment buildings of its day, attracting doctors, lawyers, and stockbrokers, along with their small household staffs. In 1923, the ground floor of the building was converted into retail stores, and by the 1980s, the

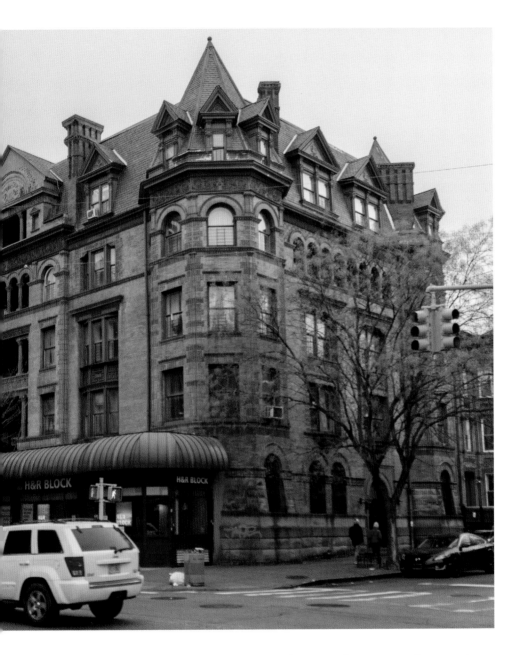

upper floors and most stores were vacant. In 1995, the building was restored and converted into low-to-moderate-income housing. It was landmarked on March 18, 1986.

Studebaker Building

BUILT: 1920
LANDMARKED: 2000
1469 BEDFORD AVENUE
CROWN HEIGHTS

For a city where 65 percent of the population doesn't own an automobile, New York has some very cool car-themed buildings. While the Chrysler Building might be the most iconic, the old Studebaker Building in Crown Heights is definitely a hidden gem. In the early part of the 1900s, Bedford Avenue between Empire Boulevard and Atlantic Avenue used to be considered automobile row, for all of the car dealerships located there. The Studebaker Building was constructed in 1920 as a dealership and showroom. The bottom two floors had large display windows, with offices occupying the upper floors. Cars were sold here only until 1939. The building was then converted into textile and furniture showrooms and was eventually turned into apartments for low-income families in 2000. It was landmarked on December 19, 2000.

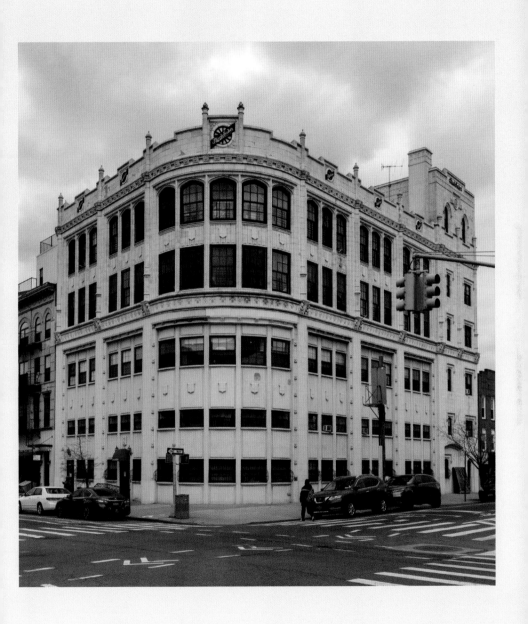

Weeksville

BUILT: CIRCA 1830
LANDMARKED: 1970
158 BUFFALO AVENUE
CROWN HEIGHTS

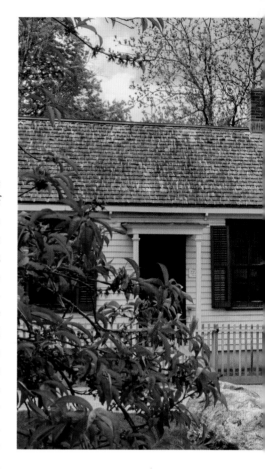

This collection of buildings are the Hunterfly Road houses, all that remain of Weeksville, the largest free Black community in New York during the nineteenth century. The homes were built around the 1830s, less than a decade after the gradual abolition of slavery in the state. Weeksville was founded after the purchase of land from the Lott and Lefferts family estates in what was then Brooklyn's Ninth Ward by Henry Thompson and Sylvanus Smith, who in turn sold land to James Weeks. Prior to the Civil War, Weeksville attracted many free Black people from around New York and later all over the country. By 1850, an estimated 45 percent of the population of the neighborhood was born below the Mason-Dixon Line. The population thrived, and Weeksville became a way for Black men to own property thanks to relatively cheap land and a supportive community. Landownership was crucial at the time, as there was a still a property requirement for Black men to vote in New York State, even though all white men had been given the vote regardless of ownership status. The town had a school, church, multiple businesses, and two newspapers, the *Freedman's Torchlight* and *People's Journal*.

During the Civil War, the neighborhood became a refuge during the draft riots in 1863, which saw mobs comprised of working-class New Yorkers target Black institutions and people in Manhattan. Weeksville would continue to thrive after the Civil War; however, over the subsequent decades, it would be absorbed by the rapidly expanding city and later borough of Brooklyn. By the early portion of the twentieth century, the neighborhood began to experience a decline, various plots were purchased

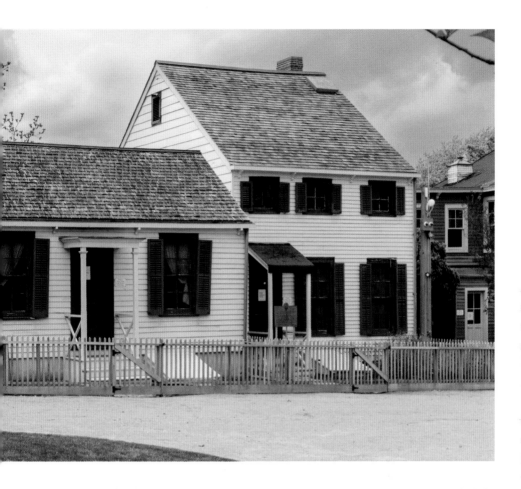

and torn down, and public housing complexes were built around the houses. By the 1960s, there was little if any evidence that the neighborhood had even existed.

By 1968, James Hurley, a local historian, tried to find the remaining buildings and did an aerial survey of the area with pilot Joe Haynes. They discovered the four remaining homes tucked away in an alley that had been previously unseen. A year later, the Weeksville Society was formed in conjunction with an archeological dig done by local students, who then pushed the Landmarks Preservation Commission to landmark the houses. Joan Maynard, the president of the Weeksville Society from 1972 to 1974, organized funding to restore the homes, creating the Weeksville Heritage Center we know today. The Weeksville Heritage Center now provides tours of the four homes, each exploring living conditions in a different decade of Weeksville. The Hunterfly Road houses were landmarked together on August 18, 1970.

Williamsburgh Savings Bank

BUILT: 1875
LANDMARKED: 1966
175 BROADWAY
WILLIAMSBURG

One of the most iconic buildings in Brooklyn has to be the old headquarters of the Williamsburgh Savings Bank at the intersection of Driggs Avenue and Broadway. Built in 1875 and designed by architect George Post, who would later go on to design the New York Stock Exchange, it was an early example of the Classical Revival style, and one of the few domed buildings in the borough. The building was used as the primary location for the bank until it opened the Williamsburgh Savings Tower at 1 Hanson Place, near where the Barclays Center currently stands. Over the years, after various mergers, the bank ended up being a part of HSBC. In 2010, the building was converted into a banquet hall called Weylin. It was landmarked on May 17, 1966.

Colored School No. 3

BUILT: 1879–1881
LANDMARKED: 1998
270 UNION AVENUE
WILLIAMSBURG

This building is a sobering reminder that segregation based on race was not exclusive to just the American South. It had official standing in New York. This is the former Colored School No. 3, at 270 Union Avenue in Williamsburg, Brooklyn. It was designed in 1879 by Samuel B. Leonard, who was the superintendent of building and repairs for the then independent Brooklyn Board of Education. The school can trace its roots back to the beginnings of public education in the city of Brooklyn in 1816, when Black students were educated in the same buildings as white students, but in different classrooms. That was short-lived, however, as eventually Black students were pushed out of those schools. This led to the creation of the African Free School in 1834 by Abraham Brown and Henry Thompson, the president of the Brooklyn African Woolman Benevolent Society. While state law stated that Black schools must be funded at the same level as white schools, that was rarely the case.

By 1873, New York State was pushing for the desegregation of schools, which, like the law regarding school funding, was loosely enforced. In addition to opposition from good old-fashioned racists, there were some concerns within the Black community that the integration of schools could affect the job security of Black teachers and principals, who would likely be replaced if integration were to go forward, something that would eventually happen. During this debate, the current building was constructed, and called Colored School No. 3, a name it would hold until 1887, when all schools in the city of Brooklyn would conform with the standard numbering system. This changed the name of the school to Public School 69. Brooklyn allowed for parents to continue to send their children to exclusively Black schools or integrated schools depending on their preference. The school would eventually see a decline of enrollment based on demographic changes to the neighborhood as well as integration of the school system. However, it would serve as a segregated school until 1924, when it merged with PS 18. During the Great Depression, the building was used for the federal Civil Works Administration under the umbrella of the Public Works Commission, after which it was utilized by the sanitation department. In 1983 it was restored and converted into an art studio and apartments. It was landmarked on January 13, 1998.

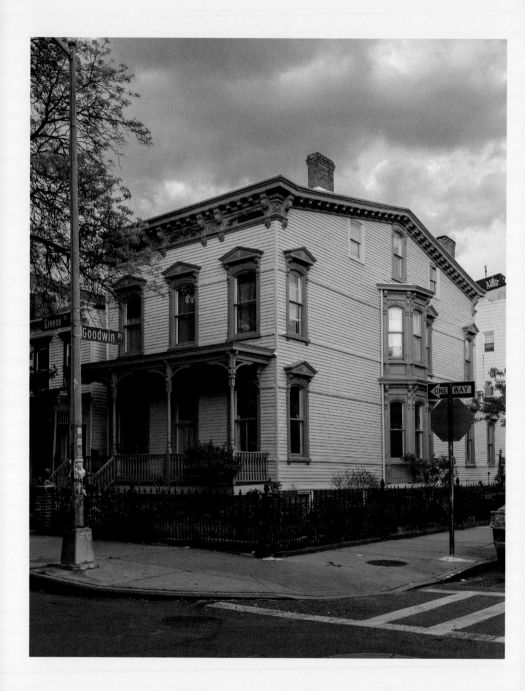

Doering-Bohack House

BUILT: CIRCA 1887
LANDMARKED: 2014
1090 GREENE AVENUE
BUSHWICK

Bushwick has seen a lot of change throughout its history. Up until the late 1800s, the area was lightly developed. With the opening of the elevated train on Myrtle Avenue in the 1880s, there was a building boom to keep up with its growing need for housing. During that decade more than three hundred buildings like this were built and scattered around the neighborhood.

This house was built by Frederick Doering in 1887 on Goodwin Place. It is one of the only remaining wooden buildings in the area. Because Bushwick was far enough from the other areas of Brooklyn, it wasn't subject to the same fire code in effect for the other parts of the city. This allowed developers to put up houses like these quickly and cheaply. In 1902, it was moved to its current location on Greene Avenue by German grocer Henry Bohack, who used it as a home and storehouse. It has remained a single-family home ever since and was landmarked on September 30, 2014.

William Ulmer Brewery Complex

BUILT: 1885
LANDMARKED: 2010
31 BELVIDERE STREET
BUSHWICK

Did you know Brooklyn had more than twenty breweries prior to Prohibition? Williamsburg and Bushwick had large German populations in the late 1800s, causing an explosion in brewing. This is one of the few remaining examples of that industry. William Ulmer was a German immigrant who started his career working for his uncle in the 1850s. By the 1880s he would go on to be the owner of the William Ulmer Brewery, and in 1885 he built this complex for his growing company. It included an office, warehouse, and brewhouse. The complex even had its own ice room and machine shop. You can still see all of it on Belvidere Street between Beaver Street and Broadway.

The William Ulmer Brewery was one of the most successful in Brooklyn, and it made Ulmer a millionaire. Prohibition forced the company to close, but the main reason we still have this building is that the Ulmers continued to use it as an office until the 1950s. It was landmarked on May 11, 2010.

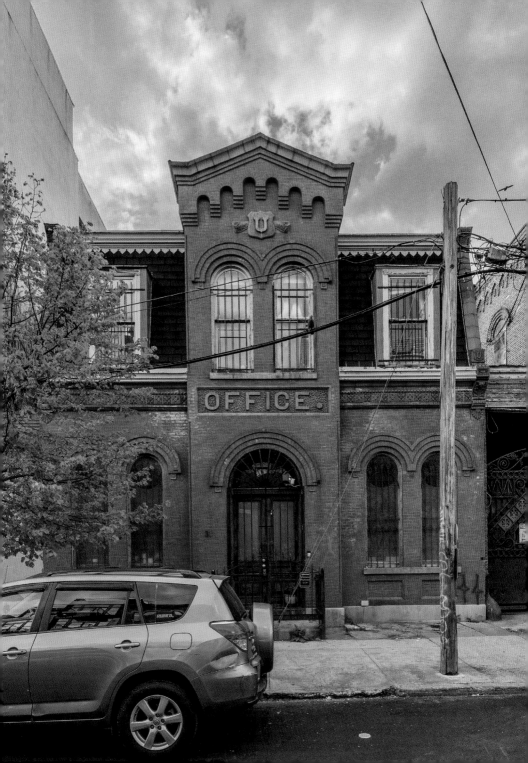

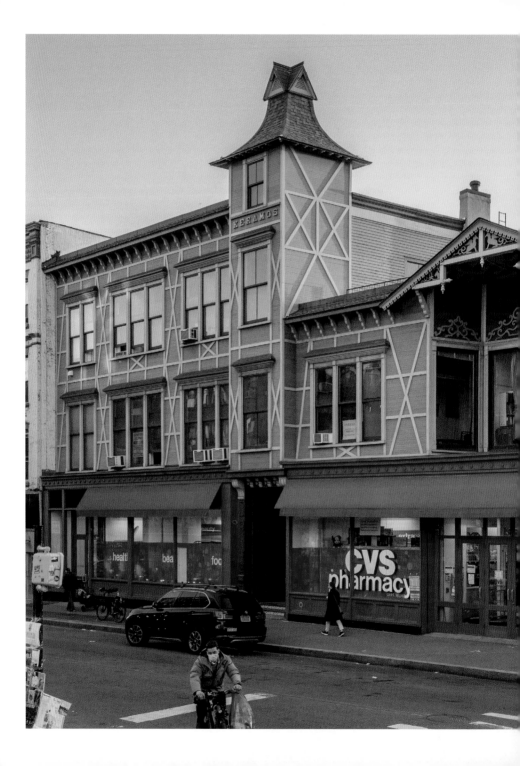

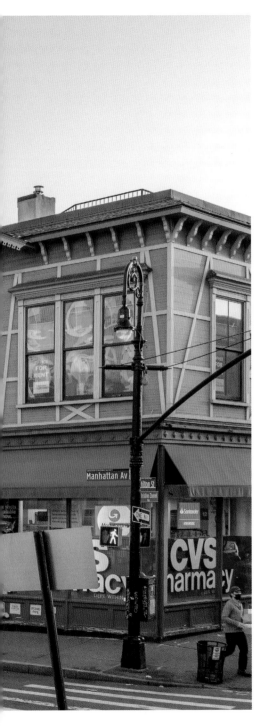

857-863
Manhattan Avenue

BUILT: 1886-1887
LANDMARKED: 1982
857-863 MANHATTAN AVENUE
GREENPOINT

Want to feel Swiss in a formerly Polish neighborhood across from a church built for Italians? Look no further than this eccentric building on Manhattan Avenue in Greenpoint, Brooklyn. These are actually two separate buildings, erected between 1886 and 1887. The building at 861 was built by Thomas Smith for Peter Burden; Smith also began construction on 863 before Burden also purchased that property from him. Smith was a prominent resident of Greenpoint who designed and developed many of the buildings in the neighborhood. In the 1860s, he would also take over the bankrupt United Porcelain Company, which was a major employer in the neighborhood. If you look on the tower of this building, you'll see the Greek word *keramos*, which means pottery. The buildings were always commercial and lost their luster in the 1970s when the cornice was removed from the tower and it was clad in some less-than-flattering siding. It underwent a full restoration in 2012 and is honestly one of the most unusual buildings I've seen in the five boroughs. It was landmarked as part of the Greenpoint Historic District on September 14, 1982.

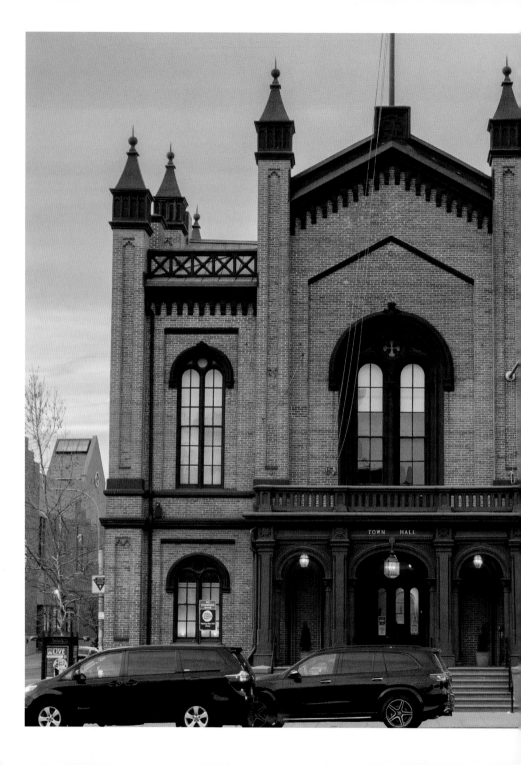

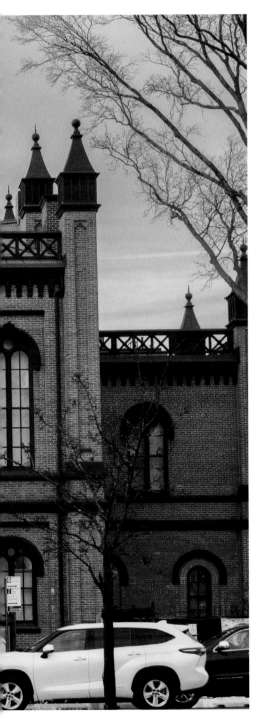

QUEENS

Flushing Town Hall

BUILT: 1862
LANDMARKED: 1968
137-35 NORTHERN BOULEVARD
FLUSHING

For those of you not too familiar with New York City history, you might wonder why a neighborhood in a borough within a city has its own town hall. Flushing was one of the original towns that made up Queens County. It was inhabited by the Indigenous Matinecock tribe before the arrival of Europeans. The first Dutch settlement was established in 1645 and named Vlissingen after the town of the same name in the Netherlands. However, it was primarily populated by English Quakers. This iteration of Flushing's town hall was built in 1862 and was used as such until 1900. Later, it served as a courthouse and finally as a police precinct for the 1964 World's Fair. Today it is owned by the city and leased by the Flushing Council on Culture and the Arts, which has done multiple renovations since 1990. Flushing Town Hall was landmarked on July 30, 1968.

Bowne House

BUILT: 1661
LANDMARKED: 1966
37-01 BOWNE STREET
FLUSHING

If you want to find the oldest building left in Queens, you'll need to venture out to Flushing to see the John Bowne House. John Bowne began building this house in 1661, and expanded it two additional times in the seventeenth century. The current house footprint was completed in 1815. John Bowne was a Quaker, and his wife was a relative of both the Connecticut and Massachusetts governors. Bowne was one of the key figures in fighting for religious freedom in New Netherland, to allow worship outside of the officially sanctioned Dutch Reformed Church. He succeeded as part of the Flushing remonstrance, one of the first examples of freedom of consciousness in the New World. Bowne would spend a few months in jail in Manhattan before the ruling came through.

Nine generations of Bownes would occupy the house, with the last moving out in 1945. Unlike many seventeenth-century buildings throughout the five boroughs, the Bowne House would not employ the use of enslaved Africans for free labor, with many members of the Bowne family being active abolitionists. Today the Bowne House is a museum and is open for guided tours. It was landmarked on February 15, 1966.

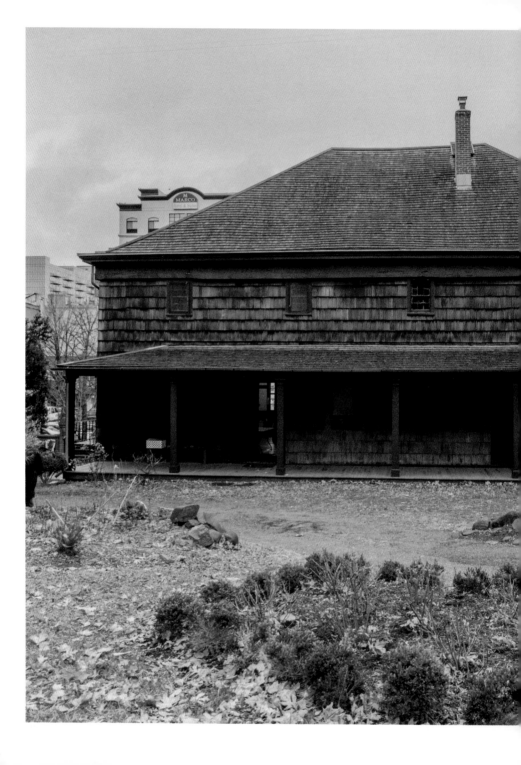

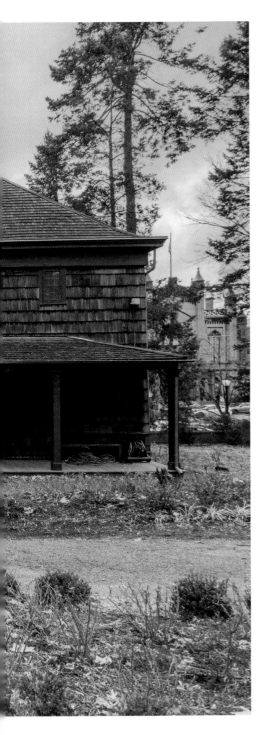

Friends Meeting House

BUILT: 1694
LANDMARKED: 1970
137–16 NORTHERN BOULEVARD
FLUSHING

This is the oldest house of worship still standing in New York City. The Religious Society of Friends meetinghouse was constructed starting in 1694, and the original portion still stands. It was Flushing's English Quaker community that petitioned the Dutch government for religious freedom and succeeded, laying the groundwork for religious freedom in the future United States. The land for the meetinghouse was found and purchased by John Rodman and John Bowne, and the latter's house still stands a few blocks away from the meetinghouse. Throughout its history, the Friends Meeting House had many who preached against the practice of enslavement, a not insignificant fact considering how widespread slavery was in New York prior to the mid-nineteenth century. The property also includes a cemetery dating back to 1667, though graves were unmarked until 1835. The Friends Meeting House was landmarked on August 18, 1970.

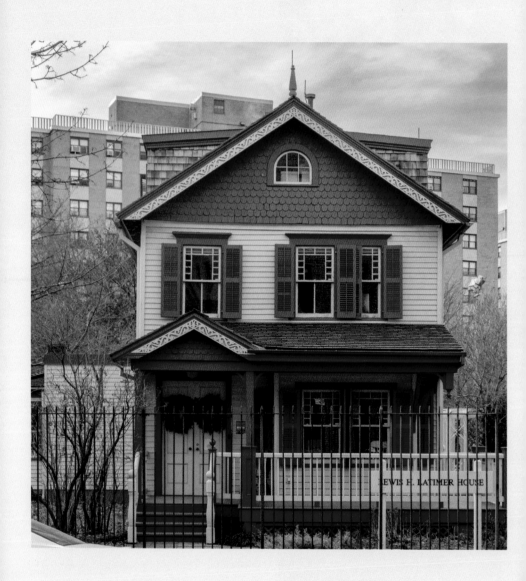

Lewis H. Latimer House

BUILT: CIRCA 1887–1889
LANDMARKED: 1995
34–41 137TH STREET
FLUSHING

This is the Lewis Latimer House in Flushing, Queens, which was the home of prominent African American inventor and civil rights advocate Louis Howard Latimer. When Latimer was born in 1848 in Massachusetts, his parents had both escaped enslavement in the South. He would join the Union Navy during the Civil War and teach himself mechanical drawing while in the service. After the war he became a patent expert. Latimer helped Alexander Graham Bell with the invention of the telephone and worked with Thomas Edison and Hiram Maxim. He was also an inventor in his own right. Arguably, his most important discovery was a cheaper way of manufacturing carbon filament, which allowed for less expensive, longer-lasting lightbulbs that became accessible to the general public.

Latimer and his wife Mary purchased this house in 1902. It was originally built for William and Emma Sexton around 1887. The Latimer family would go on to own the home until the 1960s. In addition to engineering, Lewis Latimer was an advocate of civil rights and for Black cultural identity. His home played host to many of the leading Black leaders of the nation at the time, including W. E. B. DuBois, Arturo Schomburg, and Richard Theodore Greener. In order to avoid demolition, in 1988 the building was moved from its original location on Holly Avenue near Kissena Boulevard to its current site about a mile away. Today it is a museum dedicated to highlighting Latimer's work. It was landmarked on March 21, 1995.

Queens Courthouse

BUILT: 1870
LANDMARKED: 1976
25–10 COURT SQUARE WEST
LONG ISLAND CITY

Queens, despite being New York's largest borough, grew quite differently from Manhattan and Brooklyn. There were no central planning authorities or one single municipality within the county that drove development. Instead, it comprised a series of small towns in what now makes up present-day Queens and Nassau Counties on Long Island.

This courthouse in what is now Long Island City was part of an attempt to change that. The county seat of Queens since its inception was Flushing; however, this was not a very convenient location at the end of the nineteenth century. Additionally in the 1860s, the Long Island Rail Road moved its primary terminus from Atlantic Avenue in Brooklyn to Hunterspoint Avenue in Queens due to the objections of local residents. This presented the area with a new opportunity. Local leaders sought to capitalize on the new access to the railways and sprang into action building boardinghouses, factories,

and shops. Additionally, they sought to create a new city in the county of Queens called "Long Island City." Established in 1870, this area would comprise the neighborhoods of Hunters Point, Astoria, and Ravenswood.

Freshly incorporated, the residents of Long Island City lobbied the State of New York to move the county seat to the area, which it did in 1872. As part of its new status, new county buildings needed to be constructed, including this courthouse in what is now appropriately named Court Square. Designed by architect George Hathorne in 1872, the courthouse officially opened in 1877.

In 1898, the court's jurisdiction would change, as Nassau County split from the rest of Queens, refusing to join the newly unified city of New York. As of this writing, the building is still home to the Queens Supreme Court in the New York State Unified Court System. It was landmarked on May 11, 1976.

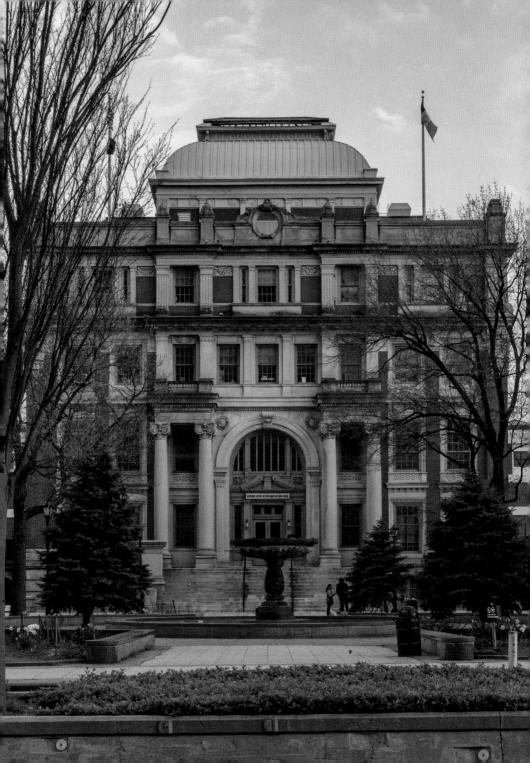

THE BRONX

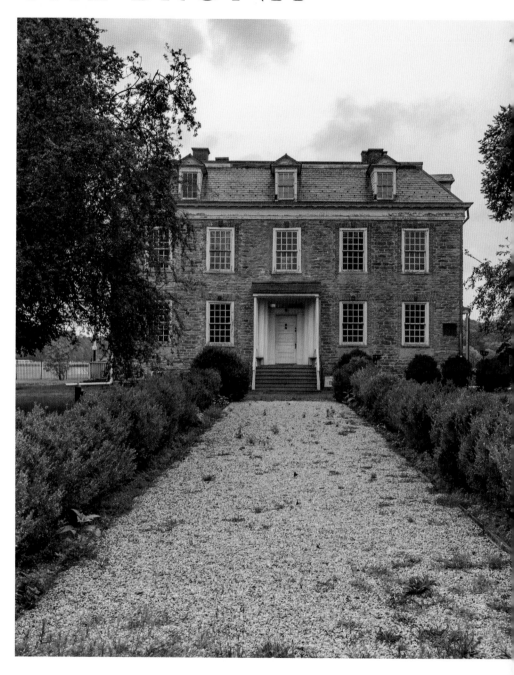

Van Cortlandt House

BUILT: 1748-1749
LANDMARKED: 1966
6036 BROADWAY
VAN CORTLANDT PARK

The Van Cortlandt manor, located in the Bronx park that bears its name, is the oldest building in the entire borough. It was inhabited by the Van Cortlandt family for nearly 140 years. At the time it was constructed, in 1748, the Bronx was picturesque countryside filled with little hamlets within Westchester County, and the house was located in a town called Yonkers. Although there are no records confirming it, it is likely that enslaved African laborers were used in the home's construction. The Van Cortlandt family profited from the slave trade, and records indicate that multiple enslaved men worked on the property until at least 1821.

During the Revolutionary War, the mansion played a large role in the evacuation of New York. George Washington was known to have visited the home at least twice during the chaotic retreat. In 1886, the Van Cortlandts sold the mansion to the City of New York, and it has been operating as a museum under the stewardship of the National Society of Colonial Dames. It was landmarked on March 15, 1966.

Fordham University Administrative Building

BUILT: 1836–1838
LANDMARKED: 1970
441 EAST FORDHAM ROAD
THE BRONX

Fordham University opened its doors on June 24, 1841. Prior to becoming a university, its Rose Hill campus was a Westchester country estate. It was originally known as the Manor of Fordham when it was created in 1671. The land was given by Francis Lovelace, the second English governor of New York colony, to Dutch settler John Archer, and it would be subdivided over the subsequent years. Wealthy New York merchant Robert Watts purchased the estate in 1787 and gave it the name Rose Hill, a nod to the area of Manhattan where his father grew up. A man named Horatio Shepheard Moat would be the last private citizen to own the land, and built this house between 1836 and 1838. He sold it a year later to coadjutor bishop and later archbishop John Hughes for the founding of St. John's College, the first Catholic institution of higher education in the Northeast.

Initially it served as a seminary, but the archbishop had grander plans. Due to biases against the Irish immigrant community in the mid-nineteenth century, Hughes thought it imperative to create institutions of higher and lower learning, as well as banks and other social services, for the new Catholic immigrants. Fordham would expand and enroll mostly Irish and later Italian students. The institution was under the supervision of the Jesuits after it was sold to the order in 1845 and had become one of the major academic institutions serving the city. In 1907, St. John's College was incorporated as a university and officially changed its name to Fordham University. Archbishop John Hughes also played a major role in the Irish Emigrant Aid Society, which helped create Emigrant Savings Bank, and commissioned the construction of St. Patrick's Cathedral on Fifth Avenue.

The stately building that used to be the manor house on campus is now home to the administration of Fordham University, including the office of the president, and remains relatively original to its design from the 1830s. It was landmarked on August 18, 1970.

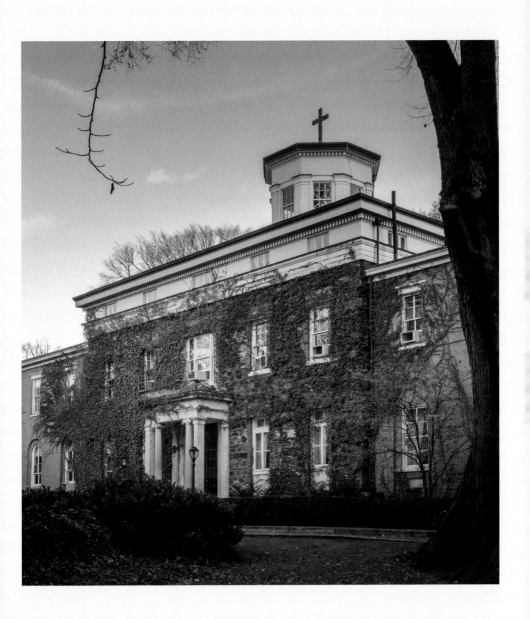

Bertine Block Historic District

BUILT: 1877–1878
LANDMARKED: 1994
408–412 EAST 136TH STREET
MOTT HAVEN

On 136th Street, just off the Major Deegan Expressway, sits the Bertine Block Historic District. This small street is home to a group of buildings that date back to the 1870s to 1890s (and it also happens to be the block where my great-great-grandfather lived). The district is part of the Mott Haven section of the Bronx, which became a part of New York City in 1874. A wave of development was spurred in the area after the annexation. One developer was a man by the name of Edward D. Bertine. Bertine developed the block in sections, with the buildings pictured here on the south side of the street being erected between 1877 and 1878. Bertine hired architect George Keister, who also designed Harlem's Apollo Theater, to draw up the plans for these homes. This is one of the few areas of the Bronx where row houses were popular relative to, say, Manhattan or Brooklyn. Residents of the area pushed for increased public transportation, which set off a small building boom. Many of the people who either purchased or rented these homes were firmly middle class, split between native-born New Yorkers and immigrants. They were land-marked as part of the Bertine Block Historic District on April 5, 1994.

Poe Cottage

BUILT: CIRCA 1812
LANDMARKED: 1966
2640 GRAND CONCOURSE
THE BRONX

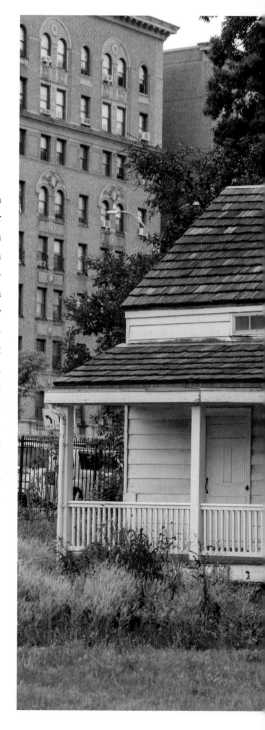

Baltimore likes to claim poet Edgar Allan Poe—it named its football team after his poem "The Raven." However, that poem was written on West Eighty-Fourth Street in Manhattan. In 1846, Poe moved to this cottage in the Bronx, which he rented for $100 a month. The move was prompted by the poor health of his wife Virginia, who had tuberculosis. He took the medical advice of doctors at the time who thought some good clean air could cure her. It did not, and she died in 1847. While living here, Poe befriended the Jesuits who ran St. John's College, which later became Fordham University. Legend has it that his poem "The Bells," which was published after his death, was inspired by the bells of the Fordham University Church. In addition to "The Bells," he also wrote "Eureka" and "Annabel Lee" while living here.

Poe would live here until 1849, when he would pass away at the age of forty. The home, which was built around 1812, managed to survive the expansion of Kingsbridge Road in 1913. That same year, it was moved a few blocks north to its current location within Poe Park. The cottage is now a museum open to the public, and was landmarked on February 15, 1966.

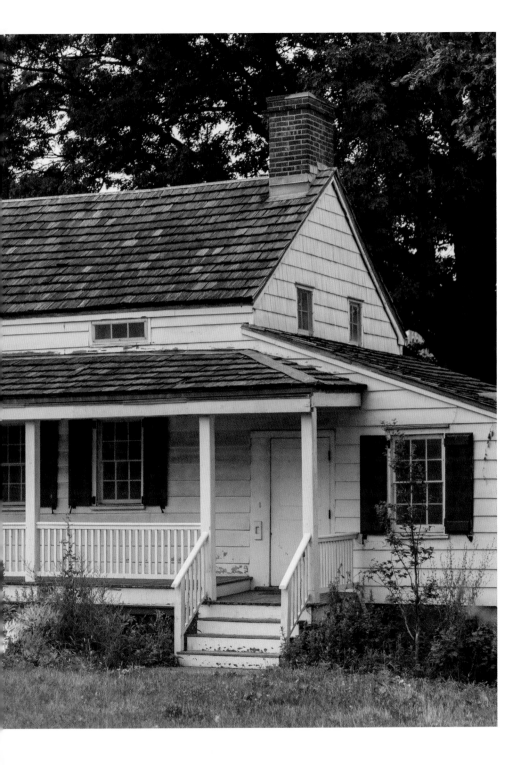

STATEN ISLAND

Aakawaxung Munahanung

BUILT: CIRCA 6000 BCE
LANDMARKED: 2021
CONFERENCE HOUSE PARK
TOTTENVILLE

There is a single landmark dedicated to the people who called New York home for thousands of years prior to European colonization. That landmark is the Aakawaxung Munahanung (Island Protected from the Wind) Archaeological Site, and it sits at the bottom of Staten Island within Conference House Park. The site has artifacts dating back eight thousand years, including hearths, pottery, and hunting equipment. This area was an active Indigenous settlement on and off until the late 1600s. It is unclear what the original inhabitants called themselves, but by the age of European colonization, the Raritan tribe inhabited much of Staten Island. The first excavations began here in the 1850s, without the input from the tribal nations and prior to modern-day archaeological standards. The site had also been looted multiple times. As a result, the landmarking is meant to preserve the integrity of the archeological site as well as to serve as a link to the history of Indigenous peoples of New York. Again, this is the only Indigenous landmark out of more than thirty-seven thousand. It received its designation on June 22, 2021.

The Conference House

BUILT: CIRCA 1675–1688
LANDMARKED: 1967
7455 HYLAN BOULEVARD
TOTTENVILLE

Located at the far southern tip of Staten Island sits one of the oldest buildings in all of New York, the Conference House. On a hilltop overlooking New Jersey, this home was built for Captain Christopher Billopp of the Royal Navy sometime between 1675 and 1688. If legend is to be believed, Billopp was the reason Staten Island is part of New York and not New Jersey. The (likely untrue) story is that Billopp was able to settle a territorial dispute between New York and New Jersey by sailing around the island in less than twenty-four hours. This would classify the island as "small" which would, according to the Duke of York, make it part of New York. As fun as that story sounds, a *New York Times* article from 2008 found that the earliest mention of this story didn't occur until 1873.

During the American Revolution, his home would play a more important role. New York was occupied by the British for a majority of the war, from 1776 to 1783. During that time, Lord Admiral Richard Howe, the commander of the Royal Navy, held informal peace negotiations at the home, giving it the name the Conference House. His terms were extremely limited due to demands from the British government, and on September 11, 1776, a delegation of

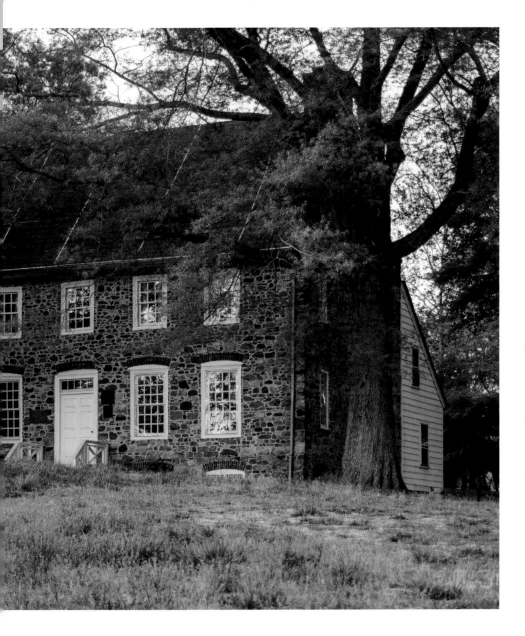

John Adams, Benjamin Franklin, and Edward Rutledge politely declined after a three-hour meeting there. In 1926, the house was purchased by New York City and was renovated. In 1929 it would open as the Conference House Museum. It was landmarked on February 28, 1967.

Sailors' Snug Harbor

BUILT: 1831–1880
LANDMARKED: 1965
1000 RICHMOND TERRACE
ST. GEORGE

Sailors' Snug Harbor is one of New York's truly hidden gems. It was founded as an organization to help retired merchant sailors in 1801 on the directive of the will of Captain Robert Richard Randall. (His will was allegedly said to be drawn up by another famous New Yorker, Alexander Hamilton.) Randall was a wealthy merchant who sought to create what was effectively a retirement home for sailors, as there was no safety net for men who had been injured while on the job. Randall owned a significant amount of property north of Washington Square Park in Manhattan and wished to build the facility on this land. However, due to the increasing property values in that area, combined with his death in 1801, both the city and his descendants decided to lease that land instead, and build on the north shore of Staten Island in 1830. The campus features five Greek Revival buildings known as "Temple Row" designed by architects Richard Smyth and Minard Lafever. They served as dormitories for retired sailors.

In the later part of the nineteenth century, the organization, known as the Trustees of the Sailors' Snug Harbor, was run by Captain Thomas Melville. If that name sounds familiar, it's because his brother, Herman, was the author of *Moby-Dick*. At its height, more than one thousand men lived in the complex. However, with the advent of Social Security, the organization saw a decline in both sailors and funding, causing the board of trustees to demolish some of the buildings including a large Greek Revival church. The rest of the seven buildings were saved when they were landmarked on May 15, 1973, with the property being purchased by the city and handed over to the newly formed Snug Harbor Cultural Center in 1975. The organization continued to own the Manhattan property until the 1980s, when the last parcel was sold off to fund the organization's endowment. The organization continues to operate to this day, providing financial support to sailors with assets less than $75,000 who have spent over 2,555 days, or seven years, at sea. The Temple Row buildings were landmarked on October 14, 1965.

ACKNOWLEDGMENTS

Writing this book has been nearly five years in the making. There are a multitude of people without whom this would not have been possible. I could not have done this without the unwavering support of my wife, Jillian Silk. From day one, she encouraged me to go on this harebrained scheme to track down as many landmarks in New York City as possible, and sat and listened to me blabber on and on about old buildings. Jillian had no previous interest in history, but despite that, her constant support kept me going, and her advice and feedback have made this work possible. She has stood by me and encouraged me despite some terrible family tragedies that we experienced in 2023. It has made my life to hear her come back to our apartment and, unprompted, tell me about some building she saw. I'm so proud.

I have to also thank my entire family, especially my late grandfather, teacher and historian Thomas Casey, who instilled in me a love of all things history, especially that of New York. My parents and siblings, Kevin and Claudia, Michael and Annie, have been constant cheerleaders with their inexhaustible encouragement.

I'm especially grateful to my editor, Lisa Tenaglia, and the team at Black Dog and Leventhal. Lisa took a huge risk by reaching out to an Instagrammer who had never written anything longer than a fifteen-page college essay on the Baltic Crusades to write a full book on the history of New York. Her advice and guidance have been invaluable to the completion of this project.

To my friends, Henry Sicarrdi and Will Schaffer, whom I credit with shaping my writing style. Whenever I wrote a post or an entry for this book, I always thought to myself, "How would this sound if I was BS-ing with Will and Henry?" and tried to write as close to how that conversation would sound.

I would like to thank my friend and former Fordham roommate Christopher Kennedy, and my friend Diana Flatto, who accompanied me on many walks photographing buildings in all corners of the city.

A special thanks to Allison, Christie, and Jenny Schneider, who helped me create my landmark tours of New York as well as being evangelists for the @landmarksofny Instagram page.

Finally to my late mother-in-law, Karen Faxon, and daughter, Emery Silk. Karen was always such a great supporter and took such an interest in my work. I'm grateful that she was able to hear the news of this book before we lost her in the winter of 2022 to 2023. To my beautiful daughter, Emery Faxon Silk, who was stillborn at thirty-nine weeks. Thank you for being my daughter. I was so excited to share my love of our home with you. This book is dedicated to you.

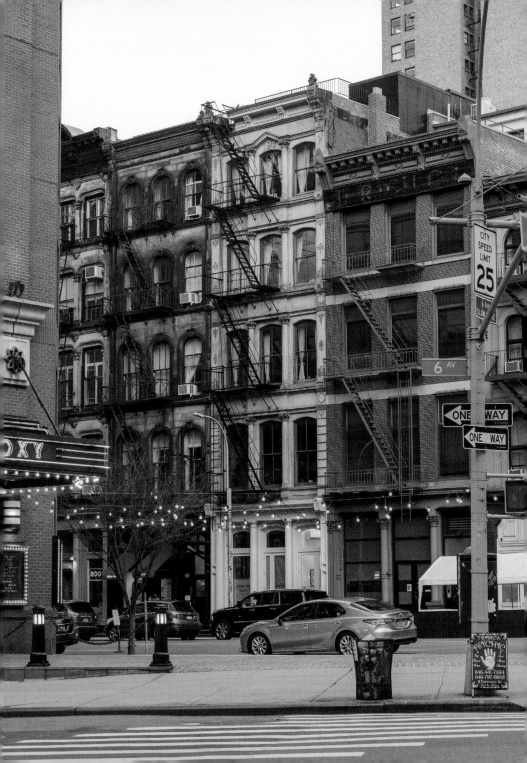

Abulhasan, Mohammad A. "A Brief History of the Islamic Cultural Center of New York." 2023. Islamic Cultural Center of New York. https://icc-ny.us/history/.

Adams, Janet, et al. *Ladies' Mile Historic District Designation Report*. New York Landmarks Preservation Commission, 1989. http://s-media.nyc.gov/agencies/lpc/lp/1609.pdf.

Adams, Luella, et al. *Expanded Carnegie Hill Historic District Designation Report*. New York Landmarks Preservation Commission, 21 December 1993. http://s-media.nyc.gov/agencies/lpc/lp/1834.pdf.

American Battlefield Trust. "American Revolution Facts." American Battlefield Trust. https://www.battlefields.org/learn/articles/american-revolution-faqs.

Apmann, Sarah Bean. "Napoleon LeBrun—Firehouse Architect and So Much More." *Off the Grid* (blog). Village Preservation, 2 January 2019. https://www.villagepreservation.org/2019/01/02/napoleon-lebrun-firehouse-architect-and-so-much-more/.

Arak, Joey. "Bouwerie Lane Theater Gutted, Chopped Up & On the Market!" *Curbed New York*, 17 September 2009. https://ny.curbed.com/2009/9/17/10532740/bouwerie-lane-theater-gutted-chopped-up-on-the-market.

———. "CurbedWire: Harlem House is Deal of the Year, WTC Cash Spent." *Curbed New York*, 22 October 2009. https://ny.curbed.com/2009/10/22/10529798/curbedwire-harlem-house-is-deal-of-year-wtc-cash-spent.

Baldwin, Jessica, et al. *Sullivan-Thompson Historic District Designation Report*. New York Landmarks Preservation Commission, 13 December 2016. http://s-media.nyc.gov/agencies/lpc/lp/2590.pdf.

Balsamo, Michael. "FBI at Russian Oligarch's Homes for 'Law Enforcement' Action." Associated Press, 19 October 2021. https://apnews.com/article/donald-trump-russia-elections-presidential-elections-paul-manafort-90c01dfee5c36ebd75a38e20640e6b38.

Barbanel, Josh. "Grand on a Small Scale." *Wall Street Journal*, 19 September 2013. https://www.wsj.com/articles/SB10001424127887323308504579085060860112966.

Barron, James. "50 Years Later, Traces of an Air Crash Linger in Rusty Metal, and Memories." *New York Times*, 10 December 2010. https://www.nytimes.com/2010/12/13/nyregion/13cityroom.html.

Bergdoll, Barry, et al. *Upper East Side Historic District Designation Report*. New York: City of New York, 19 May 1981. http://s-media.nyc.gov/agencies/lpc/lp/1051.pdf.

Bindelglass, Evan. "Meet NYC's Newest Landmark, a 19th-Century Bushwick Home." *Curbed New York*, 30 September 2014. https://ny.curbed.com/2014/9/30/10041282/meet-nycs-newest-landmark-a-19th-century-bushwick-home.

Bowery Mission. "The Legacy of Transformation Timeline." Bowery Mission. https://www.bowery.org/legacy/timeline/.

Bowne House Historical Society. "Edward Farrington: Flushing's Honorary Town Father." Bowne House Historical Society, 3 October 2020. https://www.bownehouse.org/profiles-of-the-flushing-charter-signers.

———. "History of the Bowne House." Bowne House Historical Society. https://www.bownehouse.org/history-of-the-house.

———. "The Bownes." Bowne House Historical Society. https://www.bownehouse.org/the-bownes.

———. "Three Centuries of Activism." Bowne House Historical Society. https://www.bownehouse.org/three-centuries-of-activism.

Bradley, Betsy. *Jeffrey's Hook Lighthouse ("The Little Red Lighthouse") Designation Report*. New York: New York City Landmarks Preservation Commission, 14 May 1991. http://s-media.nyc.gov/agencies/lpc/lp/1654.pdf.

Bradley, Betsy, et al. *Tribeca West Historic District Designation Report*. New York: Landmarks Preservation Commission, 7 May 1991. http://s-media.nyc.gov/agencies/lpc/lp/1713.pdf.

———. *Upper West Side/Central Park West Historic District Designation Report*. New York Landmarks Preservation Commission, 24 April 1990. http://s-media.nyc.gov/agencies/lpc/lp/1647.pdf.

Brazee, Christopher. *143 Allen Street House Designation Report*. New York: Landmarks Preservation Commission, 2010. http://s-media.nyc.gov/agencies/lpc/lp/2350.pdf.

Breiner, David M., and Margaret M. M. Pickart. *Tribeca East Historic District Designation Report*. New York Landmarks Preservation Commission, 8 December 1992. http://s-media.nyc.gov/agencies/lpc/lp/1711.pdf.

Burrows, Edwin G., and Mike Wallace. *Gotham: A History of New York City to 1898*. New York: Oxford University Press, 1999.

Campanella, Thomas J. *Brooklyn: The Once and Future City*. Princeton, NJ: Princeton University Press, 2019.

Capote, Truman. *A House on the Heights*. New York: Little Bookroom, 2002.

Caratzas, Michael and Jessica Baldwin. *Sunset Park North Historic District Designation Report*. New York Landmarks Preservation Commission, 18 June 2019. http://s-media.nyc.gov/agencies/lpc/lp/2625.pdf.

Caratzas, Michael. *Bedford Historic District Designation Report*. New York Landmarks Preservation Commission, 8 December 2015. http://s-media.nyc.gov/agencies/lpc/lp/2514.pdf.

———. Caratzas, Michael D. *Julius' Bar Building Designation Report*. New York Landmarks Preservation Commission, 6 December 2022. http://s-media.nyc.gov/agencies/lpc/lp/2663.pdf.

———. *United Palace (Formerly Loew's 175th Street Theatre) Designation Report*. New York Landmarks Preservation Commission, 13 December 2016. http://s-media.nyc.gov/agencies/lpc/lp/0656.pdf.

Carley, Rachel. *Schomburg Collection for Research in Black Culture Designation Report*. New York: Landmarks Preservation Commission, 3 February 1981. http://s-media.nyc.gov/agencies/lpc/lp/1133.pdf.

Carlson, Jen. "A Little Look Back at Brooklyn's Montauk Club." *Gothamist*, 16 January 2012. https://gothamist.com/arts-entertainment/a-little-look-back-at-brooklyns-montauk-club.

———. "Royal Tenenbaum's Harlem House Is on the Rental Market." *Gothamist*, 13 May 2021. https://gothamist.com/arts-entertainment/royal-tenenbaums-harlem-house-rental-market.

Carr, Nick. "In SoHo, a Historied Haunt." *Wall Street Journal*, 24 October 2011. https://www.wsj.com/articles/BL-METROB-14110.

Center for Brooklyn History. "Our History." Brooklyn Public Library. https://www.bklynlibrary.org/cbh/about/history.

Chan, Sewell. "That Old Tale About S.I.? Hold On Now." *New York Times*, 21 February 2008. https://www.nytimes.com/2007/02/21/nyregion/21mayor.html.

Chang, Clio. "12 Gay Street Has a Lot Going On." *Curbed*, 12 October 2022. https://www.curbed.com/2022/10/graham-bonham-carter-sanctions-12-gay-street.html.

Clarke, Katherine. "Schinasi Mansion Buyer Revealed: Goldman's Mark Schwartz." *Real Deal*, 5 September 2013. https://therealdeal.com/new-york/2013/09/05/schinasi-mansion-buyer-revealed-goldmans-mark-schwartz/.

Compass. "339 Convent Ave." Compass. https://www.compass.com/listing/339-convent-avenue-manhattan-ny-10031/779665403154702257/.

Conference House Association. "History." Conference House Association. https://theconferencehouse.org/about/history/.

Congregation Shearith Israel. "Congregational History." Congregation Shearith Israel. https://www.shearithisrael.org/about/our-history/congregational-history/.

Danza, Cynthia. *339 Grand Street House Designation Report*. New York: Landmarks Preservation Commission, 29 October 2013. http://s-media.nyc.gov/agencies/lpc/lp/2413.pdf.

Danza, Cynthia, Donald G. Presa, and Michael Caratzas. *Park Slope Historic District Extension Designation Report.* New York Landmarks Preservation Commission, 17 April 2012. http://s-media.nyc.gov/agencies/lpc/lp/2443.pdf.

Davis, Amanda. *Free Public Baths of the City of New York, East 11th Street Bath Designation Report.* New York: Landmarks Preservation Commission, 18 March 2008. http://s-media.nyc.gov/agencies/lpc/lp/2252.pdf.

De Vries, Susan. "How Litchfield Villa, the Picturesque Mansion of Prospect Park, Came to Be." *Brownstoner*, 16 January 2017. https://www.brownstoner.com/architecture/litchfield-villa-prospect-park-alexander-jackson-davis-brooklyn-architecture-95-prospect-park-west/.

———. "Inside One of Brooklyn Heights' Oldest Houses, 24 Middagh, and Its Mysterious Past." *Brownstoner*, 21 August 2018. https://www.brownstoner.com/architecture/brooklyn-heights-oldest-houses-24-middagh-street-mysterious-past-history-architecture-federal-wood-frame/.

———. "The Swiss Chalet of Greenpoint." *Brownstoner*, 29 August 2017. https://www.brownstoner.com/architecture/brooklyn-architecture-keramos-861-manhattan-avenue-greenpoint/.

Des Verney Sinnette, Elinor. *Arturo Alfonso Schomburg: Black Bibliophile & Collector.* Detroit: Wayne State University Press, 2000.

Dillon, James T. *Alhambra Apartments Designation Report.* New York: Landmarks Preservation Commission, 18 March 1986. http://s-media.nyc.gov/agencies/lpc/lp/1431.pdf.

———. *The New York House and School of Industry Designation Report.* New York: Landmarks Preservation Commission, 2 October 1990. http://s-media.nyc.gov/agencies/lpc/lp/1632.pdf.

Dillon, James T., Andrew S. Dolkart, and Lisa Niven. *Greenpoint Historic District Designation Report.* New York: Landmarks Preservation Commission, 14 September 1982. http://s-media.nyc.gov/agencies/lpc/lp/1248.pdf.

Dolkart, Andrew S. *Bertine Block Historic District Designation Report.* New York Landmarks Preservation Commission, 5 April 1994. http://s-media.nyc.gov/agencies/lpc/lp/1900.pdf.

———. *Hamilton Fish Park Play Center Designation Report.* New York: Landmarks Preservation Commission, 21 December 1982. http://s-media.nyc.gov/agencies/lpc/lp/1264.pdf.

Dunlap, David W. "African Burial Ground Made Historic Site." *New York Times*, 26 February 1993. https://www.nytimes.com/1993/02/26/nyregion/african-burial-ground-made-historic-site.html.

———. *From Abyssinian to Zion: A Guide to Manhattan's Houses of Worship.* New York: Columbia University Press, 2004.

Dyckman Farmhouse Museum Alliance. "DyckmanDISCOVERED." Dyckman Farmhouse Museum Alliance. https://dyckmanfarmhouse.org/dyckmandiscovered/.

———. "The Dyckman Family." Dyckman Farmhouse Museum Alliance. https://dyckmanfarmhouse.org/about/history/dyckman-family/.

Ear Inn. "The History." Ear Inn. http://www.theearinn.com/about.

Flushing Town Hall. "Mission and History." Flushing Town Hall. https://www.flushingtownhall.org/mission-and-history.

Fordham University. "Historical Timeline." Fordham University. https://www.fordham.edu/about/fordhams-history/historical-timeline/.

Frye, Timothy. "Amendment of Landmark Designation, Alexander Hamilton House, aka Hamilton Grange." 30 June 2020. In *Hamilton Grange Designation Report*. New York: Landmarks Preservation Commission, 2 August 1967. http://s-media.nyc.gov/agencies/lpc/lp/0317.pdf.

Furman, Robert, and Brian Merlis. *Brooklyn Heights: The Rise, Fall and Rebirth of America's First Suburb*. Charleston, SC: History Press, 2015.

Gill, John Freeman. "A Slice of the Fulton Fish Market Gets a New Life." *New York Times*, 28 February 2021. https://www.nytimes.com/2020/02/28/realestate/a-slice-of-the-fulton-fish-market-gets-a-new-life.html.

———. "Another Landmark Lost, This Time on Astor Row in Harlem." *New York Times*, 5 November 2021. https://www.nytimes.com/2021/11/05/realestate/nyc-landmarks-demolition.html.

———. "A Tiny House in Manhattan Has a Link to the Underground Railroad." *New York Times*, 28 August 2022. https://www.nytimes.com/2022/08/28/realestate/streetscapes-tribeca-abolition.html.

Gould, Jennifer. "Bob Dylan Liked This Home So Much, He Turned It into an Album Cover." *New York Post*, 28 June 2017. https://nypost.com/2017/06/28/bob-dylan-liked-this-home-so-much-he-turned-it-into-an-album-cover/.

Gray, Christopher. "Streetscapes/150th Street and St. Nicholas Place; 1888 Mansion Built by the Bailey of Barnum & Bailey." *New York Times*, 8 April 2001. https://www.nytimes.com/2001/04/08/realestate/streetscapes-150th-street-st-nicholas-place-1888-mansion-built-bailey-barnum.html.

———. "Streetscapes: Engine Company 31 Firehouse; Getting to the Bottom of a Restoration." *New York Times*, 23 September 1990. https://www.nytimes.com/1990/09/23/realestate/streetscapes-engine-company-31-firehouse-getting-to-the-bottom-of-a-restoration.html.

———. "The Lavish 'Studio Palace' Called Alwyn Court." *New York Times*, 6 April 1997. https://www.nytimes.com/1997/04/06/realestate/the-lavish-studio-palace-called-alwyn-court.html.

———. "The Marble Manor That Turkish Tobacco Built." *New York Times*, 4 May 1997. https://www.nytimes. com/1997/05/04/realestate/the-marble-manor-that-turkish-tobacco-built.html.

Guillen, Nalleli. "Hunterfly Road and Brooklyn's Weeksville." *Brooklynology* (blog). Brooklyn Public Library, 26 February 2020. https://www.bklynlibrary. org/blog/2020/02/26/hunterfly-road-and.

Harris, Gale. *Delmonico's Building Designation Report*. New York: Landmarks Preservation Commission, 13 February 1996. http://s-media.nyc.gov/agencies/lpc/lp/1944.pdf.

———. *Doering-Bohack House Designation Report*. New York: Landmarks Preservation Commission. 30 September 2014. http://s-media.nyc.gov/agencies/lpc/lp/2548.pdf.

———. *Lewis H. Latimer House Designation Report*. New York: Landmarks Preservation Commission, 21 March 1995. http://s-media.nyc.gov/agencies/lpc/lp/1924.pdf.

Harris, Gale, Jean Howson, and Betsy Bradley. *African Burial Ground and the Commons Historic District Designation Report*. New York Landmarks Preservation Commission, 25 February 1993. http://s-media.nyc.gov/agencies/lpc/lp/1901.pdf.

Harrison, Tara. *William Ulmer Brewery Designation Report*. New York: Landmarks Preservation Commission, 11 May 2010. http://s-media.nyc.gov/agencies/lpc/lp/2280.pdf.

Henne, David. "Building Our History." *SJNY Magazine*, 15 October 2016. https://oncampus.sjny.edu/building-our-history/8/.

Higgins, Michelle. "Federal-Style Brooklyn Heights House for $7 Million." *New York Times*, 23 September 2016. https://www.nytimes.com/2016/09/25/realestate/federal-style-brooklyn-heights-house-for-7-million.html.

Hill, Isabel. *The Studebaker Building Designation Report*. New York: Landmarks Preservation Commission, 19 December 2000. http://s-media.nyc.gov/agencies/lpc/lp/2083.pdf.

Historic House Trust. "Old Stone House." Historic House Trust. https://historichousetrust.org/houses/old-stone-house/.

Historical Society of the New York Courts. "People v. Levi Weeks, 1800." Historical Society of the New York Courts. https://history.nycourts.gov/case/people-v-weeks/.

Holterman, Gabriele, and Robert Pozarycki. "Drama at Delmonico's: Fight over Trademark Puts Reopening of Landmark NYC Steakhouse in Jeopardy." *The Villager*, 25 January 2023. https://www.amny.com/news/delmonicos-reopening-trademark-battle-nyc-steakhouse/.

Holusha, Josh. "A Dream Grows in Brooklyn." *New York Times*, 22 June 1997. https://www.nytimes.com/1997/06/22/realestate/a-dream-grows-in-brooklyn.html.

Hoogenboom, Olive, and Ari Hoogenboom. "Alfred T. White: Settlement Worker and Housing Reformer." *Hayes Historical Journal* 9, no. 1 (Fall 1989): https://www.rbhayes.org/research/hayes-historical-journal-alfred-t.-white/.

Hornbeck, Leigh. "Old in Columbia County." *Times Union*, 27 August 2013. https://blog.timesunion.com/realestate/13071/13071/.

Howard University. *The New York African Burial Ground: Unearthing the African Presence in Colonial New York*, 2009. https://www.gsa.gov/system/files/Volume5_GenAudNYABG_2.pdf.

Hurley, Marianne. *Harriet and Thomas Truesdell House Designation Report*. New York Landmarks Preservation Commission, 2 February 2021. https://s-media.nyc.gov/agencies/lpc/lp/2645.pdf.

International Churchill Society. "Sir Winston and His Mother." 10 April 2017. International Churchill Society. https://winstonchurchill.org/the-life-of-churchill/life/family-man/sir-winston-and-his-mother/.

Kim, Elizabeth. "After Landmarking Effort, City Buys Brooklyn House with Ties to Underground Railroad." *Gothamist*, 16 March 2021. https://gothamist.com/news/after-landmarking-effort-city-buys-brooklyn-house-ties-underground-railroad.

Kurshan, Virginia. *(Former) Congregation Beth Hamedrash Hagadol Anshe Ungarn Designation Report*. New York: Landmarks Preservation Commission, 18 March 2008. http://s-media.nyc.gov/agencies/lpc/lp/2261.pdf.

———. *56 West 130th Street House Designation Report*. New York: Landmarks Preservation Commission, 11 August 1981. http://s-media.nyc.gov/agencies/lpc/lp/1161.pdf.

———. *Jonathan W. Allen Stable Designation Report*. New York: Landmarks Preservation Commission, 17 June 1997. http://s-media.nyc.gov/agencies/lpc/lp/1954.pdf.

———. *Kehila Kadosha Janina Synagogue Designation Report*. New York: Landmarks Preservation Commission, 11 May 2004. http://s-media.nyc.gov/agencies/lpc/lp/2143.pdf.

Lancaster, Clay. *Old Brooklyn Heights: New York's First Suburb*. New York: Dover Publications, 1979.

Landmarks Preservation Commission. *120 East 92nd Street House Designation Report*. New York: Landmarks Preservation Commission, 19 November 1969. http://s-media.nyc.gov/agencies/lpc/lp/0590.pdf.

———. *122 East 92nd Street House Designation Report*. New York: Landmarks Preservation Commission, 19 November 1969. http://s-media.nyc.gov/agencies/lpc/lp/0589.pdf.

———. *2 White Street House Designation Report*. New York: Landmarks Preservation Commission, 19 July 1966.

http://s-media.nyc.gov/agencies/lpc/lp/0086.pdf.

———. *203 Prince Street House Designation Report.* New York: Landmarks Preservation Commission, 19 February 1974. http://s-media.nyc.gov/agencies/lpc/lp/0830.pdf.

———. *311 East 58th Street House Designation Report."* New York: Landmarks Preservation Commission, 25 May 1967. http://s-media.nyc.gov/agencies/lpc/lp/0583.pdf.

———. *313 East 58th Street House.* New York: Landmarks Preservation Commission, 14 July 1970. https://s-media.nyc.gov/agencies/lpc/lp/0584.pdf.

———. *317 Washington Street House Designation Report.* New York: Landmarks Preservation Commission, 13 May 1969. http://s-media.nyc.gov/agencies/lpc/lp/0552.pdf.

———. *Albemarle-Kenmore Terraces Historic District Designation Report.* New York: Landmarks Preservation Commission, 11 July 1978. http://s-media.nyc.gov/agencies/lpc/lp/0989.pdf.

———. *Alwyn Court Apartments Designation Report.* New York: Landmarks Preservation Commission, 7 June 1966. http://s-media.nyc.gov/agencies/lpc/lp/0254.pdf.

———. *Blackwell House Designation Report."* New York: Landmarks Preservation Commission, 23 March 1976. http://s-media.nyc.gov/agencies/lpc/lp/0912.pdf.

———. *Bouwerie Lane Theatre (Originally Bond Street Savings Bank) Designation Report.* New York: Landmarks Preservation Commission, 11 January 1967. http://s-media.nyc.gov/agencies/lpc/lp/0192.pdf.

———. *Bowne House Designation Report.* New York: Landmarks Preservation Commission, 15 February 1966. http://s-media.nyc.gov/agencies/lpc/lp/0143.pdf.

———. *Brooklyn Borough Hall Designation Report.* New York: Landmarks Preservation Commission, 19 April 1966. http://s-media.nyc.gov/agencies/lpc/lp/0147.pdf.

———. *Brooklyn Heights Historic District Designation Report.* New York: Landmarks Preservation Commission, 23 November 1965. http://s-media.nyc.gov/agencies/lpc/lp/0099.pdf.

———. *Building "C" Designation Report.* New York: Landmarks Preservation Commission, 14 October 1965. http://s-media.nyc.gov/agencies/lpc/lp/0024.pdf.

———. *Chelsea Historic District Designation Report.* New York: Landmarks Preservation Commission, 15 September 1970. http://s-media.nyc.gov/agencies/lpc/lp/0666.pdf.

———. *Church of the Transfiguration Designation Report.* New York: Landmarks Preservation Commission, 1 February 1966. http://s-media.nyc.gov/agencies/lpc/lp/0085.pdf.

———. *Clinton Hill Historic District Designation Report*. New York Landmarks Preservation Commission, 10 November 1981. http://s-media.nyc.gov/agencies/lpc/lp/2017.pdf.

———. *Cobble Hill Historic District Designation Report*. New York: Landmarks Preservation Commission, 30 December 1969. http://s-media.nyc.gov/agencies/lpc/lp/0320.pdf.

———. *Conference House Designation Report*. New York: Landmarks Preservation Commission, 28 February 1967. http://s-media.nyc.gov/agencies/lpc/lp/0393.pdf.

———. *Congregation Shearith Israel (the Spanish and Portuguese Synagogue) Designation Report*. New York: Landmarks Preservation Commission, 19 March 1974. http://s-media.nyc.gov/agencies/lpc/lp/0832.pdf.

———. *Dyckman House Designation Report*. New York: Landmarks Preservation Commission, 12 July 1967. http://s-media.nyc.gov/agencies/lpc/lp/0309.pdf.

———. *E. V. Haughwout Building Designation Report*. New York: Landmarks Preservation Commission, 23 November 1965. http://s-media.nyc.gov/agencies/lpc/lp/0017.pdf.

———. *Edward Mooney House Designation Report*. New York: Landmarks Preservation Commission, 23 August 1966. http://s-media.nyc.gov/agencies/lpc/lp/0084.pdf.

———. *Fire House, Engine Company 31 Designation Report*. New York: Landmarks Preservation Commission, 18 January 1966. http://s-media.nyc.gov/agencies/lpc/lp/0087.pdf.

———. *First Free Congregational Church Designation Report*. New York: Landmarks Preservation Commission, 24 November 1981. http://s-media.nyc.gov/agencies/lpc/lp/2004.pdf.

———. *Flatbush Dutch Reformed Church, Expanded Landmark Site Designation Report*. New York: Landmarks Preservation Commission, 9 January 1979. http://s-media.nyc.gov/agencies/lpc/lp/0170E.pdf.

———. *Flushing Municipal Courthouse Designation Report*. New York: Landmarks Preservation Commission, 30 July 1968. http://s-media.nyc.gov/agencies/lpc/lp/0139.pdf.

———. *Former Lord & Taylor Building Designation Report*. New York: Landmarks Preservation Commission, 15 November 1977. http://s-media.nyc.gov/agencies/lpc/lp/0970.pdf.

———. *Former Police Headquarters Building Designation Report*. New York: Landmarks Preservation Commission, 26 September 1978. http://s-media.nyc.gov/agencies/lpc/lp/0999.pdf.

———. *Fort Greene Historic District Designation Report*. New York: Landmarks Preservation Commission, 26 September

1978. http://s-media.nyc.gov/agencies/lpc/lp/0973.pdf.

———. *Fraunces Tavern Block Historic District Designation Report*. New York: Landmarks Preservation Commission, 14 November 1978. http://s-media.nyc.gov/agencies/lpc/lp/0994.pdf.

———. *Fraunces Tavern Designation Report*. New York: Landmarks Preservation Commission, 23 November 1965. http://s-media.nyc.gov/agencies/lpc/lp/0030.pdf.

———. *Free Public Baths of the City of New York, East 11th Street Bath Designation Report*. New York: Landmarks Preservation Commission, 18 March 2008. https://s-media.nyc.gov/agencies/lpc/lp/2252.pdf.

———. *Friends Meeting House Designation Report*. New York: Landmarks Preservation Commission, 18 August 1970. http://s-media.nyc.gov/agencies/lpc/lp/0141.pdf.

———. *Fulton Ferry Historic District Designation Report*. New York: Landmarks Preservation Commission, 28 June 1977. http://s-media.nyc.gov/agencies/lpc/lp/0956.pdf.

———. *Gramercy Park Historic District Designation Report*. New York: Landmarks Preservation Commission, 20 September 1966. http://s-media.nyc.gov/agencies/lpc/lp/0251.pdf.

———. *Greenwich Village Historic District Designation Report*. New York: Landmarks Preservation Commission, 29 April 1969.

http://s-media.nyc.gov/agencies/lpc/lp/0489.pdf.

———. *Hamilton Grange Designation Report*. New York: Landmarks Preservation Commission, 2 August 1967. http://s-media.nyc.gov/agencies/lpc/lp/0317.pdf.

———. *Hamilton Heights Historic District Designation Report*. New York: Landmarks Preservation Commission, 26 November 1974. http://s-media.nyc.gov/agencies/lpc/lp/0872.pdf.

———. *Henderson Place Historic District Designation Report*. New York: Landmarks Preservation Commission, 11 February 1969. http://s-media.nyc.gov/agencies/lpc/lp/0454.pdf.

———. *Houses on Hunterfly Road Designation Report*. New York: Landmarks Preservation Commission, 18 August 1970. http://s-media.nyc.gov/agencies/lpc/lp/0769.pdf.

———. *James Brown House Designation Report*. New York: Landmarks Preservation Commission, 19 November 1969. http://s-media.nyc.gov/agencies/lpc/lp/0568.pdf.

———. *James F.D. Lanier Residence Designation Report*. New York: Landmarks Preservation Commission, 11 September 1979. http://s-media.nyc.gov/agencies/lpc/lp/1048.pdf.

———. *James Watson House Designation Report*. New York: Landmarks Preservation Commission, 23 November

1965. http://s-media.nyc.gov/agencies/lpc/lp/0036.pdf.

———. *John Street Methodist Church Designation Report*. New York: Landmarks Preservation Commission, 21 December 1965. http://s-media.nyc.gov/agencies/lpc/lp/0055.pdf.

———. *Jumel Terrace Historic District Designation Report*. New York: Landmarks Preservation Commission, 18 August 1970. http://s-media.nyc.gov/agencies/lpc/lp/0638.pdf.

———. *Litchfield Villa Designation Report*. New York: Landmarks Preservation Commission, 15 March 1966. http://s-media.nyc.gov/agencies/lpc/lp/0153.pdf.

———. *Marble Collegiate Reformed Church Designation Report*. New York: Landmarks Preservation Commission, 11 January 1967. http://s-media.nyc.gov/agencies/lpc/lp/0234.pdf.

———. *Morris-Jumel Mansion Designation Report*. New York: Landmarks Preservation Commission, 12 July 1967. http://s-media.nyc.gov/agencies/lpc/lp/0308.pdf.

———. *Morris-Jumel Mansion Interior Designation Report*. New York: Landmarks Preservation Commission, 27 May 1975. http://s-media.nyc.gov/agencies/lpc/lp/0888.pdf.

———. *New World Foundation Building (Formerly Lewis G. Morris House) Designation Report*. New York: Landmarks Preservation Commission, 19 April 1973.

http://s-media.nyc.gov/agencies/lpc/lp/0654.pdf.

———. *New York State Supreme Court, Queens County, Long Island City Branch Designation Report*. New York: Landmarks Preservation Commission, 11 May 1976. http://s-media.nyc.gov/agencies/lpc/lp/0925.pdf.

———. *Old Brooklyn Fire Headquarters Designation Report*. New York: Landmarks Preservation Commission, 19 April 1966. http://s-media.nyc.gov/agencies/lpc/lp/0148.pdf.

———. *Park Slope Historic District Designation Report*. New York: Landmarks Preservation Commission, 17 July 1973. https://s-media.nyc.gov/agencies/lpc/lp/0709.pdf.

———. *Pieter Claesen Wyckoff House Designation Report*. New York: Landmarks Preservation Commission, 15 October 1965. http://s-media.nyc.gov/agencies/lpc/lp/0001.pdf.

———. *Poe Cottage Designation Report*. New York: Landmarks Preservation Commission, 15 February 1966. http://s-media.nyc.gov/agencies/lpc/lp/0110.pdf.

———. *Prospect Park Designation Report*. New York: Landmarks Preservation Commission, 15 March 1966. http://s-media.nyc.gov/agencies/lpc/lp/0153.pdf.

———. *Rose Hill (Fordham University Administration Building) Designation Report*. New York: Landmarks Preservation Commission, 18 August

1970. http://s-media.nyc.gov/agencies/lpc/lp/0116.pdf.

———. *Sara Delano Roosevelt Memorial House Designation Report*. 25 September 1973. New York: Landmarks Preservation Commission, 25 April 2019. http://s-media.nyc.gov/agencies/lpc/lp/0702.pdf.

———. *Schinasi Residence Designation Report*. New York: Landmarks Preservation Commission, 19 March 1974. http://s-media.nyc.gov/agencies/lpc/lp/0844.pdf.

———. *SoHo-Cast Iron Historic District Designation Report*. New York: Landmarks Preservation Commission, 14 August 1973. http://s-media.nyc.gov/agencies/lpc/lp/0768.pdf.

———. *Soldiers' and Sailors' Memorial Arch Designation Report*. New York: Landmarks Preservation Commission, 16 October 1973. http://s-media.nyc.gov/agencies/lpc/lp/0821.pdf.

———. *Soldiers and Sailors Monument Designation Report*. New York: Landmarks Preservation Commission, 14 September 1976. http://s-media.nyc.gov/agencies/lpc/lp/0932.pdf.

———. *South Street Seaport Historic District Designation Report*. New York: Landmarks Preservation Commission, 10 May 1977. http://s-media.nyc.gov/agencies/lpc/lp/0948.pdf.

———. *St. Mark's Historic District Designation Report*. New York: Landmarks Preservation Commission, 14 January

1969. https://s-media.nyc.gov/agencies/lpc/lp/0250.pdf.

———. *St. Michael's Chapel of Old St. Patrick's Cathedral Designation Report*. New York: Landmarks Preservation Commission, 12 July 1977. http://s-media.nyc.gov/agencies/lpc/lp/0961.pdf.

———. *Steele House Designation Report*. New York: Landmarks Preservation Commission, 19 March 1968. http://s-media.nyc.gov/agencies/lpc/lp/0161.pdf.

———. *The Bailey Residence Designation Report*. New York: Landmarks Preservation Commission, 19 February 1974. http://s-media.nyc.gov/agencies/lpc/lp/0845.pdf.

———. *The Dakota Apartments Designation Report*. New York Landmarks Preservation Commission, 11 February 1969. http://s-media.nyc.gov/agencies/lpc/lp/0280.pdf.

———. *Theodore Roosevelt House Designation Report*. New York Landmarks Preservation Commission, 15 March 1966. http://s-media.nyc.gov/agencies/lpc/lp/0218.pdf.

———. *Van Cortlandt Mansion Designation Report*. New York: Landmarks Preservation Commission, 15 March 1966. http://s-media.nyc.gov/agencies/lpc/lp/0127.pdf.

———. *Williamsburgh Savings Bank Designation Report*. New York: Landmarks Preservation Commission, 17 May 1966. http://s-media.nyc.gov/agencies/lpc/lp/0164.pdf.

———. *Williamsburgh Savings Bank Designation Report*. New York: Landmarks Preservation Commission, 15 November 1977. http://s-media.nyc.gov/agencies/lpc/lp/0971.pdf.

Lewis Latimer House Museum. "History." Lewis Latimer House Museum. https://www.lewislatimerhouse.org/about.

Library of Congress. "Dollar Princesses: Topics in Chronicling America." Research Guides. https://guides.loc.gov/chronicling-america-dollar-princesses.

Lisicky, Michael. "Lord & Taylor Locks Its Doors for the Last Time, After 195 Years." *Forbes*, 27 Feburary 2021. https://www.forbes.com/sites/michaellisicky/2021/02/27/lord--taylor-locks-its-doors-for-the-last-time-after-195-years/?sh=6e9c7dc23836.

Lord & Taylor. "About Us." Lord & Taylor. https://www.lordandtaylor.com/pages/about-us.

Lovinger, Joe. "Bistricer Plans 650 Units at Landmarked Sears in Flatbush." *Real Deal*, 30 March 2022. https://therealdeal.com/new-york/2022/03/30/bistricer-plans-650-units-at-landmarked-sears-in-flatbush/.

Madsen, Axel. *John Jacob Astor: America's First Multimillionaire*. New York: John Wiley & Sons, 2001.

Mannon, Grace. "Who's to Thank for Eggs Benedict, Our Favorite Brunch Dish?" *Taste of Home*, 15 July 2022. https://www.tasteofhome.com/article/who-created-eggs-benedict/.

Martin, Douglas. "Joan Maynard Dies at 77; Preserved a Black Settlement." *New York Times*, 24 January 2006. https://www.nytimes.com/2006/01/24/nyregion/joan-maynard-dies-at-77-preserved-a-black-settlement.html.

Miller, Tom. *Seeking New York: The Stories Behind the Historic Architecture of Manhattan—One Building at a Time*. New York: Rizzoli International Publications, 2015.

———. "The 1800 Isaacs-Hendricks House—77 Bedford Street." *Daytonian in Manhattan* (blog), 30 May 2018. http://daytoninmanhattan.blogspot.com/2018/05/the-1800-isaacs-hendricks-house-77.html.

———. "The Elegant 1834 House at No. 203 Prince Street." *Daytonian in Manhattan* (blog), 9 May 2011. http://daytoninmanhattan.blogspot.com/2011/05/elegant-1834-house-at-no-203-prince.html.

Mixson, Colin. "Pushing Tin: Preservationists Blast City's Approval to Move Historic Tin Building." *AMNY*, 7 April 2016. https://www.amny.com/news/pushing-tin-preservationists-blast-citys-approval-to-move-historic-tin-building/.

Mohylowski, Edward. *17 East 128th Street House Designation Report*. New York: Landmarks Preservation Commission, 21

December 1982. http://s-media.nyc.gov/
agencies/lpc/lp/1237.pdf.

Morris-Jumel Mansion. "Mission and
History." Morris-Jumel Mansion. https://
morrisjumel.org/about/.

Morrone, Francis. *An Architectural Guidebook
to Brooklyn.* Salt Lake City: Gibbs Smith,
2001.

Moskowitz, Sam. "A Prince of a House:
No. 203 Prince Street." *Off the Grid
Village Preservation Blog*, 19 February
2019. https://www.villagepreservation.
org/2019/02/19/a-prince-of-a-house-no-
203-prince-street/.

———. "The Irish Emigrant Aid Society's
Greenwich Village Roots." *Off the Grid
Village Preservation Blog*, 22 March
2022. https://www.villagepreservation.
org/2022/03/22/the-irish-emigrant-aid-
societys-greenwich-village-roots/.

Museum Association of New York.
"Breaking Down the Walled City: A
Look into the Brooklyn Historical
Society's New Exhibition in DUMBO."
Museum Association of New York, 28
August 2018. https://nysmuseums.org/
MANYnews/6642988.

Nadelson, Reggie. "In Greenwich Village, the
Perfect New York Bookstore Lives On."
T: The New York Times Style Magazine, 25
November 2019. https://www.nytimes.
com/2019/11/25/t-magazine/three-lives-
bookstore.html.

———. "The 200-Year-Old Bar Beloved
by Book Editors and Longshoremen."

T: The New York Times Style Magazine,
13 November 2018. https://www.
nytimes.com/2018/11/13/t-
magazine/ear-inn-new-york-history.
html?searchResultPosition=4.

National Football League. "Baltimore
Ravens," Team Histories. National Football
League. https://operations.nfl.com/
learn-the-game/nfl-basics/team-histories/
american-football-conference/north/
baltimore-ravens/.

National Park Service. "A Monumental
Move." National Park Service, 22 June
2022. https://www.nps.gov/articles/000/
a-monumental-move.htm.

———. "Archaeology." African Burial
Ground. National Park Service, 14 January
2022. https://www.nps.gov/afbg/learn/
historyculture/archaeology.htm.

———. "Blackwell's Island (Roosevelt
Island), New York City." National Park
Service, 5 April 2021. https://www.nps.
gov/places/blackwell-s-island-new-york-
city.htm.

———. "Carnegie Libraries: The Future
Made Bright (Teaching with Historic
Places)." National Park Service, 29 March
2023. https://www.nps.gov/articles/
carnegie-libraries-the-future-made-bright-
teaching-with-historic-places.htm.

———. "Fernando Wood." National Park
Service. https://www.nps.gov/people/
fernando-wood.htm.

———. "Reinterment." African Burial
Ground, 15 December 2018. https://

www.nps.gov/afbg/learn/historyculture/reinterment.htm.

———. "Hamilton Grange National Monument." Founders and Frontiersmen: Survey of Historic Sites and Buildings. National Park Service. https://www.nps.gov/parkhistory/online_books/founders/sitea23.htm.

New York City Department of City Planning. "Total and Foreign-Born Population: New York City, 1790–2000." Population Census Information and Data—Historical Population Info. https://www.nyc.gov/assets/planning/download/pdf/data-maps/nyc-population/historical-population/1790-2000_nyc_total_foreign_birth.pdf.

New York City Department of Citywide Administrative Services. "Brooklyn Borough Hall." New York City Department of Citywide Administrative Services. https://www.nyc.gov/site/dcas/business/dcasmanagedbuildings/brooklyn-borough-hall.page.

New York City Department of Parks & Recreation. "Edgar Allan Poe & the Historic Poe Park." New York City Department of Parks & Recreation. https://www.nycgovparks.org/highlights/edgar-allan-poe-and-the-historic-poe-park.

———. "Fidler-Wyckoff House Park." New York City Department of Parks & Recreation. https://www.nycgovparks.org/parks/m-fidler-wyckoff-house-park/history.

———. "Fort Greene Park." New York City Department of Parks & Recreation. https://www.nycgovparks.org/parks/fort-greene-park/monuments/1222.

———. "Fort Washington Park." New York City Department of Parks & Recreation. https://www.nycgovparks.org/parks/fort-washington-park/highlights/11044.

———. "Mannahatta Park." New York City Department of Parks & Recreation. https://www.nycgovparks.org/parks/mannahatta-park/highlights/19696.

———. "Van Cortlandt Park." New York City Department of Parks & Recreation. May 2023. https://www.nycgovparks.org/parks/VanCortlandtPark/facilities/historichouses.

———. "Washington Park." New York City Department of Parks & Recreation. https://www.nycgovparks.org/parks/washington-park/highlights/138.

New York City Tourism + Conventions. Flatbush Dutch Reformed Church. https://www.nycgo.com/attractions/flatbush-dutch-reformed-church/.

New York Preservation Archive Project. "Hunterfly Road Houses." Oral Histories. New York Preservation Archive Project. https://www.nypap.org/preservation-history/hunterfly-road-houses/.

New York Times. "Alfred T. White, Brooklyn Philanthropist, Leaves $15,000,000 Estate to Daughter." *New York Times*, 20 February 1921. https://timesmachine.nytimes.com/

timesmachine/1921/02/20/112672193. html?pageNumber=42.

———. "Mansion to House India Diplomats." *New York Times*, 12 December 1948. 17 July 2023. https://timesmachine.nytimes.com/timesmachine/1948/12/12/96607407.pdf?pdf_redirect=true&ip=0.

———. "Save Lighthouse, Child Experts Ask." *New York Times*, 12 July 1951. https://timesmachine.nytimes.com/timesmachine/1951/07/12/121434013.html?pageNumber=23.

Noble Maritime Collection. "History." Sailors' Snug Harbor. https://noblemaritime.org/sailors-snug-harbor.

Noonan, Theresa C. The Bowery Mission Designation Report. New York: Landmarks Preservation Commission, 26 June 2012. http://s-media.nyc.gov/agencies/lpc/lp/2494.pdf.

Nwoye, Irene Chidinma. "Is There Really a Haunted Well at New York's New COS Store?" *Village Voice*. 2 February 2015. https://www.villagevoice.com/2015/02/02/is-there-really-a-haunted-well-at-new-yorks-new-cos-store/.

NYC Department of Housing Preservation and Development. "Saving the Alhambra." Urban Archive. https://www.urbanarchive.org/stories/mbXWKzXrvr5.

NYC LGBT Historic Sites. "PHOTOS: Plaque Unveiled at Julius' Bar, Commemorating History-Making Act of Civil Disobedience." 22 April 2022.

NYC LGBT Historic Sites. https://www.nyclgbtsites.org/2022/04/26/julius-plaque-photos/.

NYC Office of Management and Budget and NYC Department of Parks and Recreation. "Soldiers' & Sailors' Memorial: Conditions Survey & Restoration Treatment Study." New York City Department of Parks & Recreation, 22 February 2017. https://www.nycgovparks.org/pagefiles/130/Soldiers-and-Sailors-CB-Presentation-2-22-17__5b7495b5ad4b2.pdf.

NYCEDC. "New Yorkers and Their Cars." New York City Economic Development Corporation, 5 April 2018. https://edc.nyc/article/new-yorkers-and-their-cars.

Office of the Mayor. "Mayor Bill de Blasio Announces $8.9 Million Restoration of Grand Army Plaza." Office of the Mayor, 24 August 2018. https://www.nyc.gov/office-of-the-mayor/news/434-18/mayor-bill-de-blasio-8-9-million-restoration-grand-army-plaza#/0.

Oser, Alan S. "Metrotech: A Test for a New Form of Urban Renewal." *New York Times*, 6 January 1985. https://timesmachine.nytimes.com/timesmachine/1985/01/06/197387.html?pageNumber=368.

Pearson, Marjorie. *Langston Hughes House Designation Report*. New York: Landmarks Preservation Commission, 11 August 1981. http://s-media.nyc.gov/agencies/lpc/lp/1135.pdf.

Phillips, Jessica B. "Samuel Fraunces: Revealed?" Fraunces Tavern Museum, 5 September 2018. https://www.frauncestavernmuseum.org/samuel-fraunces-revealed.

Pickart, Margaret M. *The Prentiss Residence Designation Report*. New York: Landmarks Preservation Commission, 8 January 1991. http://s-media.nyc.gov/agencies/lpc/lp/1715.pdf.

Plagianos, Irene. "One Last Shot for a Historic Manhattan Bar." *Wall Street Journal*, 22 February 2020. https://www.wsj.com/articles/one-last-shot-for-a-historic-manhattan-bar-11582381962.

Postal, Matthew A. *Gay Activists Alliance Firehouse (Former Engine Company No. 13) Designation Report*. New York Landmarks Preservation Commission, 18 June 2019. http://s-media.nyc.gov/agencies/lpc/lp/2632.pdf.

———. *Park Avenue Historic District Designation Report*. New York Landmarks Preservation Commission, 29 April 2014. http://s-media.nyc.gov/agencies/lpc/lp/2547.pdf.

Postal, Matthew. *Sears Roebuck & Company Department Store Designation Report*. New York: Landmarks Preservation Commission, 15 May 2012. http://s-media.nyc.gov/agencies/lpc/lp/2469.pdf.

Presa, Donald G. *(Former) Colored School No. 3 Designation Report*. New York: Landmarks Preservation Commission, 13 January 1998. http://s-media.nyc.gov/agencies/lpc/lp/1977.pdf.

———. *190 Grand Street Designation Report*. New York: Landmarks Preservation Commission, 16 November 2010. http://s-media.nyc.gov/agencies/lpc/lp/2411.pdf.

———. *NoHo Historic District Designation Report*. New York Landmarks Preservation Commission, 29 June 1999. http://s-media.nyc.gov/agencies/lpc/lp/2039.pdf.

———. *Vinegar Hill Historic District Designation Report*. New York: Landmarks Preservation Commission, 14 January 1997. http://s-media.nyc.gov/agencies/lpc/lp/1952.pdf.

Prospect Park Alliance. "Grand Army Plaza Restoration." Prospect Park Alliance. https://www.prospectpark.org/learn-more/what-we-do/advancing-the-park/grand-army-plaza-restoration/.

Riverside Park Conservancy. "Mayor Adams' FY24 Budget Includes $62.3 Million for the Restoration of the Soldiers' and Sailors' Monument in Riverside Park." Riverside Park Conservancy, 13 January 2023. https://riversideparknyc.org/mayor-adams-fy24-budget-includes-62-3-million-for-the-restoration-of-the-soldiers-and-sailors-monument-in-riverside-park/.

Sandoval, Gabriel. "Sears Closing Brooklyn Store, Its Last Outpost in New York City." *The City*, 18 September 2021. https://www.thecity.nyc/

brooklyn/2021/9/17/22680361/signs-
sears-closing-last-nyc-store-brooklyn.

Schulz, Dana. "Hold Your Horses, This
Clinton Hill Carriage House is Younger
Than You Think." *6sqft*, 28 July 2014.
https://www.6sqft.com/hold-your-horses-
this-clinton-hill-carriage-house-is-younger-
than-you-think/.

Shaman, Diana. "Neighborhood Pride;
Restoring Harlem's Astor Row Houses."
New York Times, 23 October 1992.
https://www.nytimes.com/1992/10/23/
nyregion/neighborhood-pride-restoring-
harlems-astor-row-homes.html.

Snug Harbor Cultural Center & Botanical
Garden. "History." Snug Harbor Cultural
Center & Botanical Garden. https://snug-
harbor.org/about-us/history/.

Spellen, Suzanne. "Building of the Day:
232 Clinton Avenue." *Brownstoner*,
1 November 2013. https://www.
brownstoner.com/architecture/building-
of-the-day-232-clinton-avenue/.

———. "'Separate But Equal' in 1870s
Williamsburg: Colored School No. 3."
Brownstoner, 5 August 2021. https://
www.brownstoner.com/architecture/
williamsburg-brooklyn-270-union-avenue-
colored-school-number-3-segregation-
history/.

St. Patrick's Cathedral. "History &
Heritage." St. Patrick's Cathedral. https://
saintpatrickscathedral.org/history-
heritage.

Stargard, William, and Marjorie Pearson.
*New York Stock Exchange Building
Designation Report*. New York: Landmarks
Preservation Commission, 9 July 1985.
http://s-media.nyc.gov/agencies/lpc/
lp/1529.pdf.

StreetEasy. "14 Henderson Place." StreetEasy.
https://streeteasy.com/building/14-
henderson-place-new_york#tab_building_
detail=2.

———. "17 Grove Street." StreetEasy.
https://streeteasy.com/building/17-grove-
street-new_york#tab_building_detail=2.

———. "70 Willow Street." StreetEasy.
https://streeteasy.com/building/70-willow-
street-brooklyn#tab_building_detail=2.

———. "75 1/2 Bedford Street." StreetEasy.
https://streeteasy.com/building/75-and-
a-half-bedford-street-new_york#tab_
building_detail=1.

———. "77 Bedford Street." StreetEasy.
https://streeteasy.com/building/77-
bedford-street-new_york#tab_building_
detail=2.

———. "James A. and Ruth M. Bailey House."
StreetEasy. https://streeteasy.com/
building/james-a-and-ruth-m-bailey-house.

———. "Joseph Steele House." StreetEasy.
https://streeteasy.com/building/joseph-
steele-house#tab_building_detail=2.

Sutphin, Amanda, Jessica Striebel MacLean,
and MaryNell Nolan-Wheatley.
*Aakawaxung Munahanung (Island
Protected from the Wind) Archaeological
Site Designation Report*. New York

Landmarks Preservation Commission, 22 June 2021. http://s-media.nyc.gov/agencies/lpc/lp/2648.pdf.

Taylor, Paul J. "The Fabulous Leonard Jerome: Churchill's 'Fierce' American Roots." International Churchill Society, 28 August 2017. https://winstonchurchill.org/publications/finest-hour/finest-hour-176/leonard-jerome/.

The Lo-Down. "Historic Ideal Hosiery Building, 339 Grand St., Put Up for Sale." The Lo-Down, 2 August 2018. https://www.thelodownny.com/leslog/2018/08/historic-ideal-hosiery-building-339-grand-st-put-up-for-sale.html.

Toner, Ian. "Your House and Your Facade: A Separation Agreement." Toner Architects, 13 June 2013. https://ian-toner.squarespace.com/blog/2013/6/13/your-house-and-your-facade-a-separation-agreement.html.

Trustees of the Sailors' Snug Harbor in the City of New York. "Brief History." Trustees of the Sailors' Snug Harbor in the City of New York. https://thesailorssnugharbor.org/brief-history/.

Tummino, Annie. "Herman Melville and Sailors' Snug Harbor." In "A Medium in Which I Seek Relief": Manuscripts and Letters of American Sailors, circa 1920s–1940s. Updated 26 August 2021. https://scalar.usc.edu/works/sailormemoirs/herman-melville-and-sailors-snug-harbor?path=sailors-and-literary-culture.

Van Cortlandt House Museum. "An Overview of Van Cortlandt House Museum." Van Cortlandt House Museum. https://www.vchm.org/about.html.

Van Cortlandt Park Alliance. "Van Cortlandt House." Van Cortlandt Park Alliance. https://vancortlandt.org/tour_enslavedafrican/van-cortlandt-house.

Village Preservation. "Edward Hopper's Drug Store." Off the Grid Village Preservation Blog. Village Preservation, 31 March 2011. https://www.villagepreservation.org/2011/03/31/edward-hoppers-drug-store/.

———. "Wood-Frame Houses in the Village." Off the Grid Village Preservation Blog. Village Preservation, 22 July 2013. https://www.villagepreservation.org/2013/07/22/wood-frame-houses-in-the-village/.

Weylin. "About Us." Weylin. https://weylin.com/about/history/.

White, Norval, and Elliot Willensky. AIA Guide to New York City. 4th ed. New York: Three Rivers Press, 2000.

White, Norval, and Elliot Willensky. AIA Guide to New York City. With Fran Leadon. 5th ed. New York: Oxford University Press, 2010.

Winchell, Louisa. "A Marriage Leads to Construction of Manhattan's Oldest Residence." Off the Grid Village Preservation Blog. Village Preservation, 30 January 2020. https://www.villagepreservation.org/2020/01/30/a-marriage-leads-to-construction-of-manhattans-oldest-residential-building/.

Wright, Carol Von Pressentin. *Blue Guide New York*. 5th ed. New York: W. W. Norton, 2016.

Wyckoff House Museum. "Garden & Farm." Wyckoff House Museum. https://wyckoffmuseum.org/garden/.

———. "The Story of Pieter and the Wyckoff Farmhouse." Wyckoff House Museum Brooklyn. https://wyckoffmuseum.org/wp-content/uploads/2015/08/The-Story-of-Pieter-and-the-Wyckoff-Farmhouse.pdf.

Yeats, Dylan. "Colonial Brooklyn." Old Stone House. https://theoldstonehouse.org/history/dutch-colonial-era/.

Young, Greg, and Tom Meyers. *The Bowery Boys: Adventures in Old New York*. Berkeley: Ulysses Press, 2016.

———. "Ten Fabulous Facts About 70 Willow Street, Brookyn Heights, aka 'The Truman Capote House.'" Bowery Boys, 6 March 2012. https://www.boweryboyshistory.com/2012/03/ten-fabulous-facts-about-70-willow.html.

Zacks, Stephen. "Landmarked Brooklyn Heights Carriage House with Lofty Living Room, Indoor Parking Asks $6.5 Million." *Brownstoner*, 3 June 2019. https://www.brownstoner.com/real-estate-market/brooklyn-heights-historic-district-carriage-house-for-sale-4-hunts-lane-three-bedroom-parking/.

Zavin, Shirley. *Forward Building Designation Report*. New York: Landmarks Preservation Commission, 18 March 1986. http://s-media.nyc.gov/agencies/lpc/lp/1419.pdf.

INDEX